KU-665-507

Bromley Libraries

30128 80297 632 7

# PICTURING
## PRINCE

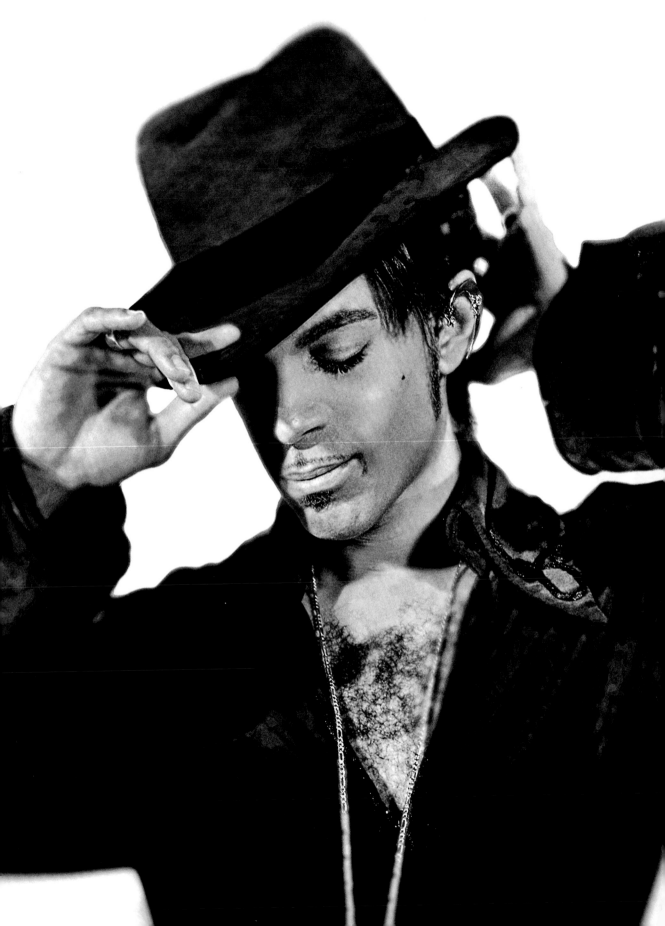

An Intimate Portrait
featuring unseen photography

# PICTURING
# PRINCE

Steve Parke
Foreword by Sheila E.

CASSELL
ILLUSTRATED

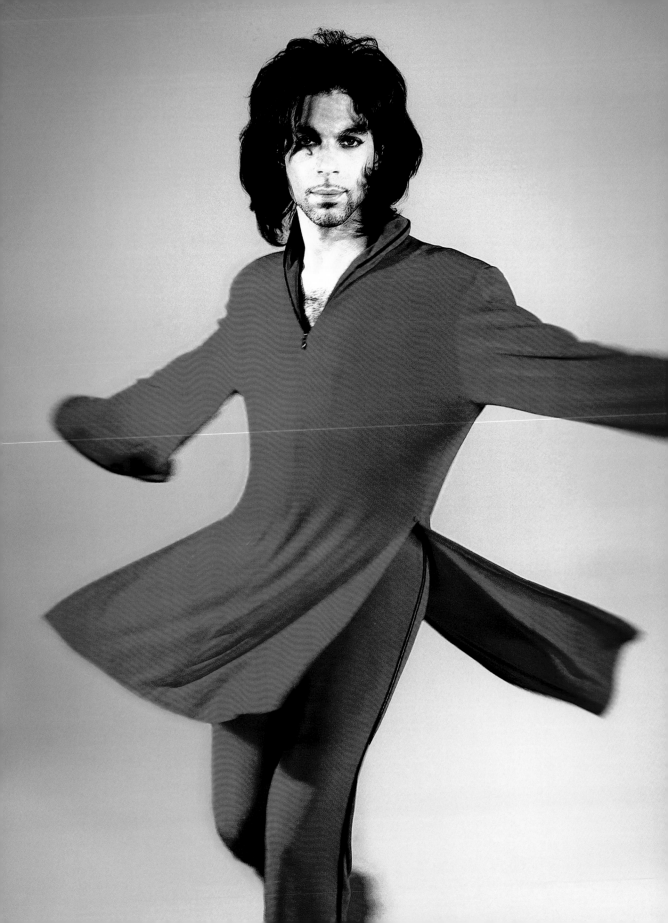

# CONTENTS

# FOREWORD
## BY SHEILA E.

When Steve asked me to write a foreword for this book, my initial reaction was to respectfully decline. Like many of you, the event of Prince's passing had left me feeling exhausted and confused regarding which direction to choose in moving on. I also felt some hesitation, knowing that Prince was very protective of and private in his personal life—something that I, as a friend and fellow artist, respect and understand. It's this other side of us that helps to sustain the level of celebrity and mystery that fans come to expect of an artist. But, more importantly, it's a facet of our lives that helps us to maintain our humanity and that keeps us connected to the real world, something we often find ourselves insulated from.

Prince was an enigma to the public, perhaps one of the greatest in modern history. It is what most would say and agree with and also it's the wrapping in which most who did know him dress their own stories of him: the mystery, the magic, the unknown. I understand that it's how the public came to relate to and appreciate Prince the artist, the celebrity, the genius. But what of the man himself? To me, and to many of us who knew Prince personally, to have had those times of friendship, collaboration, and interaction that existed outside the circle of celebrity, how would those be conveyed without violating the respect and privacy of such a beloved friend?

Out of respect for Steve, as an artist and friend, I put aside my anxieties and decided to take a peek at the work he had created (and which you now hold in your hand), and found myself adrift in memories of the man that I knew. Upon perusing the text and photos therein I smiled, laughed, and cried at the beautiful recollections shared by a person whose responsibility it was to capture the essence of Prince and translate it into a format that would be acceptable to and understood by his mass of followers. Through this work, Steve has once more given us images and messages that not only support the public Prince persona but also reveal the real person that some of us were so very fortunate to know.

I know that, in sharing this work with you, Steve has enabled you to catch a glimpse of so much more than Prince the celebrity. Perhaps you will come to realize, too, that the world lost so much more than just a celebrated Prince; it lost a man whose humanity will touch and color the world for many dawns to come.

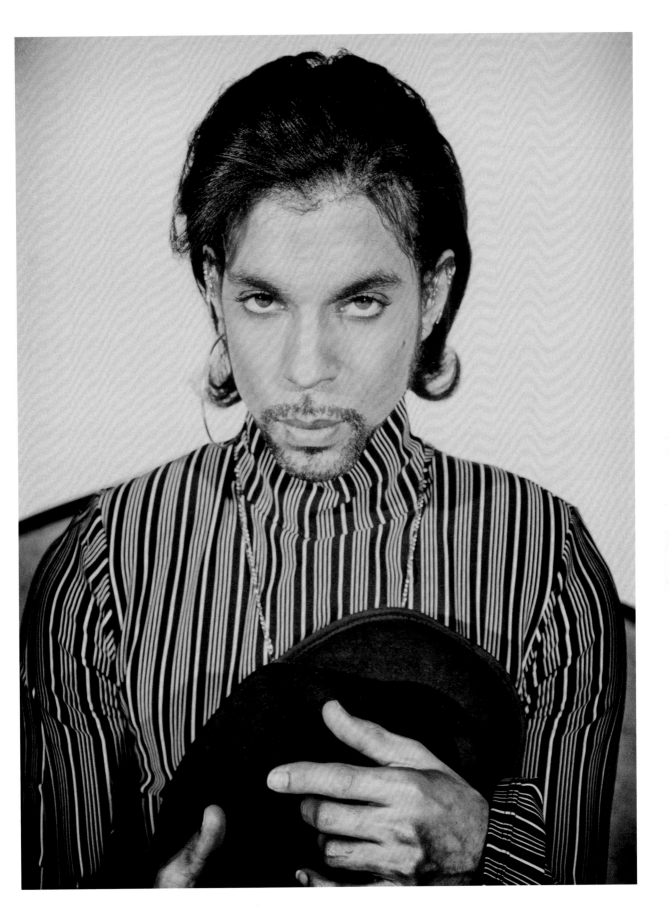

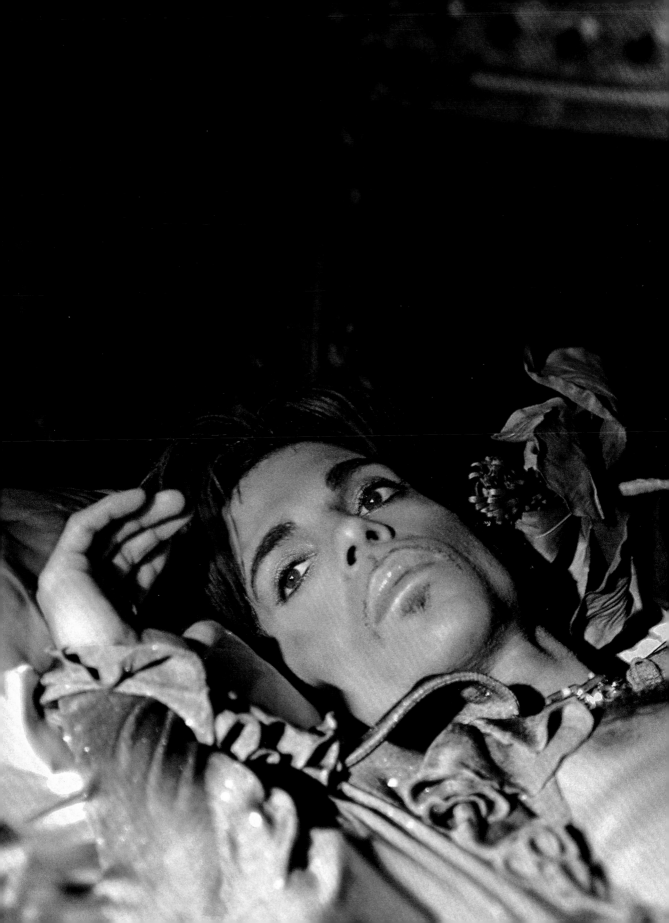

# INTRODUCTION

The morning of April 21, 2016, my friend George in St. Paul, Minnesota, called me at my studio in Baltimore to ask if I'd heard the news. Something had happened at Paisley Park, he said. Then, the news broke that a body had been found there. I imagined it was an employee, maybe someone I'd known during my own 13 years there, but I hoped not. More calls came, and then my phone was buzzing non-stop and emails were flying around as well as news reports online until, finally, the confirmation—Prince was dead. Found in the elevator. I knew that elevator. It was across the hall from where my office had been all those years before; back then, I'd hear the ding of that elevator and know he was coming.

At first, I didn't have time to take it in because all at once reporters from magazines and newspapers were calling—it seemed as if every media outlet in the world phoned me that day—but then I turned off the ringer, shut off the internet, and just sat for a while and tried to comprehend it.

I hadn't seen Prince in 15 years, since I'd quit; I'd burned myself out and wanted to spend more time with my infant son. I'd always thought I'd see him again. I didn't think he would die. I'm sure he didn't think he would die. When speculation came over the next days that he didn't leave a will, I wasn't too surprised. He'd once made an argument that buying health insurance was like asking to get sick.

This news brought a memory to the fore: when we'd sat in my office listening quietly to Stevie Wonder's *Fullingness' First Finale* album; Prince and I spent countless hours together listening to music we both loved. The track "They Won't Go When I Go" was wrapping up and the song ends introspectively:

When I go / Where I'll go / No one can keep me / From my destiny

When the synths faded out, he looked up at me and said: "I'm just not going to go at all."

<p align="center">✳   ✳   ✳   ✳   ✳   ✳</p>

As a teenager in Fairfax, Virginia, in the late 1970s and early '80s, I never would have dreamed I'd end up working for Prince. I was a huge fan—spreading the gospel of Prince long before it was hip and before anyone I knew had even heard of him ("You mean that girl on 'Soft and Wet' is a *guy*?"). At that time, all I wanted to do was draw and listen to music.

A few years later, thanks to a TV producer friend on the local broadcast of *Friday Night Videos*, I started shooting concert photos at local music venues for them to feature each month between breaks. In the late '80s I met Sheila E. (a friend to this day) when she was opening for Lionel Richie. I also became friends with her guitarist Levi

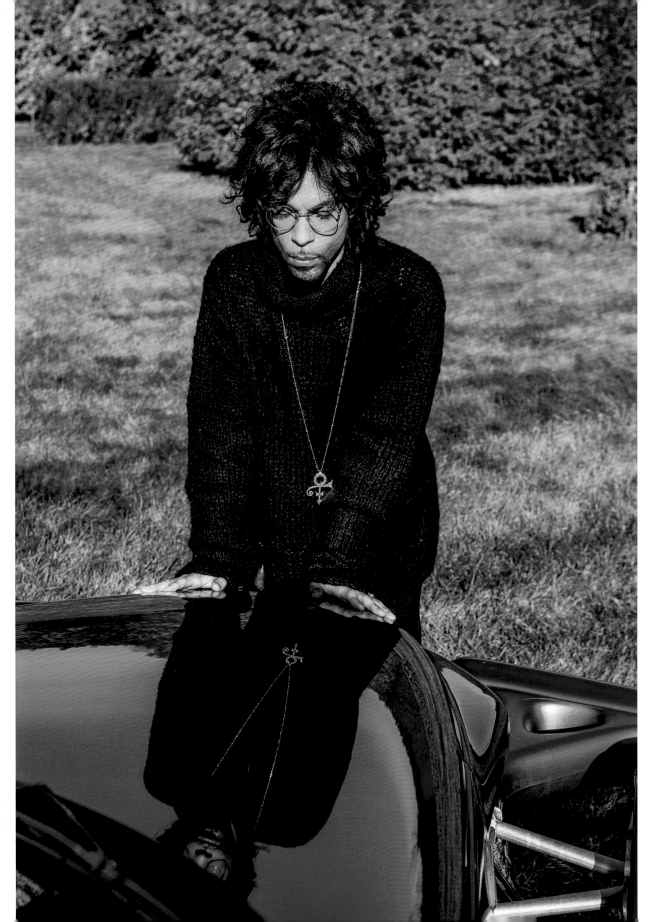

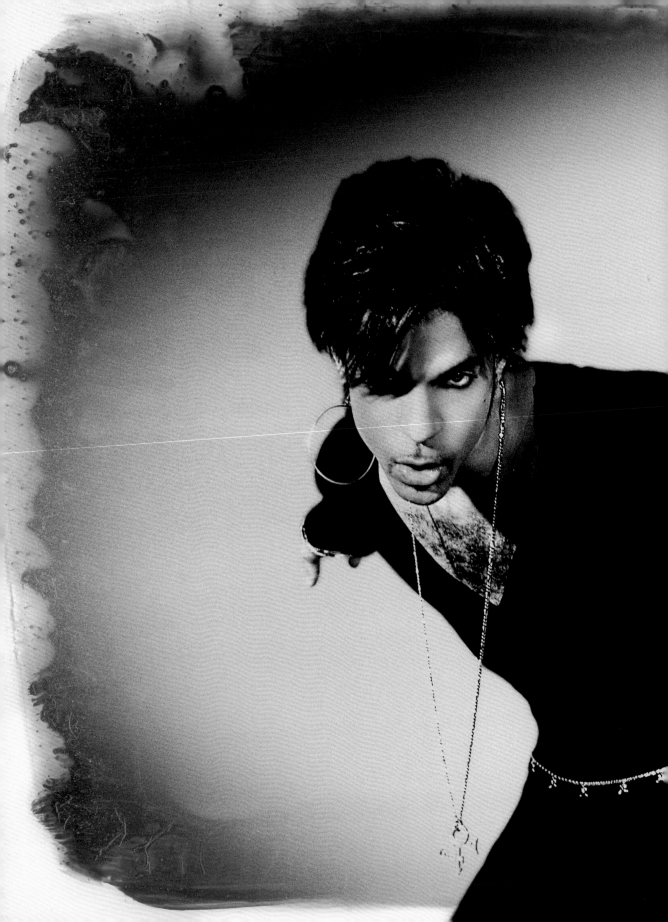

Seacer Jr., and was super excited when, a little while later, he was hired to be in Prince's band. I was doing a lot of photorealistic paintings then and Levi suggested showing my work to Prince. Of course, I was thrilled. So, over the next months I sent a few of my paintings off to Levi in Minnesota.

And then one day Alan Leeds, Prince's manager, called me out of the blue, asking if I could paint designs on a stage floor. I was 25 and even though I'd never done anything exactly like that, I said, "Yes!" (*Hell yes!*). They booked me a plane ticket from Baltimore to Minneapolis, and from there I was driven out of the city and past the cornfields to Paisley Park.

Levi had already told me that Prince had fired the last design team because it wasn't producing quickly enough, so I knew I had something to prove.

I met Prince briefly…but there was no time to register the moment as it turned out he was flying to France in three hours and I had to come up with a design plan that he approved *before* then.

I hopped up like an over-caffeinated rabbit and ran around the studio, trying to wrap my brain around what was happening visually, or maybe just what was happening. Trying to get a handle on the kind of look he'd like, I studied the direction Prince had taken for his latest creation, picked through bags of jewelry in the wardrobe department, and looked at the art for the *Lovesexy* album. I grabbed some blunt colored pencils and scribbled madly, finally presenting him a sketch of my stage plans on a piece of badly cut illustration board I'd hauled out of the trash.

To my great relief he approved, then immediately left for the airport to travel to Paris on Concorde.

I knew I had three days before he returned, and that this was my chance to impress. So, I worked for 72 hours straight (alongside the amazing talents of Mike Pittman and Laura Hohanshelt, whom I had hired from the Minneapolis Children's Theater and who thought I might drop dead, as I stayed up every night while they wisely slept), and when Prince returned a third of the stage was done.

And then I heard nothing. Silence.

Sweating it out, I asked Levi what Prince had thought; had he heard anything at all from the man himself?

Levi shook his head. "Did he *say* anything to you?" he asked.

"No," I said.

He shrugged. "Then keep going."

I did. For 13 years. Lesson one learned: Keep going.

✳   ✳   ✳   ✳   ✳   ✳

The Chanhassen Inn was the little motel that happily hosted rock stars from all over the world and had chairs that rocked in the lobby (it still does). It must have been a shock to the senses for people who came to Paisley Park expecting the VIP privileges or super chic hotel accommodation typically offered in Los Angeles and New York.

After arriving at Paisley Park for my first assignment, I spent three months living at the Chanhassen Inn. They took pity on me and even gave me my very own fridge. Now it comes as standard, I think because of me. Once I'd finished the stage design, I scrounged up whatever other work I could—designing T-shirts for merchandising or drawing logos for band members in my sketchbook.

"Hi, my name is Steve. I have overcommitment problems."

Working into the wee hours even after working into the wee hours the day before, I still made sure I was back at the soundstage promptly at 1 p.m. to watch Prince and his band's eight-hour rehearsals, even when it meant I didn't get to sleep until the next day at 8 a.m.

I flew home after three months of solid working, when Prince and his band left to go on tour. I was heartbroken and figured that was likely the last time I'd be enjoying such stellar employment.

But, a few months later I got a call to come to the UK, where Prince was on tour, to paint a piece of the set for some outdoor shows: Prince's eyes on some clouds. Incredibly, I got flown halfway around the world to do it, for the first but not the last time.

Next, I had a bit of tour T-shirt work with musicians like the Grateful Dead, AC/DC, David Bowie, and Bob Dylan, but nothing as immersive or all-consuming as it had been with Prince. So, I took it upon myself to get a great portfolio of illustrations to show to art directors to get more work. And I was smart enough to use Prince in one painting, secretly hoping to impress him and get more work from him.

That painting turned into the album cover for the soundtrack to the film *Graffiti Bridge*. A call from Prince confirmed it. "I'm really proud of you," he said. Woooohoooo! But there was one change. It needed to include co-actors Morris Day and Ingrid Chavez. No problem. I just needed to sand down the illustration board and draw them into the finished painting (that was the day my subconscious created Photoshop). That took a week or two, and then we were off. I tempered my excitement with a wait-and-see attitude, since you never know. And then one day I walked into my local Tower Records—a place where I'd run my fingers over albums every day as a kid— and saw the longbox CD edition of *Graffiti Bridge* and the vinyl versions in the bins. There it was right next to all the other Prince albums I'd worn out on my turntable. My design. Unbelievable, right?

I kept getting work from Prince and other musicians, but I got passed over for in-house art positions at Paisley Park because I didn't know how to use a computer. So, I bought one and I learned how to use it. When Prince decided I was proficient in Photoshop (because I was really just teaching myself; Photoshop had no layers then… imagine that if you've ever seen *The Gold Experience* era tour books or *Exodus* record), he started asking me to do even more—everything from designing print merchandise and sets to painting his Glam Slam club in Miami. I became Prince's official art director in the mid-1990s and from then on spent a week out of every month at Paisley Park and the rest of the time at home in Baltimore (still working, of course).

I missed a lot of sleep over those years but Prince gave me a huge gift. He let me learn as I went along, trusting that I could pull it off. I don't know if it was the fact that he never went to music school and never wrote music down or not. His ability to try new things and not listen when he was told things were "impossible" led me to think the same way. "Why not?" was always the mantra during the time I spent there. Prince would walk in with a smoothie he made for me on occasion; he loved playing basketball (in high tops and shorts) and ping-pong, cycling, and bowling. He loved to talk music. And this was a guy I had watched on TV on *American Bandstand* and MTV, and on the big screen (I'd seen *Purple Rain* with my mom and drama teacher from high school…awkward). But he was, it turned out, just a guy. And he was Prince.

✳   ✳   ✳   ✳   ✳   ✳

I'd been working at Paisley Park for nearly a decade when, in 1997, Prince asked if I could use a camera. I said yes (*hell yes!*). Why not?

Digital cameras had just become a thing, and Prince was thrilled by the idea of immediate feedback and the fact that they "… left no negatives." That said, this new technology was expensive: around $35,000 for a high-end camera. So, instead we rented one to see how it worked. I used strobes for the first time, hoping just to get a decent exposure. And that was pretty much all I got. But the photos were good enough to convince Prince I could do it, though we needed "… more light." More light ended up being a 10k movie light with nothing to diffuse it. At all. That's what was there, and Prince thought it was all we needed.

A sledgehammer to drive a nail in the wall was what it was, but I had Photoshop and painting skills so I could fix the hot spots and terrible, film-noir-worthy shadows (but in the wrong places) in the mix.

He'd stand behind me and look through the photos after a shoot—a brand-new luxury—and make me get rid of anything he didn't like on the spot.

That camera opened up a world of impromptu shoots and casual forays outside for images. It was a far from perfect device—the average phone camera today operates better on many levels—but we just "kept going" (lesson one again).

In the end we managed to create some pretty cool images, I think.

✳   ✳   ✳   ✳   ✳   ✳

It was strange to go back through all those photos again when I decided to put this book together. I hadn't looked at some of these images in years. I searched through old hard drives from long-dead computers, hunted for CDs and DVDs buried in stored boxes, and came across all other kinds of memorabilia I'd forgotten about— tambourines, jackets, notes from him, promotional materials, guitar picks, tour books…I had no idea how many photos I even had still, and no idea how many I'd lost in computer crashes and moves over the years.

As I sat fixing up images, many of which have never been published before now but were ones he put aside as "keepers," I could almost feel Prince standing behind me, telling me to fix a stray piece of hair or a squinty eye or an odd shadow. I could have been right back at my desk in Paisley Park, except that these days I actually sleep when it's dark outside, rather than work through the night. In a way, it was as if no time had passed at all. Instinctively I knew the photos he'd like, the ones he'd tell me to save for later, and I organized them as if we were working together again.

Each photo brought back memories; sometimes flaring up and catching me by surprise. Conversations, moments I hadn't thought about in over a decade. Some left me smiling, others wondering how I could have ever worked for 72 hours straight or over those long nights when Prince sat talking with me about whatever until the dawn came. Sometimes, the memories hurt because that's all they will ever be now.

What follows are the photos—and memories—I like best. I hope you'll like them, too.

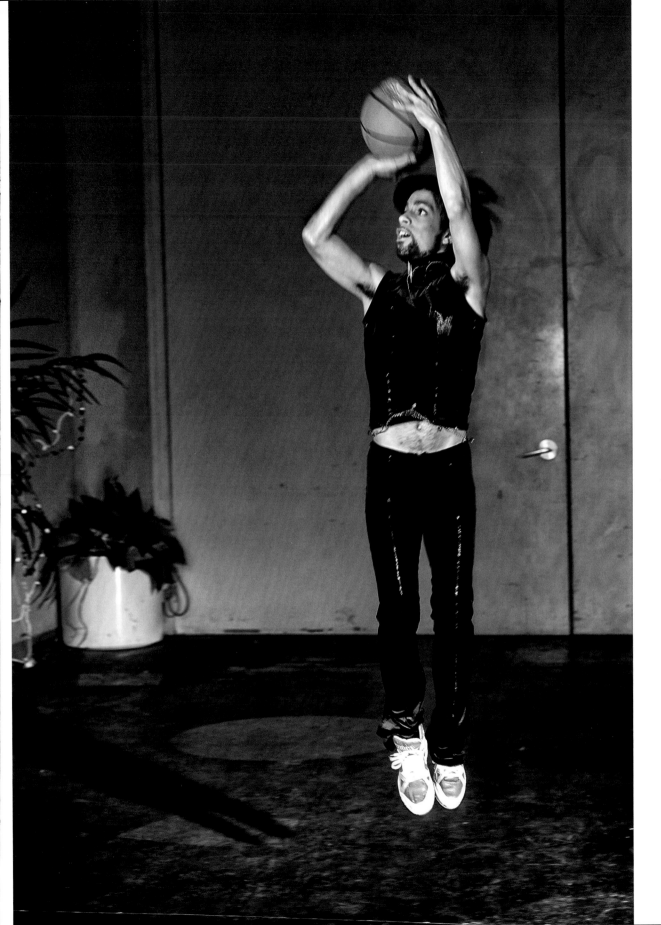

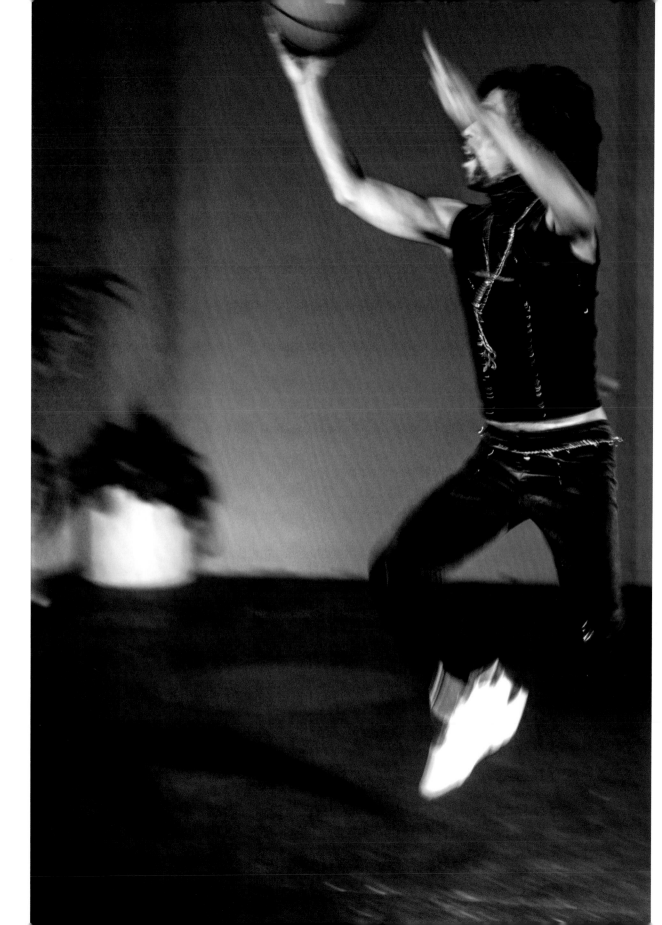

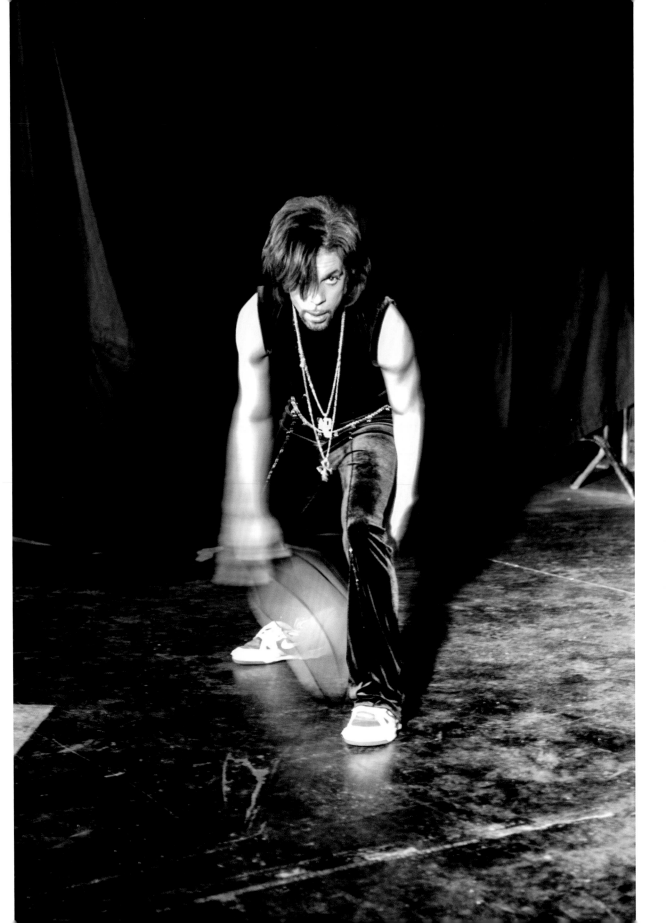

# MIDNIGHT IN MINNEAPOLIS

Around midnight one night a very frazzled woman showed up in my office. I was sitting at my desk working frantically on whatever was due at the time (there was always something, and I was always frantic) when she came walking in, paced to the end of my office, and stopped. "Do you have any idea where we can find a camel?" she asked, turning to me.

I sat for a moment and looked at her, mildly confused. Then I realized she was serious. "No, I really don't know," I said.

She sighed. "He wants a camel for this commercial we're doing."

I remembered Prince was shooting a commercial for his new perfume, Get Wild, in the soundstage downstairs. This poor woman was the producer.

"Good luck," I said, shrugging. "If I think of something, I'll let you know."

She left, and I went back to my work.

A few minutes later I heard the ding of the elevator door opening. Prince was the main person who used that elevator, which was across the hall from my office.

He walked just inside the office door. "Do you know where we can get a camel?" he asked.

"Um." I looked at the clock and then back at him. "Well," I said, "I think that any place we could get a camel is probably closed right now."

He nodded. "What about LA?"

I paused again. "Well, you'd have to fly the camel to Minneapolis and that would probably take a while."

He stood there, looking at me.

"They'd probably have to helicopter it in or something," I added. Of course, I had no idea what I was talking about, but I'd learned early on to not say no to Prince.

"Okay."

He turned and left. Maybe half an hour later my phone rang. It was Danny Soltys, the building manager, calling from the front desk.

"You've got to come down here," he said.

I took the stairs. As I rounded the corner to the lobby, I saw a mountain lion. Just sitting there, on top of the front desk. Danny looked up at me with an incredulous smile. A few other people were standing around, apparently waiting for the shoot to start.

The mountain lion was tame; it even let me pet him.

Turns out some animals *are* available at midnight in Minneapolis.

Coincidentally, this is a story that filmmaker and actor Kevin Smith riffs on when he tells stories about doing a documentary for Prince and working with the same producer in 2001.

(By the way, I got Kevin his hookup with Prince.)

(And The Time.)

I think Kevin owes me a coffee or two.

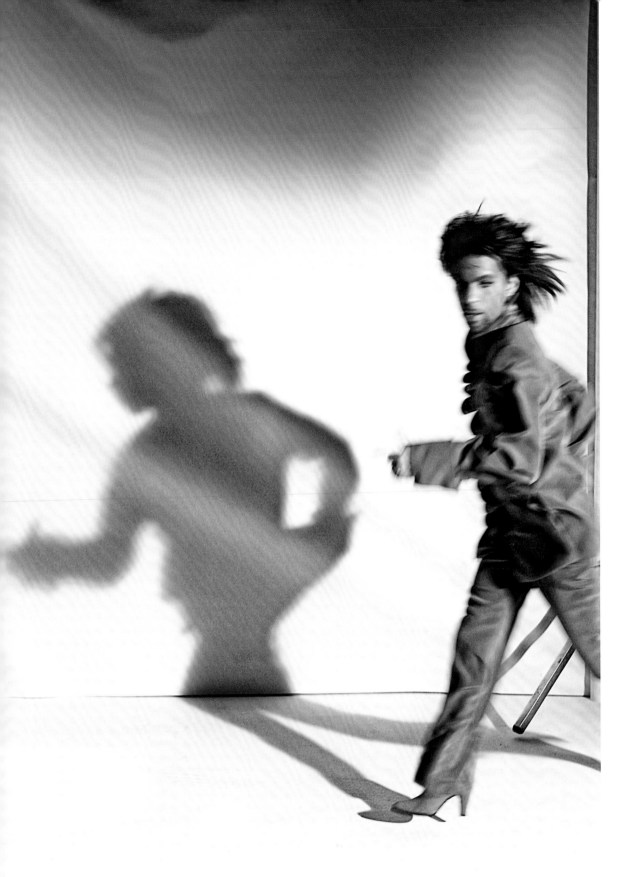

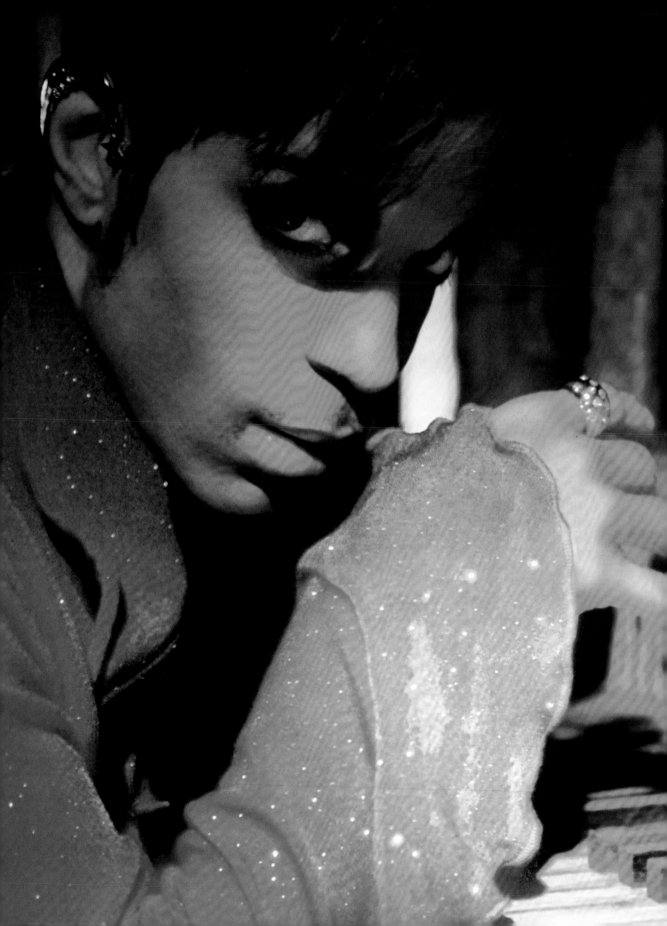

# BROWN WARRIOR

Prince knew that back home in Baltimore my wife was pregnant and that we were having a son. He asked me what we were naming him. Prince had a soft spot for children; he loved that they'd say anything at all. He got a kick out of (producer) Kirk Johnson's sassy daughter—she was probably around five—marching up to him, putting her hands on her hips, and asking him why he wore makeup and girls' shoes. To be honest, I don't think he would have liked any of the rest of us asking him that.

"We're naming him Duncan," I said.

He asked if Duncan was a family name. I said no and he asked the origins of the name. Scottish, I explained.

"Weren't those guys conquered a lot?" he asked.

I said yes.

He gave me the side-eye. Then he asked, "What does the name mean?"

He was big on names. He often said that having the name Prince (the name he was born with) gave him no choice but to live up to it.

"Duncan means Brown Warrior," I said.

He smiled. "Well…that's okay."

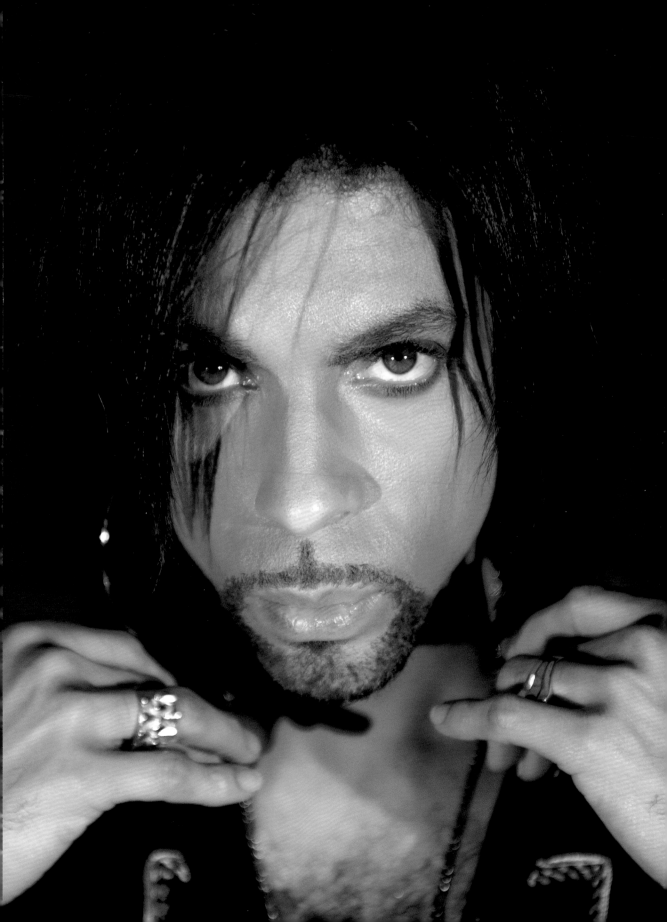

# CHICKEN GREASE

I've been a vegetarian since the mid-1980s. When I first started working at Paisley Park, I was taking a lot of vitamins, too. Prince asked me one day what I was taking. I told him and he asked if he could have one. I gave him a pill and he took it. It didn't occur to me until later how trusting that was.

Over time, he asked me about being vegetarian—why I did it, if it was difficult, etc. Then, he decided to become one himself. He was very passionate about it, as he was about everything. He even appeared on the cover of *Vegetarian Times*. About this time, I heard a rumor that he was no longer allowing any meat inside Paisley Park. He told me once that he could no longer stand the smell of it cooking. I don't know that it was the most popular decision he ever made, given the prevailing midwestern diet (and work force), but it didn't affect me, of course.

One afternoon, I walked down to the kitchen on the first floor, passing through the dining area, where there were several tables and two booths. I noticed singer-songwriter and music producer George Clinton sitting at one of the booths with a giant bucket of KFC, clearly enjoying himself. The whole place smelled of fried chicken. I hope Prince doesn't see that, I thought. And then I wondered what he'd do if he did. I continued into the kitchen to get a drink.

As I was turning to head back upstairs, I heard Prince's heels clacking along the floor as he made his way from Studio A to Studio B, cutting through the dining room. He stopped dead in his tracks and shot George the side-eye. That look could make your blood run cold if aimed at you in just the right way.

But George was much too busy devouring his food to even notice Prince was there. Neither of them saw me standing in the kitchen doorway.

And then, after a moment, Prince walked on.

I don't know if George got the memo later, but I'm guessing he got a pass.

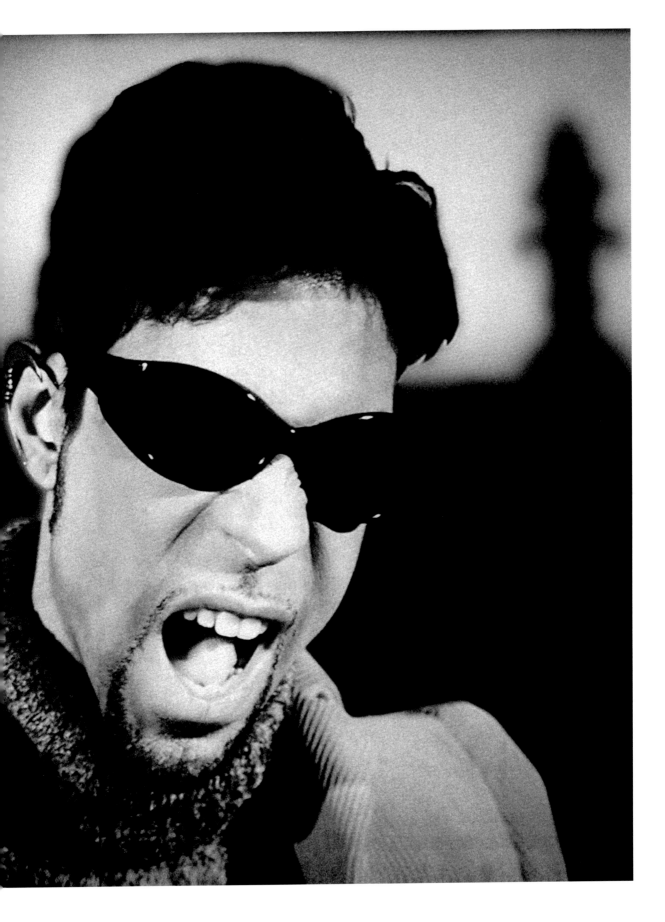

# NAKED LADY

One night Prince told me we needed to shoot some images for promotion and a lyric booklet for the *Emancipation* album. He also had some ideas for the "The Holy River" video that he'd be shooting soon. We'd already done a few band shots, plus one of him sprawled out on the loading dock stage for a song called "Face Down." These were some of my earliest images of him and I was still trying to get the new digital technology to behave with very few resources for finessing anything. Thank goodness I had a more than passable affinity for Photoshop.

We were brainstorming ideas when, suddenly, he looked at me very seriously. "Have you ever photographed a naked woman?" he asked. He emphasized the word n-a-k-e-d, drawing it out while wiggling his eyebrows up and down like Groucho Marx.

I blinked at him in disbelief. "Yes," I said, wondering if I'd heard him correctly. This was Prince, after all.

"Good," he said, and turned to leave the room. "I'll be back."

Later that night I had a brief shoot on the soundstage with a super nice woman and then shot a separate photo of Prince with his hand open—and then later I Photoshopped the woman onto his palm. I should have done a sketch for angles and set my light differently, but nothing was ever quite planned back then. I recall him seeing the end result of that shoot and nodding in approval with that restrained smile (the one with the slight Elvis-style lip).

Today, the image seems a bit awkward to my eye but at the time it was at the cutting edge of technology—something he pushed forward, even when he didn't realize he was doing it.

In fact, we didn't end up using the shot for the album, but he did like the effect enough to recreate it in the "The Holy River" video, with part of his band replacing the naked lady.

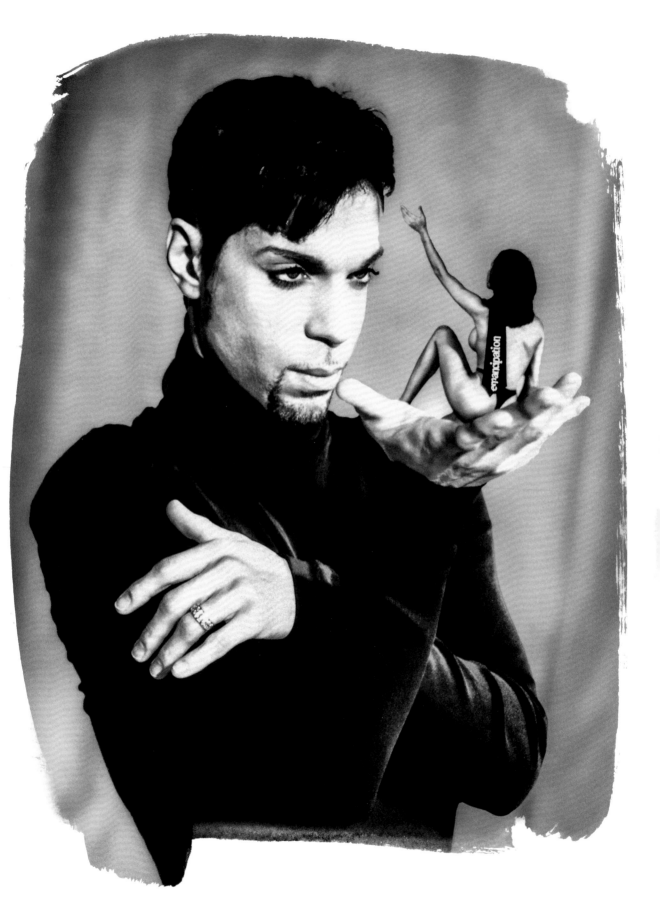

# NO POCKETS

One day I was listening to the latest Luther Vandross CD—*I Know* from 1998—in my office as I was downloading photos. Prince was sitting behind me, grooving on it.

"Luther is a great singer," he said, "but you know what his greatest skill is?"

"What?" I asked.

"Picking songs. He picks the right song to sing and arranges it in a way no one else would think of."

I worked on retouching some photos while the album finished playing.

Then, Prince wandered around to the front of my desk and snatched up his set of heavy keys (with his "symbol" as a keychain).

"Hey, can I borrow that?" He pointed to the empty Luther CD case on the shelf. "Can I have it? I'll pay you for it."

"Okay," I said.

He patted the sides of his custom-made pants, smiled a bit, and acted surprised. "Oh! I don't have any pockets."

I said that it was fine, he could pay me later.

A few days later I mentioned it as he came up the stairs. I thought it was funny, nagging Prince for $15.

He patted his pants again and shrugged. "No pockets."

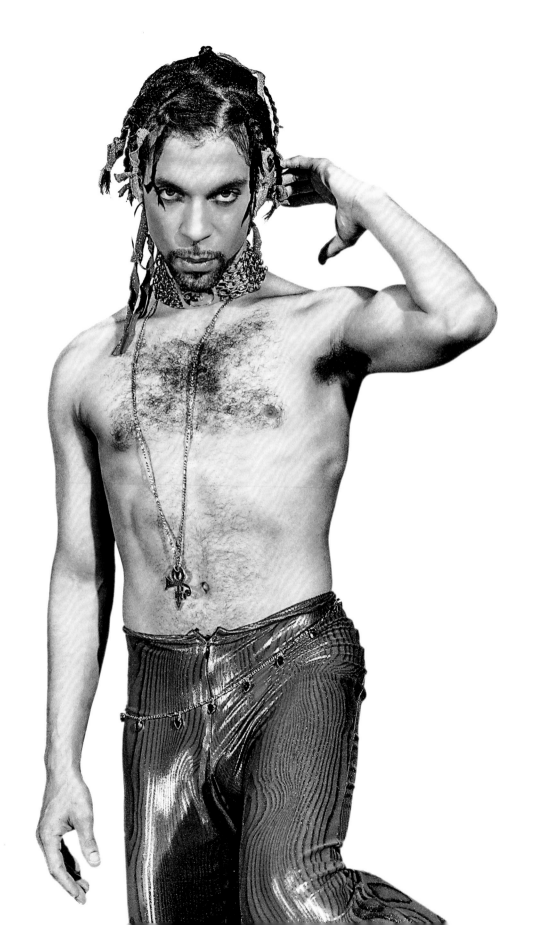

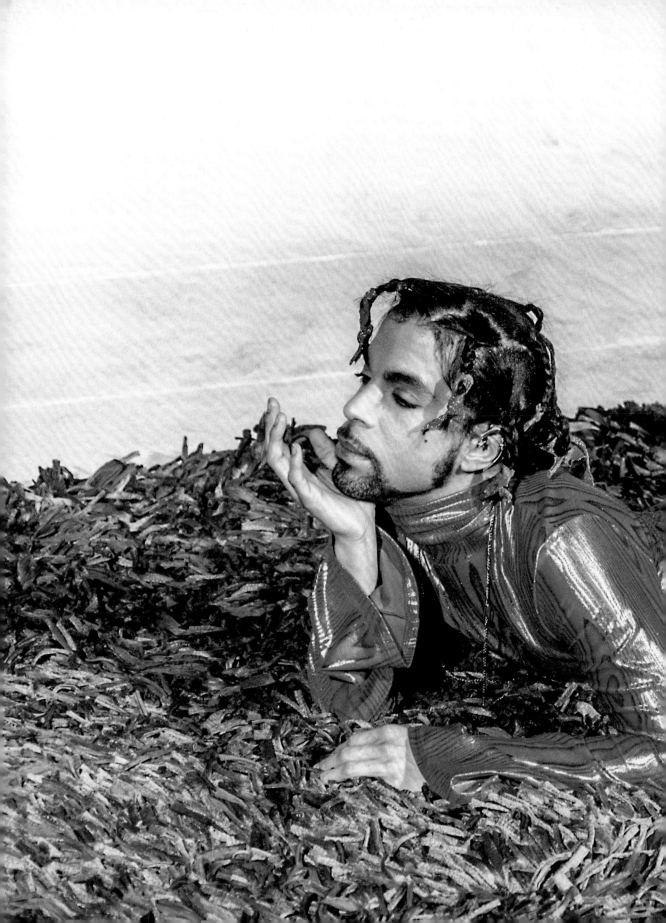

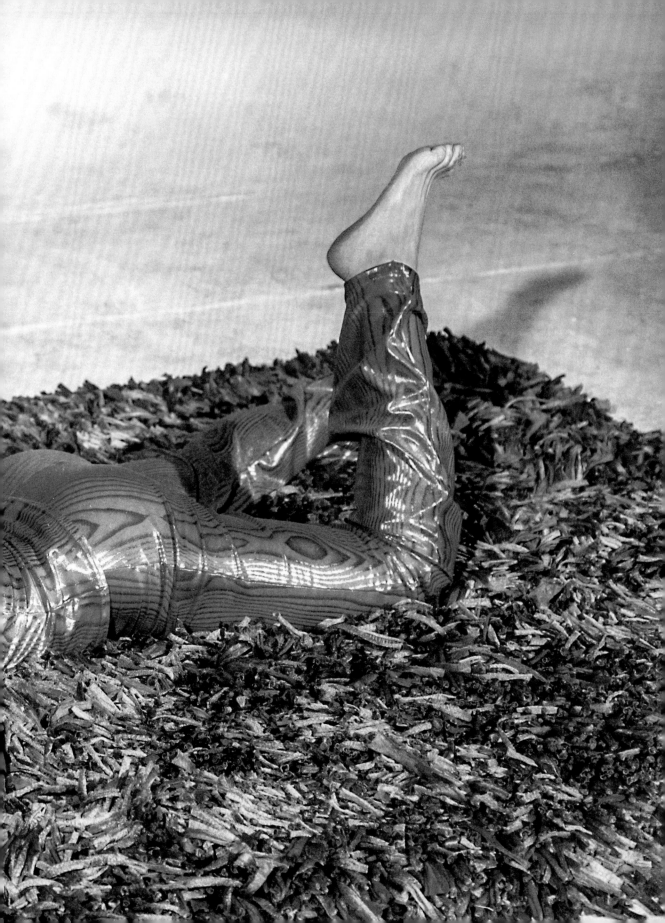

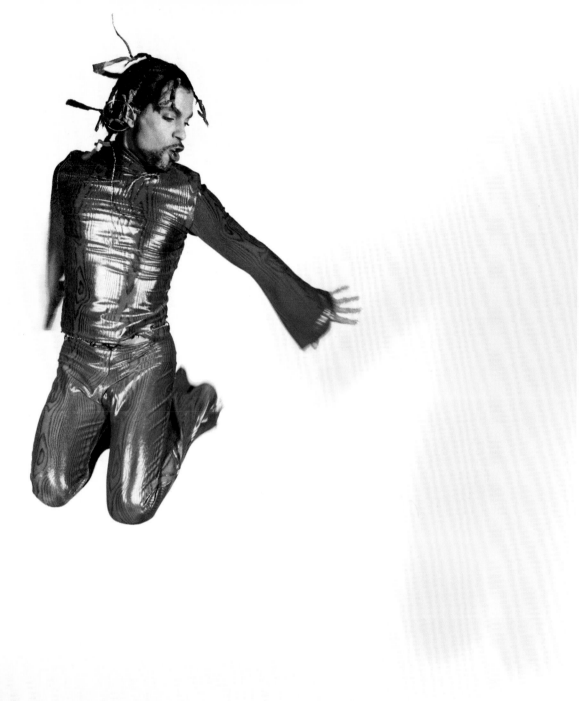

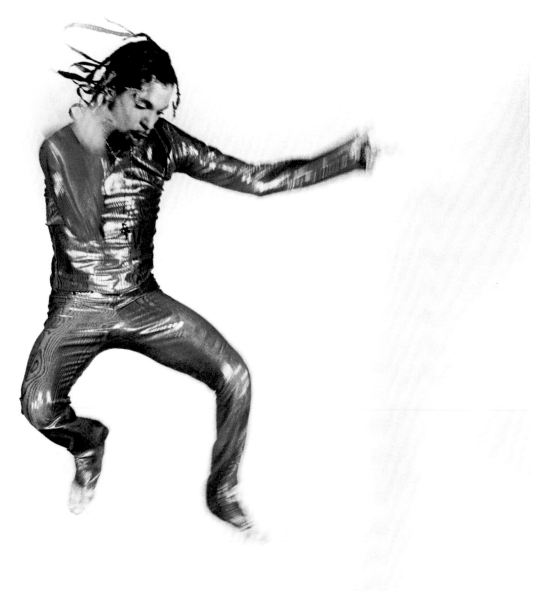

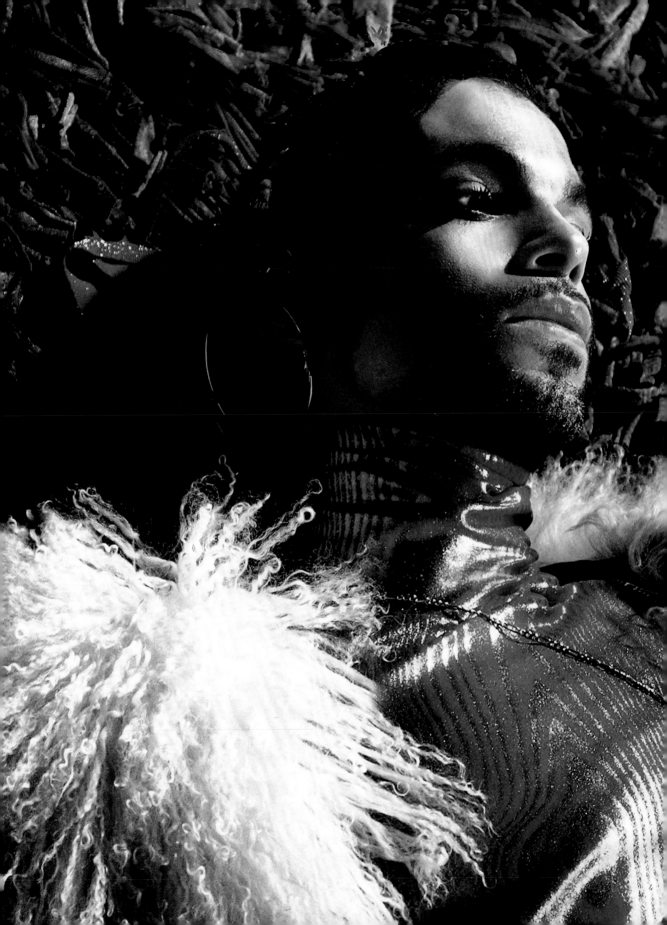

# GOLD PAINT

In 1999 we did a shoot for Puff Daddy's *Notorious* magazine, which featured Prince on its millennium issue cover. The art director flew out to Paisley Park from New York and threw ideas past Prince, many having to do with New Year's Eve and "1999." Prince wasn't having it. He chose instead to celebrate his freedom as an artist.

The art director was a nice guy, perhaps thrown a bit by the theme Prince had chosen as well as the bare bones approach we had towards shooting—the one camera and the one completely inappropriate 10k movie light we were using, not to mention the lack of in-house backdrops. (The art director actually rigged up a shower-curtain diffuser for the light—something I couldn't have gotten away with on my own. For this I was eternally grateful.)

Prince booked the shoot for 6 a.m., otherwise known as midday on Paisley Park time. Actually I don't think we ever followed a clock, just a muse.

Ideas had buzzed back and forth the day before, and Prince had decided on posing with the word "FREE" painted in gold across his stomach, as if the word had been fingerprinted on him by the female model in the photo.

The (extremely patient) art director mixed up the sparkly tempera paint in a cup with a popsicle stick and got ready to apply it. This was someone Prince had only met the day before. Prince looked at the art director tersely for a moment, then nodded to me and said, "He can do it."

So, I got a finger full of the thick metallic goop from the styrofoam cup and started writing. On Prince's stomach.

He started giggling. A lot. Because it was cold and because it tickled. And it was 6 a.m. I quickly wiped off my hands and grabbed my 5lb camera because the gold paint was starting to run. Fortunately the paint was moving slowly, so I actually had plenty of time to fill my 512 megabyte micro-drive to capacity, load a new card, and catch more before we moved to the next set-up.

It was a highly amusing beginning to what would become a fairly serious cover photo.

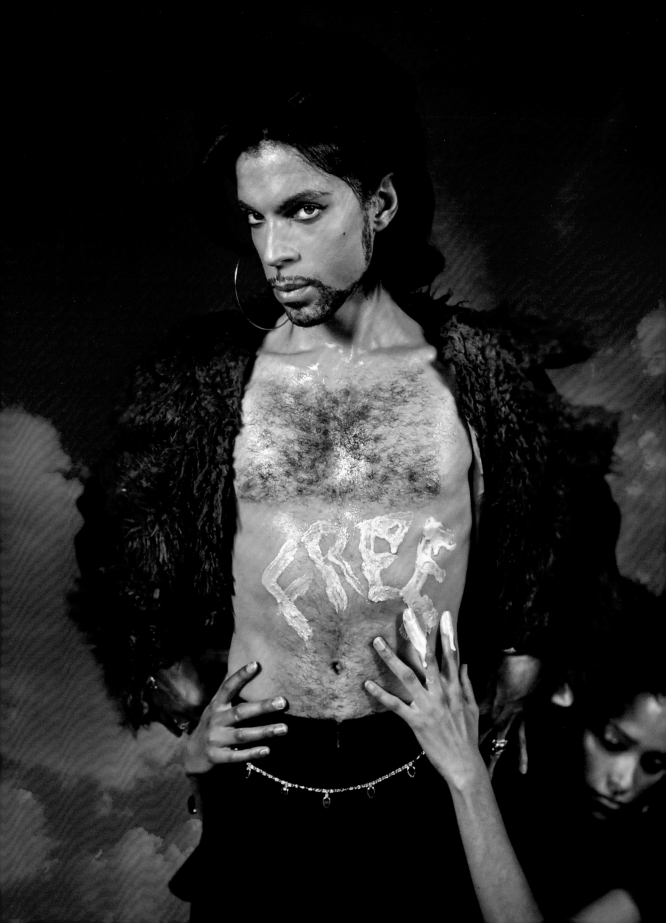

# MIND BLOWN

Prince often sat with me late at night, watching over my shoulder as I worked and usually talking with me about what I was doing and/or about music and world events, sometimes spirituality. One night he was telling me about how musician George Benson, who'd just been recording at Paisley Park, had shown him a thing or two on the guitar he'd never seen. "It *is* George Benson," he said, mildly starstruck. (It was very hard to show Prince anything new.)

I must have been tired and wasn't thinking, because I piped up with "You know where I think you're underrated?"

He just looked at me.

I wished I hadn't said anything. It can be a little weird, working so closely with someone and being so comfortable with them, then snapping awake to remember that this person is your boss, and that your boss is Prince.

"Your vocal arrangements," I said quickly, plunging forward and hoping to steer the conversation in the right direction. "I think they're amazing and so layered into the songs. People don't necessarily appreciate that about you."

He just nodded and seemed okay with that assessment.

The next day he called up to me and said to come to Studio A.

I walked into the studio—it was dark, with just a few candles burning. He gestured for me to sit next to him and played me a song over the speakers. He had just recorded it. It was an intimate and personal song, nothing but layers of vocals. Lush and yearning. Unbelievably raw and beautiful.

I can only remember one line—it was so simple and evocative: "It's so quiet, I can hear my hair grow." A song about being lonely and isolated, which I can only imagine he felt a lot.

It finished and I was stunned. I think I managed to say "thank you" and possibly mumble some other words of gratitude as I walked out.

I never took anything for granted working in that environment, but in Prince's world those were the kinds of things that could happen, so as blown away as I was I also had to get my work done.

I later found out that the song was called "Mind Blo," but I never heard it again. I have no idea what happened to it. I assume it's in his vault, along with who knows how many other songs no one's ever heard.

It's an experience I will never forget.

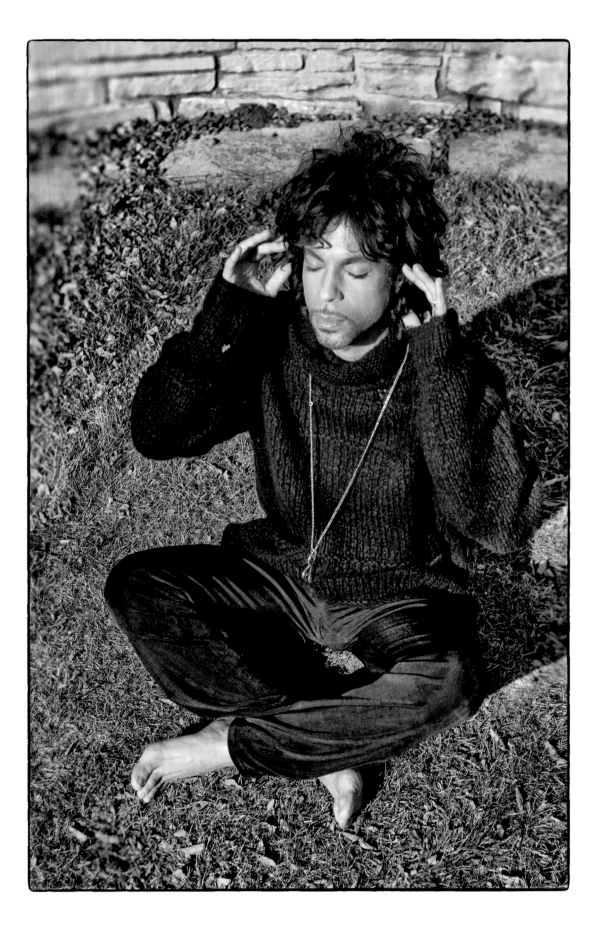

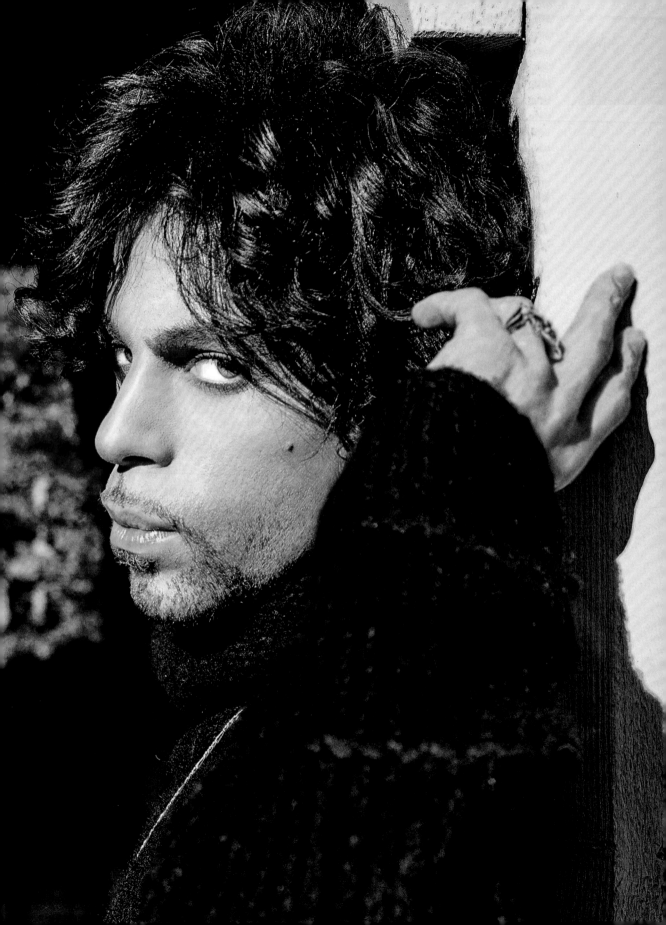

# PUNKED BY PRINCE

At night, when no one was at the front desk, the main phone line at Paisley Park was set to ring to the whole building. Often it was only Hans-Martin Buff (master engineer), Prince, and me working. I rarely answered because I couldn't remember the code I had to punch in first to pick it up.

But often, when the phone rang and Prince was in my office (which was pretty much all the time, or so it seemed sometimes), he would look at me like, "You going to get it?" I usually shrugged and kept working.

So, he took to answering the phone himself—usually with a fake "country" voice or a put-on, super thick midwestern accent; sometimes he tried out an exaggerated Italian or Chinese one. I only heard his part of it:

"Prince doesn't work here."

"I'm sorry, what number were you calling?"

"Can I take your order?"

It went on from there. "I'm sorry, ma'am, we never actually see Prince in person," he once said. He would laugh after he hung up. Punked by Prince.

When I would actually break a smile (remember I was supposed to be working) he worked the conversation harder. I swear they could last a full 10 or 15 minutes, as he answered a befuddled fan's questions.

"No, you can't speak to someone else," he'd say to the exasperated caller.

"You have to talk to me."

Sometimes it was somebody who needed to get through to the studios, in which case he'd just shove the phone at me. He even answered calls that came through to my direct line, chirping "Steve's office" in that same ridiculous hillbilly voice. Of course, I couldn't tell people who my cheerful assistant was.

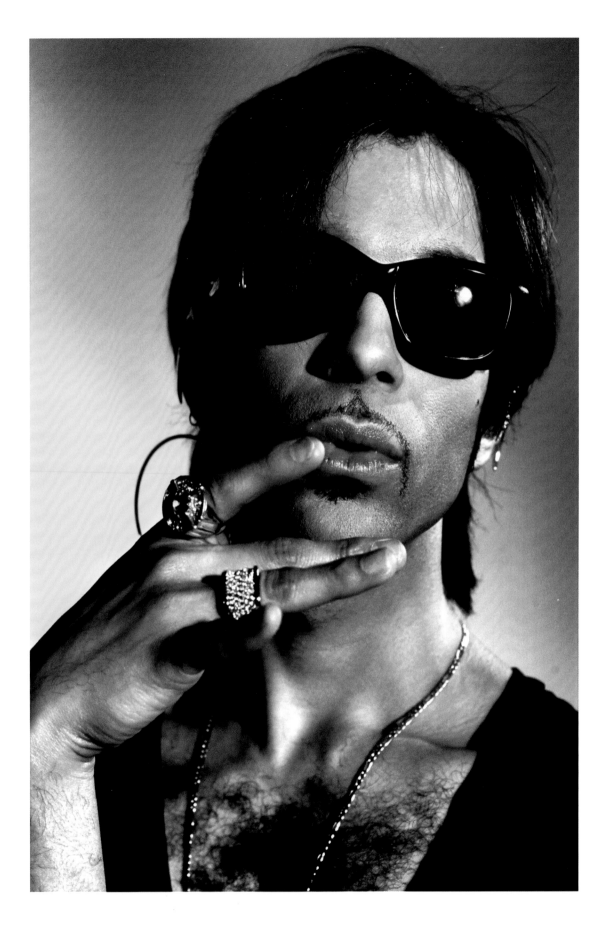

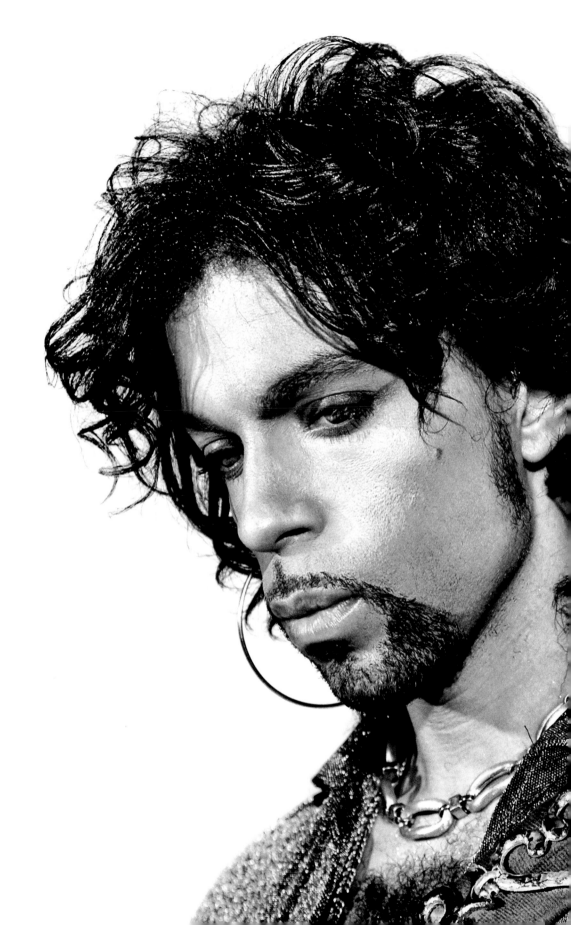

# BATTLE OF THE BANDS

Over time I noticed Prince's competitive nature, pretty much in everything he did. It occurred to me that it was likely driven by his early years as a musician. He talked sometimes about "battle of the bands" in Minneapolis, how they'd be battling each other but really trying to "beat" the musicians they listened to as kids. "We all said Earth, Wind & Fire was the band to beat," he told me once. "Of course, we never could, but that was our goal."

In those days musicians would shift from one band to another, as everyone scrambled to be the best of the best, not unlike rap battles in New York City's Queens in the '80s. Ironically Prince's "battle" continued as he created his alternative band The Time. Composed of members from his early rival band Flyte Tyme along with Morris Day from his own early band Grand Central, The Time, Prince admitted "…kept me sharp. That was the only band who could mess with us."

One night I was playing U2's *Pop* album in my office, really loud as recommended by Hans-Martin Buff (Prince's master engineer at that time). I heard Prince coming so I hopped up and turned the volume down a bit.

He stopped and walked through my office doorway. After a few minutes of listening (and turning it down further), he said, "You know what I'd do if I had a voice like that?"

"Form a rock band called U2?" I asked, trying to be clever.

"Become a janitor."

Prince didn't really think Bono was a terrible singer but he liked faux competition— it drove him to create and he could be pretty hilarious about it.

"Is this the new Sting album?" he asked once, walking into my office.

"Yes."

"Hmm," he said as he looked at the CD art, *Mercury Falling*. Well, I'm gonna have some mercury rising on my next album."

I think I blinked a few extra times but had nothing to say back.

He made similar comments about Pearl Jam—"It's not funky"—and Elvis Costello— "I don't want that guy covering my songs, let him write his own songs." The irony being that he picked up a lot of their albums the day they came out, even if he acted like they were terrible.

He set his sights on David Bowie's "Fame" once as he played me James Brown's song "Hot (I Need to Be Loved)," a note for note (with horns) backing track from Bowie. Prince was convinced it was his musical hero James who must have been pilfered from and leaped to Brown's defense. "When's the last time David Bowie was that funky?" he said. I later did some digging around this issue and found that some sources said that it was Brown who had borrowed from the Bowie track. Even in his defense of others, Prince was competitive.

But he didn't aim his competitive nature only at other musicians. He also targeted himself, often talking about how he was competing with his own catalog as he created new music. "I played as good as that when I was a teenager," he once said of a guitar riff he played me, even though it was clear to me, a non musician, that he'd advanced leaps and bounds from the skills he had on his first albums. In his song "Don't Play Me" from the *The Truth* album, he sang: "My only competition is me in the past."

And The Time, of course.

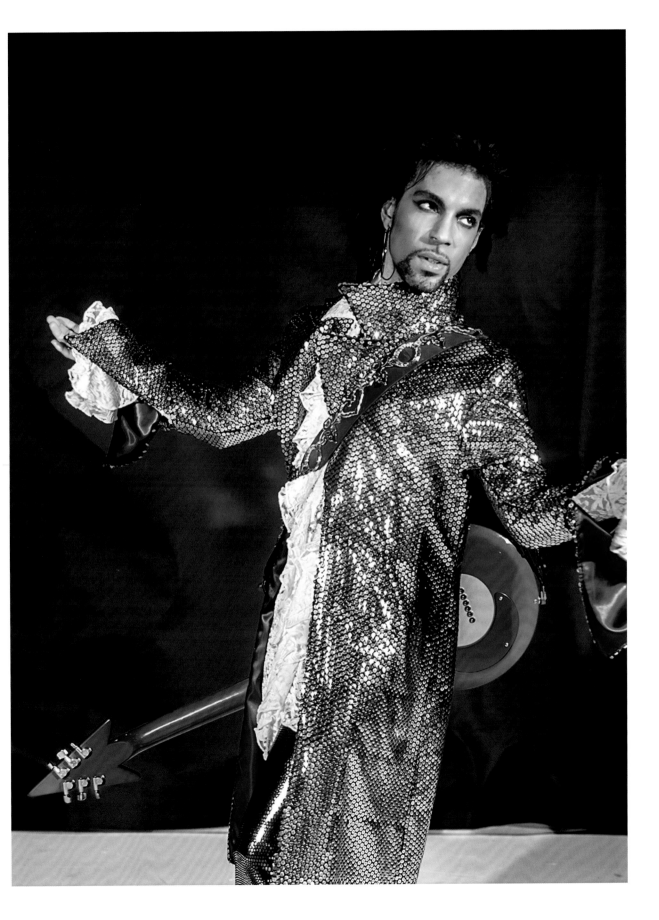

# AN ORDINARY GUY

In late summer 1993, I was painting a mural and just helping with the general set-up for Prince's retail shop, New Power Generation, in Uptown—an artsy part of Minneapolis Prince often referred to in his early songs. Duane Nelson (Prince's half-brother) was overseeing things down there and had me grab lunch and run some errands with him. We were just leaving Taco Cabana when his pager buzzed, and so we headed to the downtown retail area. I was not familiar with this part of town (when I was in Minnesota, I was working out of Paisley Park 95 percent of the time), but we headed to a large plaza with interconnecting buildings. We parked in the garage and went in. It was a mall.

Exiting the elevator, we fell in line with a few of the guys who I recognized as working as security for Prince. Suddenly I too was walking beside Prince. He just looked at me with a smile. Seems we were heading to Macy's. Interestingly the local people just sort of said "Hi Prince!" when they walked by, like it was no big deal. Somewhat matter of fact and just going on about their business. He'd nod back.

We entered Macy's. Duane tapped me and we went in a different direction than the rest of the crew. Duane picked up a few things from the men's department and then we were on our way back to Uptown. I still have no idea what we were doing there, but I didn't have to know and was just happy for the longer-than-usual lunch break.

But, still, even knowing Prince could be a regular guy, running into him at Macy's felt pretty surreal.

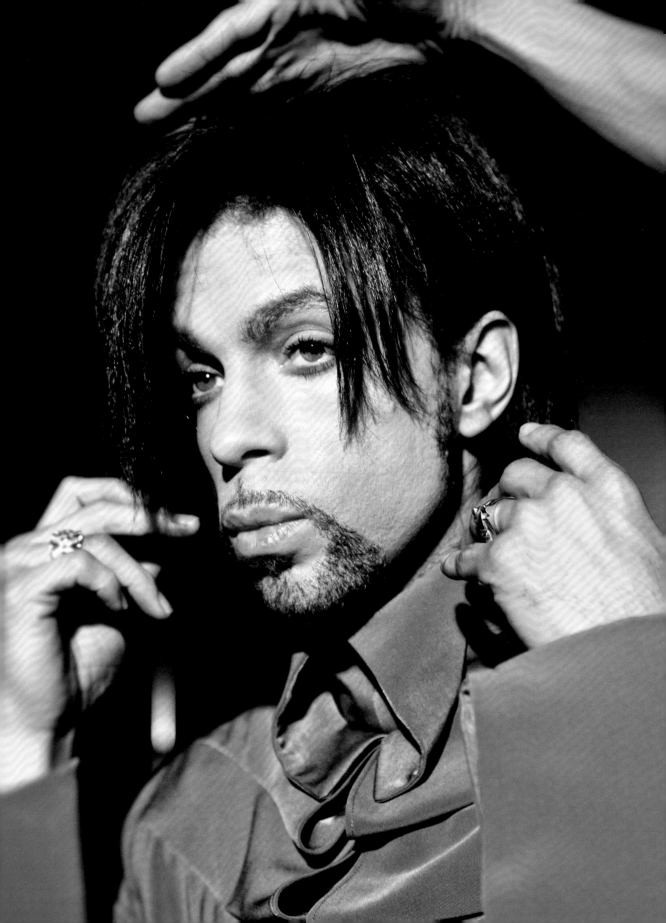

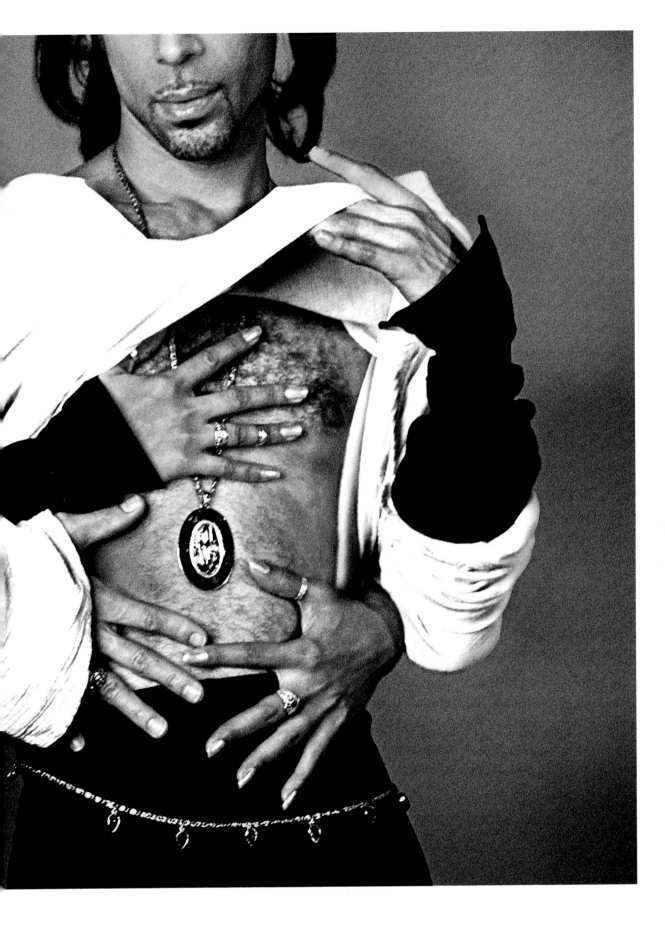

# THE BROKEN STOOL

When I took over in-house design at Paisley Park in the early '90s, I think they had shoehorned the art department into a space that was really meant for storage: it was down a ramp, there were no windows, and it stank when it rained. The upside to the space was that the stairs to Prince's apartment were right above us and the ramp down to us was hollow underneath, so you could hear footsteps coming and going. Especially someone with heels, who walked really hard. So, we usually knew when Prince was heading toward us, whichever route he took.

The odd part was that this little cramped space, which Michael Van Huffel (who I brought in as fellow designer and the department computer explainer in 1996) and I shared for a while, became one of Prince's favorite hangouts, from what we could tell. He would come sit with us while we worked for hours on end. He would tell funny stories, and I would come up with endless ideas of things we could produce—such as comics (check), tour books (check), action figures (nope).

Michael would pull his hair out every time I came up with something new. Since I was only at Paisley Park for one week each month, he figured I'd be out of town when the idea came back around and he'd be the one stuck executing it.

We'd all joke (even Prince) about how Michael and I made stuff out of whatever we found in our pockets, with so few resources. It was not far from the truth.

The only place to sit in our space besides at our desks was on one sad, rickety wooden stool, which someone had probably stuck there at some point to get out of the way. Prince insisted on sitting on it, and he'd rock back and forth. A lot. We offered up our chairs on numerous occasions, but he preferred the stool. He rocked. We watched the thin wire holding its parts together stretch to near snapping. We even tried hiding the stool in a closet, but it magically reappeared in the office. He perched on it like a bird. Finally, one day I grabbed it and tossed it into one of the large dumpsters out back. I didn't think I could take it if the thing collapsed. Prince didn't hang out as long after that, but it also seemed—perhaps coincidentally—that we got moved upstairs not long after the stool went missing.

Should have thought of it sooner.

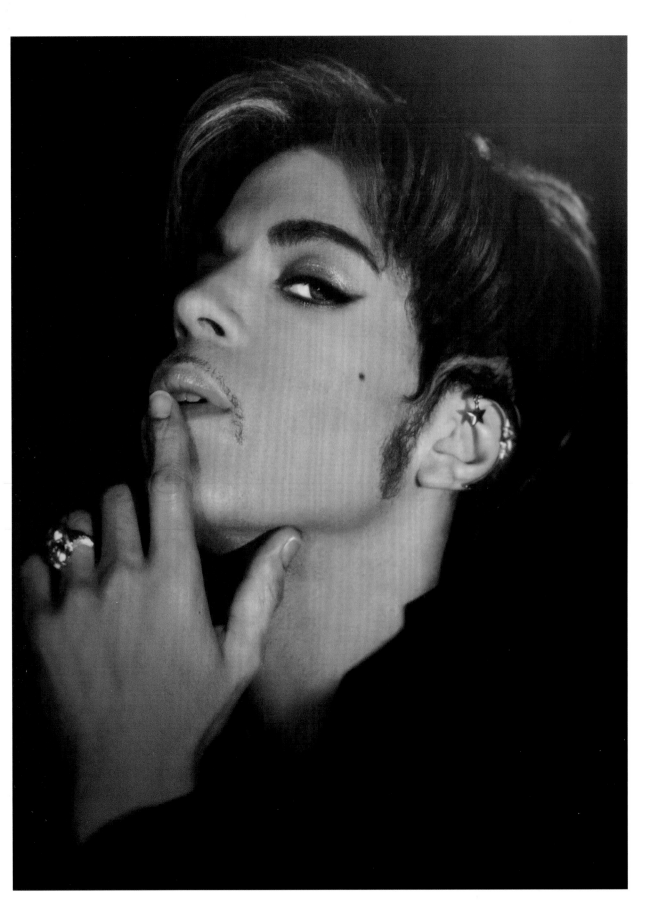

# BROTHER HUG

Prince had been gone a while, out on the road where he inevitably had to meet and greet a lot of people.

"I'm grateful for the brother hug," he told me, when I saw him again. "That saves my hand."

I gave him a questioning look. Then realized he meant the pull in and shoulder bump that had become the contemporary handshake.

He explained: "I remember when I was first on the road, brothers wanted to shake your hand like they had something to prove. I had to tell them: I have to play with that hand tomorrow night and need those fingers."

He talked more about the road and how different it was from playing in your hometown. "I never thought I'd have to have security, but when someone leans over the bathroom stall to ask for an autograph? That's when you know you need someone to look out for you."

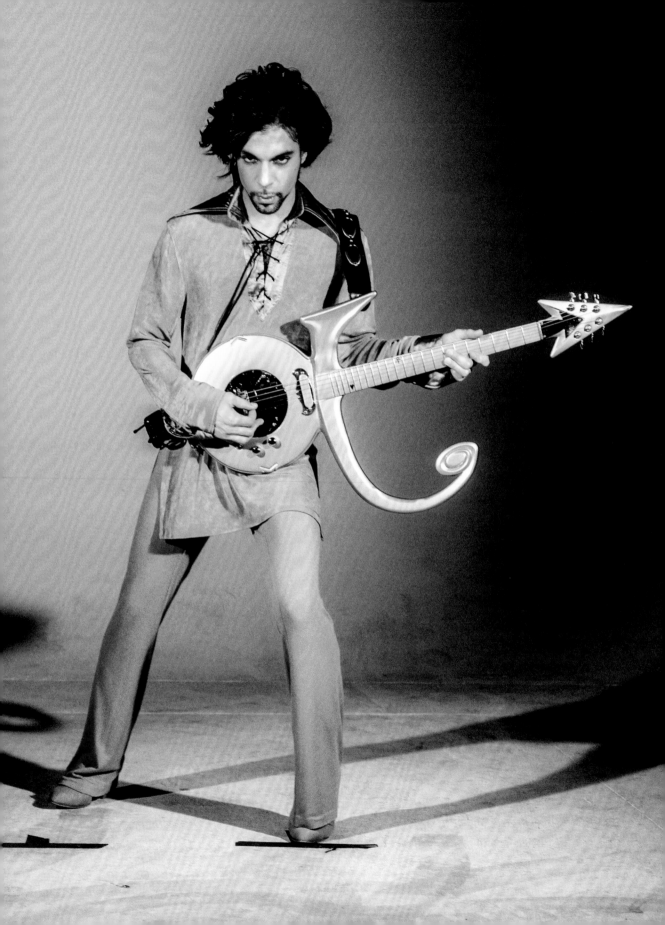

# AFTER THE SHOW

I had No Doubt on heavy rotation in my office, back when they were on tour and promoting their *Tragic Kingdom* album. Prince was impressed and would come by to listen.

Around that time, too, he'd occasionally have me come down to the kitchen eating area to watch *The Late Show with David Letterman*, especially when there was a good musical guest. That night it was No Doubt. Prince leaned in, watching intently. When Gwen stepped up on Dave's desk, Prince rocked back on the couch and clapped his hands. "That's how to do it!" he said.

A few months later, the same day a series of small tornadoes whirled through Minneapolis (Prince said we "could all go in the vault—except Danny. Just kidding."), I was sitting at my desk when the phone rang.

"You want to come see No Doubt with us?" Prince asked.

"Sure," I said, trying to play it cool.

He told me the details and where to go. Prince and a few others were already downtown. This was pre-cell phone and pre-GPS, so I called a friend to ask how to get to the venue. It seemed fairly straightforward, but fallen trees had blocked the main highway so I had to intuit my way through neighborhoods I had zero clue about. Fortunately, I made it, watched the amazing show from the soundboard, and got to meet a very sweet Gwen Stefani.

After the show, Prince told me to meet him back at Paisley Park. Back to work, I figured. At least I got to see a show before working the rest of the night. By now, the tree had been removed from the highway, making my trip back far easier.

I returned before anyone else and went upstairs to my office. There was always a pile of work to do.

My phone rang.

"Come to Studio C."

I walked in to see Prince sitting at the grand piano in the room, and then realized that Gwen was there, too, as well as the band's bass and guitar players. Prince told me to take a seat, so I settled up against the wall. Tom Dumont and Tony Kanal sat on either side of me, plugged into a jack in the studio wall. The next 45 minutes or so the four of them played, Prince letting Tony solo (Tony chose the *Headhunters* bass groove from Herbie Hancock's "Chameleon", to which Prince said "Uh-oh…watch out!"). Meanwhile he and Gwen traded vocals, swooping and muscling through songs they both knew—all with no microphone. Gwen was a powerhouse and Prince nodded his head when she dug down and really let it go. His fingers blurred across the keys while the musicians on either side of me did their best to keep up. I can only imagine feeling a lot of pressure in that situation. Prince would call out chords from time to time, his band-leading skills naturally kicking in.

It was just for us, and I got to be part of the "us." And it was sort of dazzling, seeing Prince at his most charming and seductive, off the stage. Usually I saw him as the guy who geeked out with me over music or told me what to do. But here and now, he was the real performer. And in this tiny room, the most intimate of the three studios, with just the five of us.

I loved every minute of it.

After they finished, Prince said he'd see me tomorrow. I went back to the hotel with my heart pounding, unable to sleep for hours.

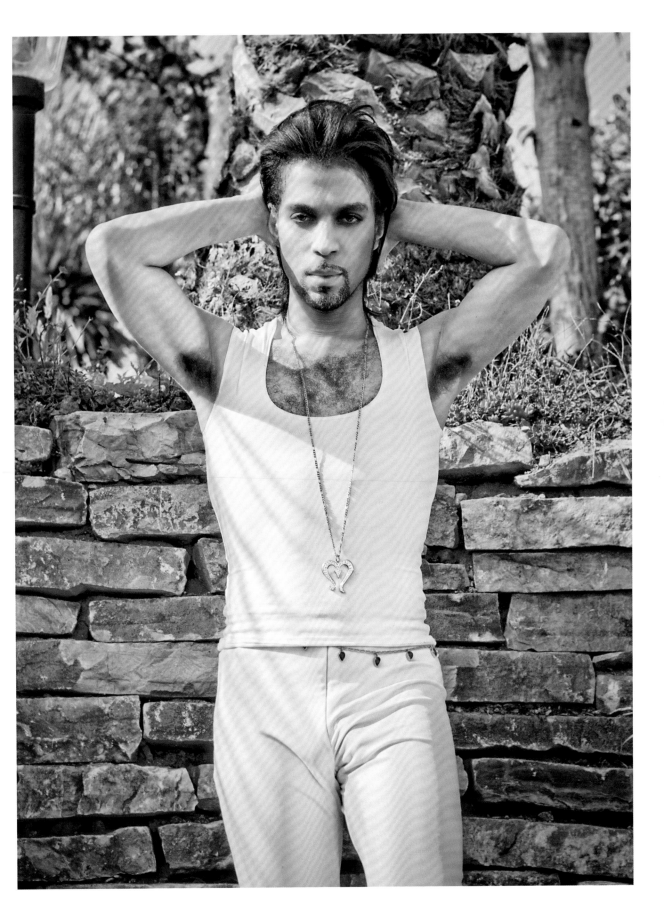

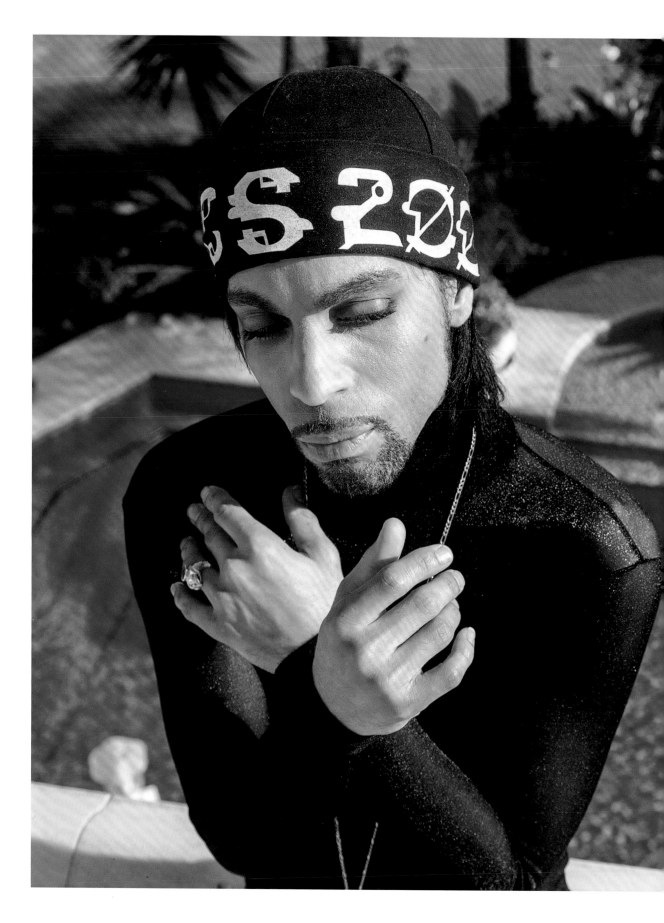

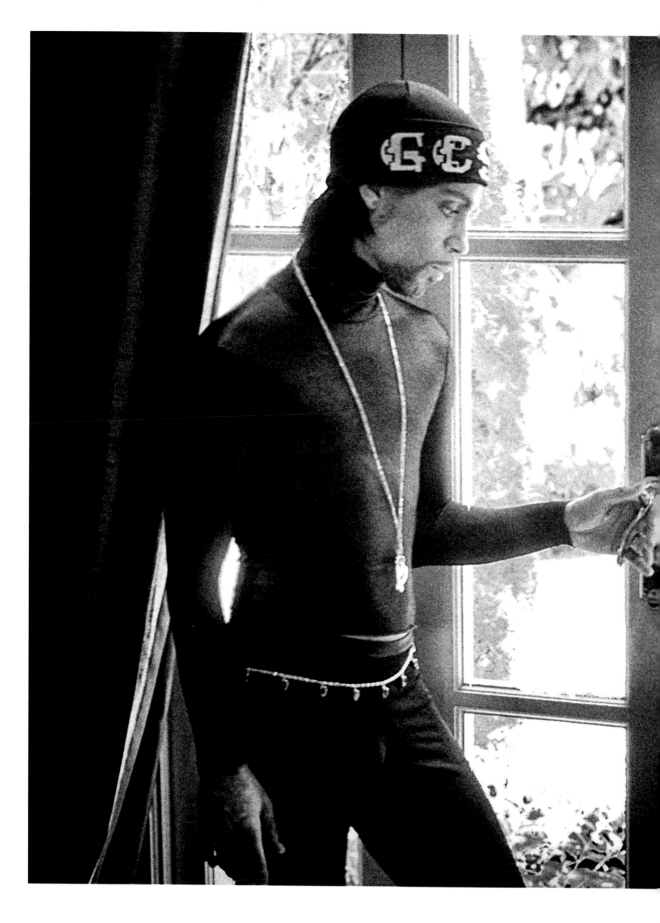

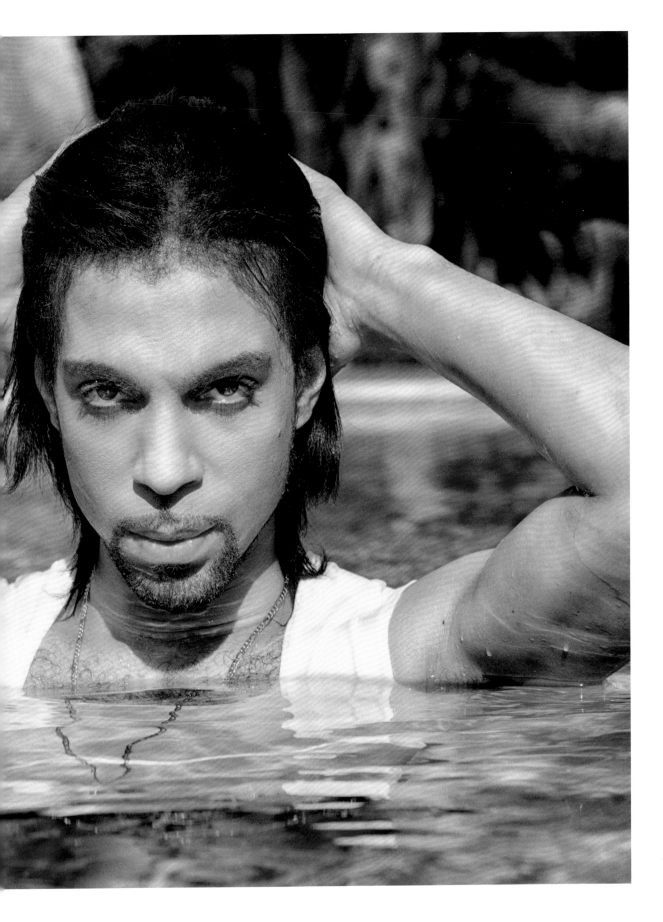

# THAT DARNED SYMBOL

Prince famously changed his name to a symbol in 1993. I don't know that any of us working for him thought much of it, except for the practical challenges it created.

Originally Prince told me he wanted to use it as an underground mark when he worked on other people's albums. "So I don't have to get permission from Warners," he said. Somewhere along the way, though, he decided to take it on as his own moniker full time. He explained that Parliament Funkadelic operated as separate musical entities: recording as Parliament and other times as Funkadelic—yet touring as Parliament / Funkadelic. I assumed he wanted to try that path as well. So, it became my job, as a designer, to make that mark work on everything.

Easier said than done. From a geometry perspective it was oddly shaped, taking up a square but leaving lots of negative space. Fortunately for me, a local type designer named Chank Diesel designed a set of fonts with the symbol and in this way offered some variations. I was grateful that Prince saw the font as a nice expansion of the symbol palette, instead of an unwelcome revision.

The name change was a bit flustering at the studios, since no one knew what to call Prince after that. The nice thing for me is that there were so few people in the studio when I was working through the night that if I shouted out a question or "Hey!" in Prince's general direction, he'd turn around. So, I encountered very few issues. Other people had more problems, like those working at the front desk. I know when we would ask if "he" was in the building most people knew who "he" referred to. Eventually, people started referencing Prince as "boss" because he was our boss. Prince picked up on this and made it clear that he didn't approve.

"I'm not the boss," he said. "Bruce Springsteen is the boss."

I was grateful that the release of *Rave Un2 the Joy Fantastic* returned the name Prince alongside the symbol, just to make things easier, but I also respected and am in awe still that he had the power and originality to have the media actually use a symbol in place of his name.

I don't know who else could have pulled that off.

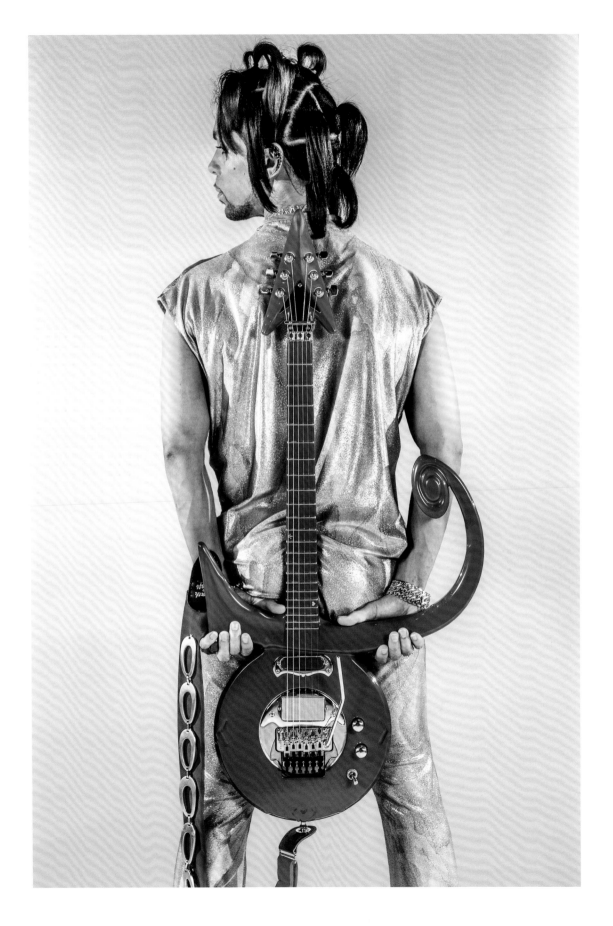

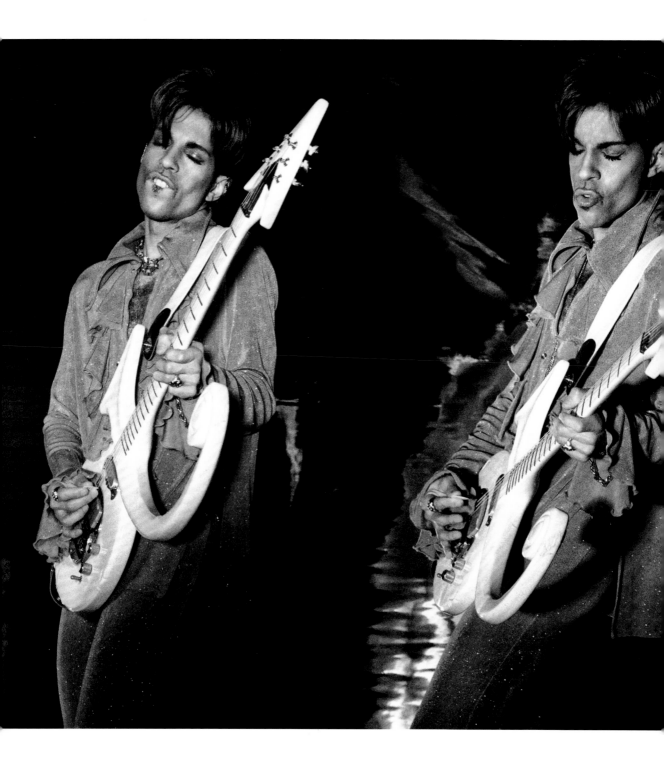

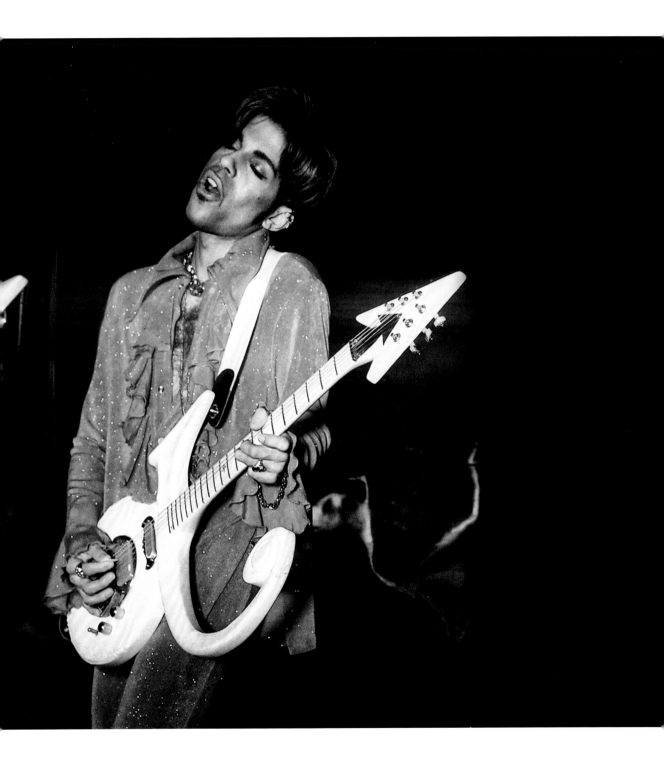

# RELEASE THE HOUNDS

When I was first at Paisley Park, the art department was down at the end of a hallway, off the beaten track. The upside was that people tended to leave you alone, so getting work done was possible (except when Prince came and hung out, not that I'm complaining). The downside was the way you could lose track of time. Often, very late, if no one needed anything and Prince wasn't in sight I'd decide to leave—to eat at the 24-hour Perkins restaurant down the road or go back to the hotel for the night. Not to say I didn't do it with a bit of stealth. If Prince happened to see me, it could mean several more hours of new ideas. If I left, those ideas simply waited till the next day.

As I was checking the hallway for any traffic, my backpack on, ready to do my fast walk down the hall, alarm bells sounded and small flashing lights went off all around the building. Then Prince appeared above me, on the bridge between the two sides of the upstairs hallway over the atrium. He grabbed the wooden rail and yelled, "Release the *hounds*!" It was hilarious. Then, the sound stopped and all was quiet.

I'd looked up of course, and Prince caught my eye.

"Steve, come up."

Busted, I thought.

I walked into the video-editing suite, which was packed with editors and several other people.

"Check this out," he said.

He started rolling the video sequence he'd been cutting for his upcoming American Music Award performance. It featured snippets from previously televised performances and his movies plus new footage of him dancing in silhouette. The small group in the room was watching from an editing standpoint but everyone was really enjoying the whole thing. At one point a scene from *Purple Rain* came up and Prince bellowed, "Look at that wig!" and burst out laughing. I laughed along. After the video ended, Prince looked back and I nodded my approval.

"See you tomorrow," he said, to my surprise.

The next day I was hanging out with Earl Jones, who'd been Prince's hair stylist for years. It occurred to me to ask him about Prince's comment on the wig.

He told me that Prince had had to reshoot a few scenes of *Purple Rain* after filming wrapped and Prince had already cut and dyed his hair bleach blond, hence the wig. He also told me that Prince's hair reacted so badly to the bleach that it started breaking off, so he'd had to let it grow out. And dye it back to black.

"The hairstyle in 'Raspberry Beret,'" he said, "was literally all I could do with it."

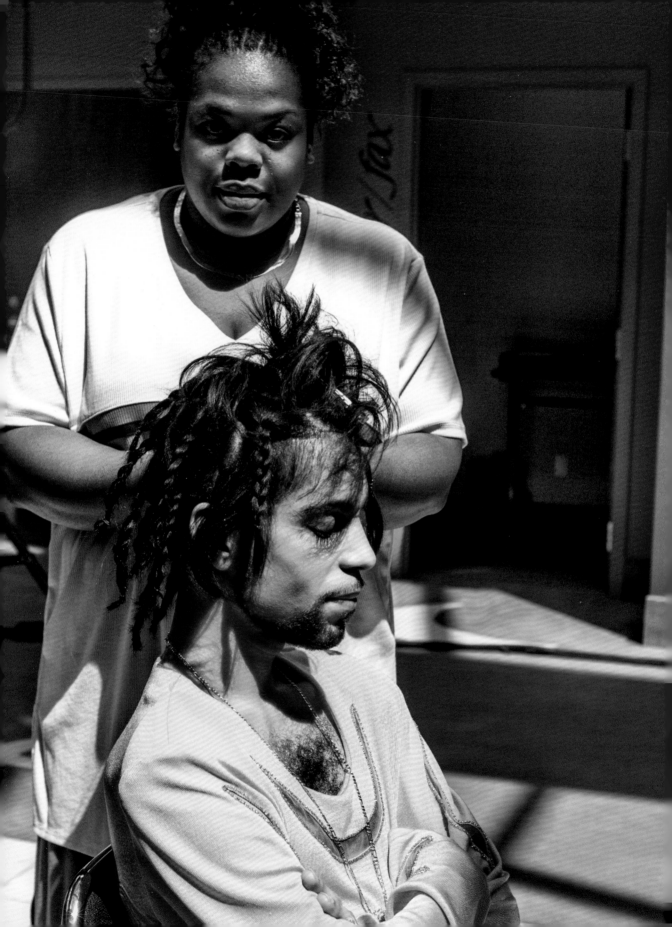

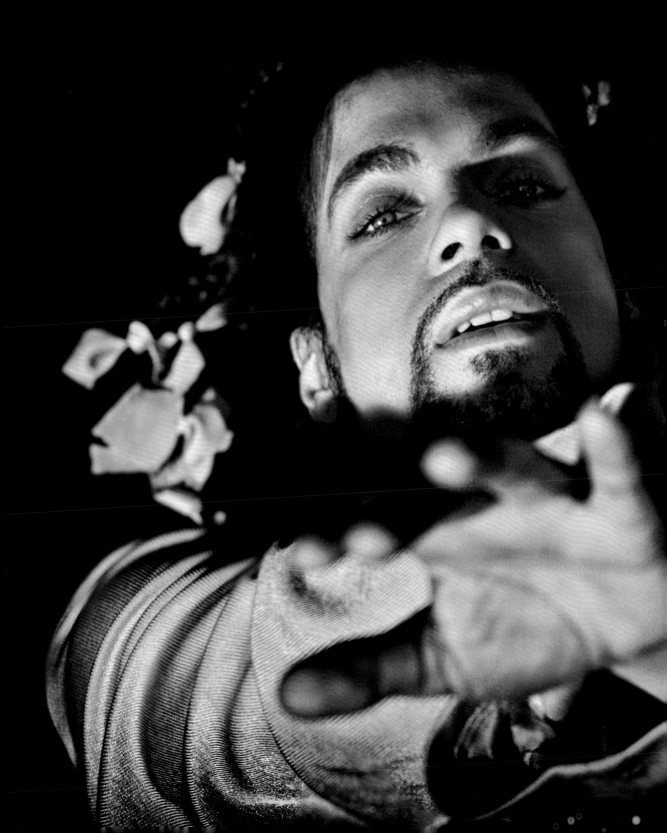

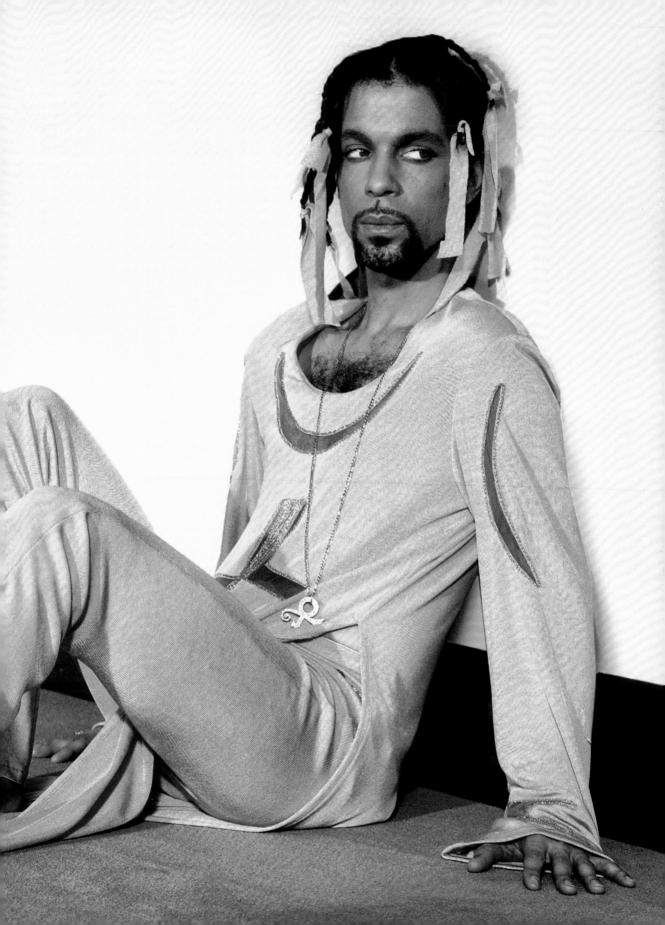

# TRADING UP

I wore fairly casual clothes when working and generally got away with that—though Prince did ask me once why I wore Lee Jeans. I had to explain that they were cheaper than Levis. He, of course, always dressed like Prince (and almost always wore heels), no matter what. I didn't see him in jeans even once in the 13 years I worked at Paisley Park.

But one day I paired my Levis (upgrade!) with a T-shirt I'd gotten at an early screening of *The Blair Witch Project*.

"What's that?" Prince asked, pointing at my chest.

Bewildered, I looked down and then explained what the movie was and where I got the T-shirt and how cool I thought it was that the movie had been made in Maryland. I sort of fan-boyed the film.

He was silent for a moment and then asked, "So, is that a good film?"

"I enjoyed it," I said.

"That's not what I mean."

I looked at him blankly.

"Do you think that it has a good impact on the world?" he asked.

"It's a scary film. I'm not sure it has a whole lot of impact one way or the other."

"Do you think it's good for people to allow that into their brains?" he pressed.

I rambled for a bit about everyone processing things differently and how suspense entertainment tended to replace some of the components of the human experience we were missing in American society, the way that rollercoasters did.

Prince returned my blank look and said, "Let's go downstairs."

We walked into another office, to the unexpected amusement of his manager Jacqui Thompson, who was sitting innocently at her desk.

"Jacqui," Prince said. "I asked Steve if he thinks this is a good movie." He pointed to my shirt.

She sat, eyes wide and attentive, now involved in a conversation with zero context. And amused. Clearly this was not the first time she had been dragged into a Prince argument.

"Wasn't *Scarface* a favorite movie of yours?" I asked Prince. "I think that sort of thing is way worse."

"It used to be," he said, with a slight edge to his voice. "I've moved past that."

"Well, give me a few years and I may think the same."

His next point took me totally by surprise.

"Do you think it's a good idea to take a 5-year-old into the theater to see *Psycho*?"

The way he said it and his body language led me to believe that someone had actually done that to him. He'd told me a few things about how mistreated he was as a child, and his voice carried the same weight now.

Which made me stop the discussion (and attitude).

"No." I said. "I do not."

"Would you wear a different shirt if I got you one?"

"Of course."

He turned to Jacqui. "Would you go get two NPG [New Power Generation] jerseys?" he asked.

"Sure," she said, and shot me a wink as she left the room.

I changed shirts and never heard another thing about it; he gave Jacqui one, too. After that, I was a bit more conscientious about what I wore on my T-shirts.

But I still have both shirts.

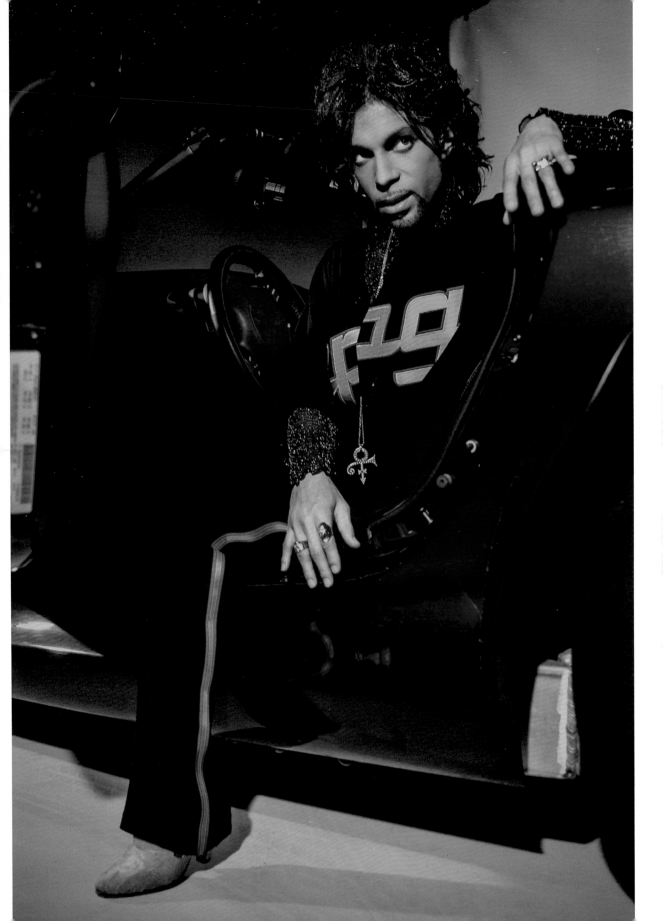

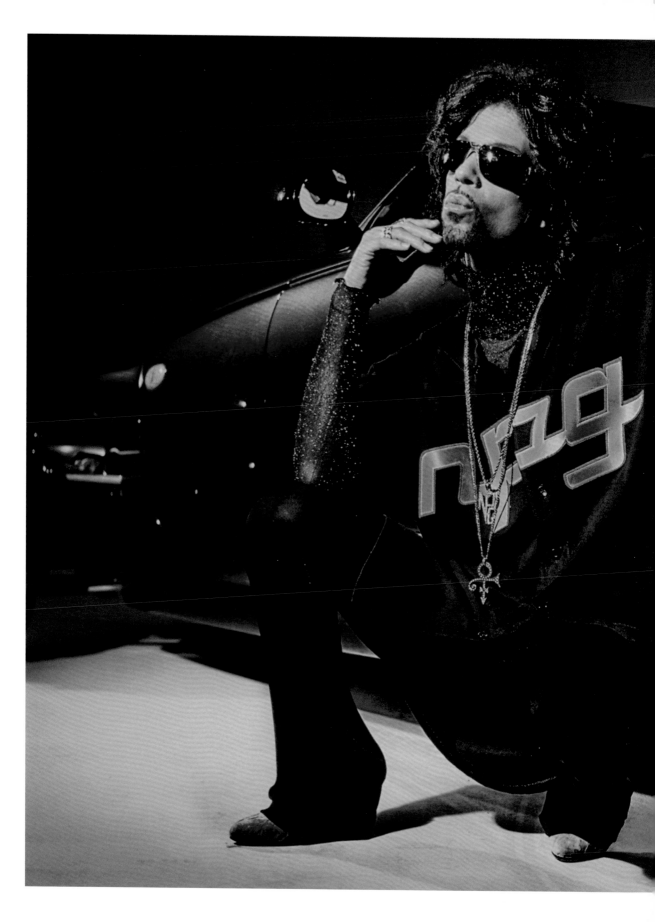

# YOU'RE NOT COVERED

Wearing an oversized polo sweater and gold pants with tiger stripes, Prince rolled
a bicycle out onto the soundstage. It was a fairly surprising look, even with his track
record of unusual fashion choices. I had my camera ready to go. I tested the shot, then
told him to hang on. I set down my camera and walked to the loading dock and grabbed
a ladder.

Returning to the soundstage, I climbed up the small A-frame, throwing a leg over to
stabilize myself.

"Can you hand me the camera?" I asked.

He looked up at me and said, "I don't have insurance for that," gesturing to the ladder.
He passed the camera up to me.

"Really?"

He looked at me and gave me a wry smile, which faded before I could focus the camera.

He said the same thing a year or so later when I was shooting some video footage
of him in his convertible, with the top down and my legs wedged on either side of the
back seat as he zipped down Audubon Road. Prince's bass player Rhonda Smith sat
next to him.

"It's ok," I said. "Great art requires sacrifice."

He laughed. "You're still not insured," he said.

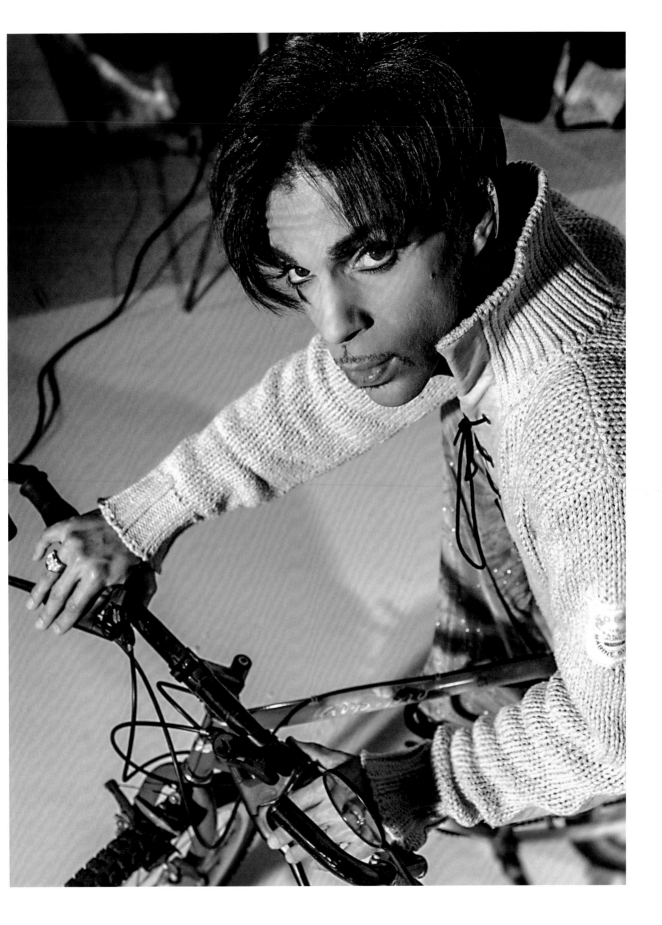

# PING-PONG WIZARD

One night around 2 a.m., the magic hour at Paisley Park, Prince yelled across the hall for me to come over to what was now a game room.

I walked over and Prince was standing at the ping-pong table. A couple of other people hung out on the couches.

"Want to play a game?"

"Sure," I said, knowing full well I didn't stand a chance against him.

Prince lobbed the first shot and may have been surprised that I returned it (I certainly was) and nicely volleyed until I missed. The next serve I managed to hit back at an angle where he missed.

Still calm, he looked past me and said, "Steve, Femi [Jiya, his engineer at the time] wants you."

I turned and, as I did so, he served the ball, with a spin that I never would have been able to return.

I was too tired to think about what I was saying and the words left my mouth before I could stop them: "Dude," I said, "you do not have to cheat. You'll win anyway."

He gave me a sheepish look and played out the rest of the game in his usual generous way. But he still won.

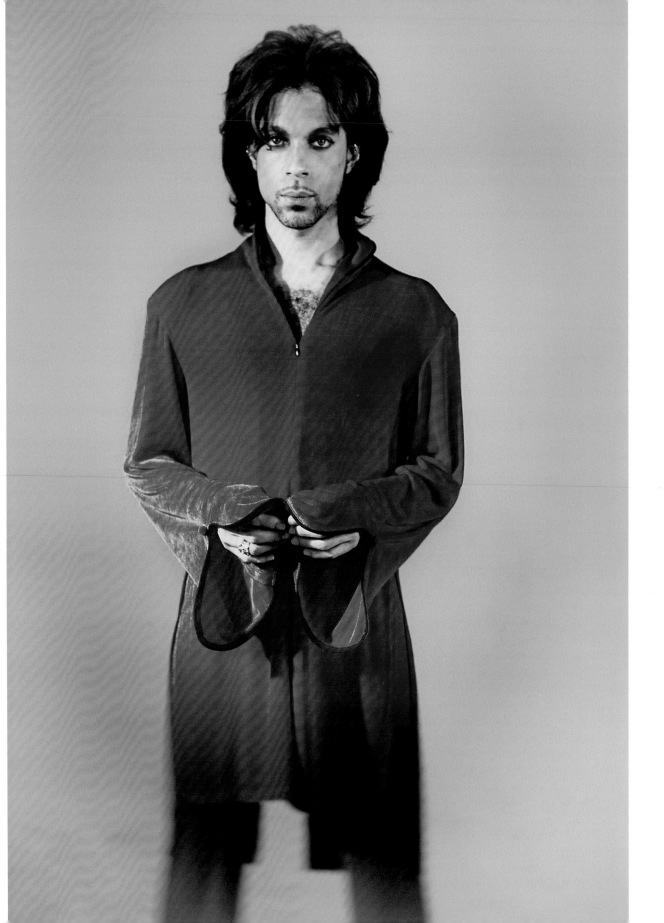

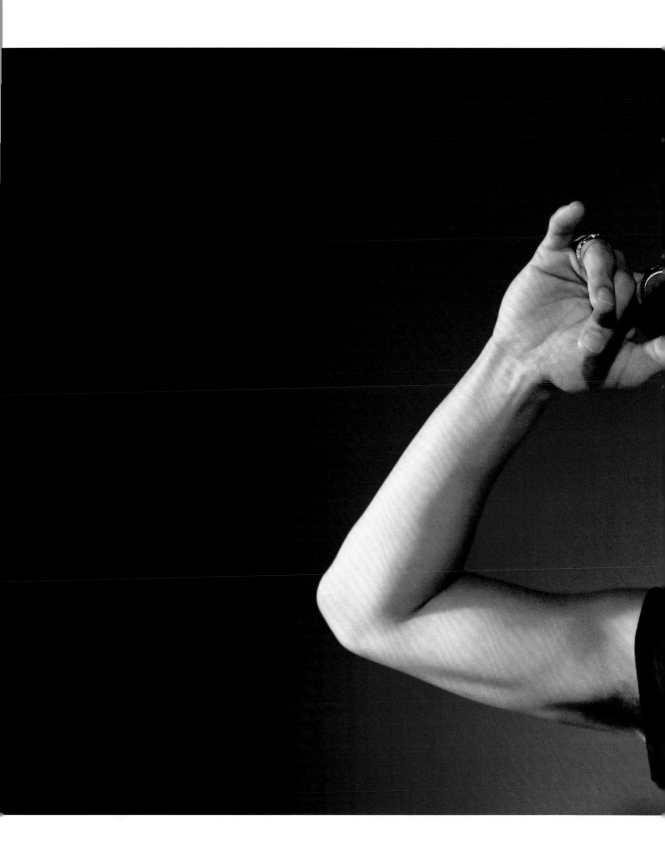

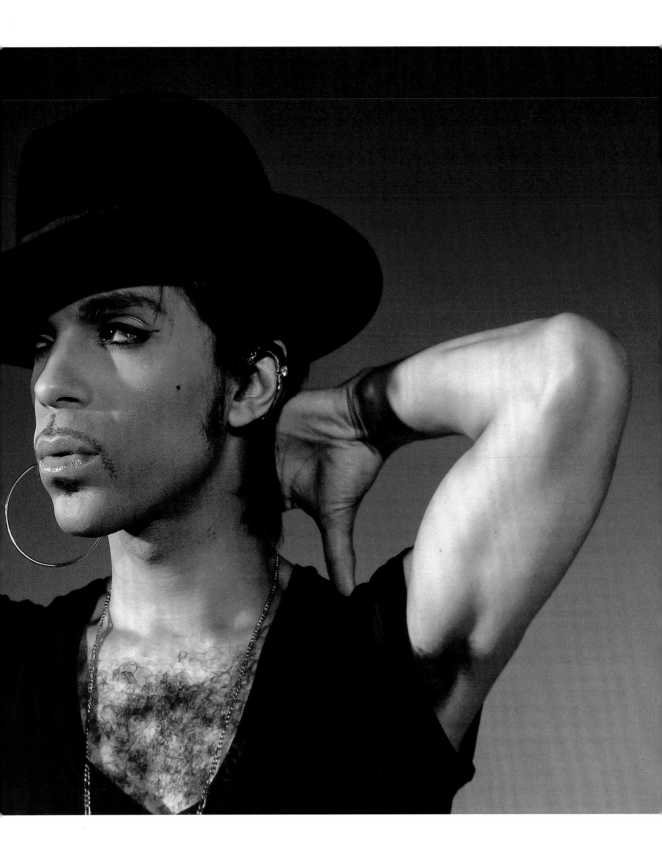

# PIANO WITH DOVES

Prince wasn't a workaholic as such, but what I'd call a create-aholic. He literally built a world around himself, a place in which to create all the time.

Working through the night with only Prince and sound engineer Hans-Martin Buff on a regular basis, I marveled at how much could be done by a relative skeleton crew. Prince recorded in the studio, leaving Hans to do his thing, and would run upstairs to my office and sit and work right behind me, sometimes dragging his finger across the screen to show me where he wanted something (and on occasion leaving a smeary trail on the surface from the base makeup still on his fingers, which, if it was late, I would rub off pointedly).

The phone would ring and Hans would let him know that something was finished, and Prince would ask if I had something to do (I *always* had something to do) before disappearing for unknown amounts of time, checking in by phone if he'd been recording for a while or calling me down to hear what was going on.

I was fully aware of the rest of the crew who came in during the day to wrap up, clean up and do business both creative and financial. But at night it seemed like Prince and I were sometimes building a template for what would happen the rest of the week or month.

As I worked, I'd sometimes hear Prince playing the custom grand piano downstairs, in the atrium. Some days he'd be tinkering, other days recording for what would become his *One Nite Alone* album. The sound bounced off the marble and lifted those notes right up through my door. Doves—in a huge cage down the hall—would begin cooing along with the music.

Sometimes I really felt I was going to wake up and find I'd been dreaming this stuff all along.

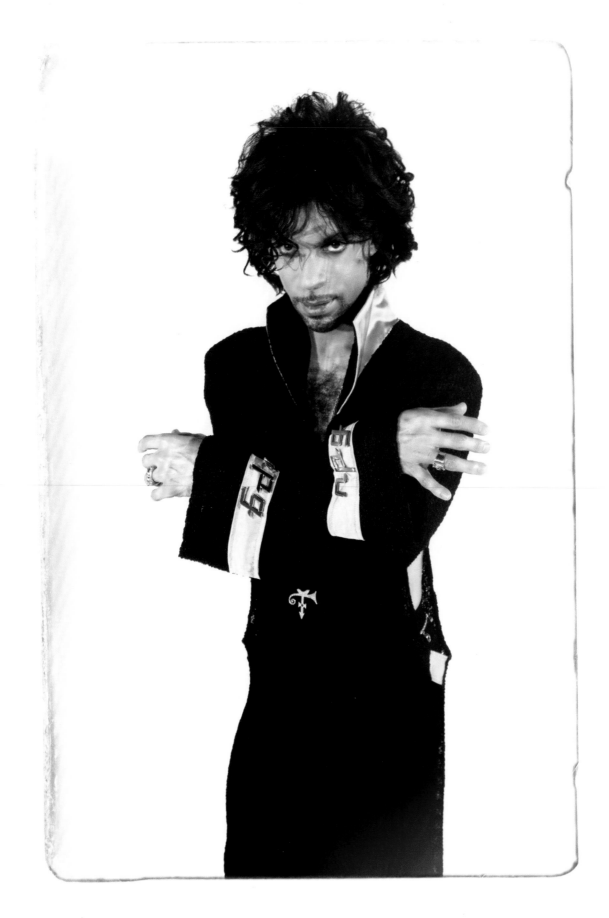

# TINY WATER FOUNTAINS

"Do you want a smoothie?" Prince asked me.

"Sure."

For a while, Prince was obsessed with smoothies and seemed to love making them. It seems funny now, imagining Prince making a smoothie for me, but in that environment I wasn't much surprised by anything.

He disappeared downstairs. I could hear him in the kitchen, the blender whirring loudly. He returned with two giant, red plastic cups full of fresh smoothie (he always drank his smoothies in those big cups), bright pink and with two fat straws sticking out of them.

He was wearing all black and his hair was in tufts. I showed him what I'd been working on as we nursed our frozen fruit, then we trekked down the stairs to the soundstage to take some shots. Walking behind him, I took a good look and realized he was wearing slippers. And they appeared to be furry. His hair was sticking up in those tufts, tied at the bottom, as if his head had tiny water fountains spraying out of it. Between the hairdo, the slippers, and the oversized red cup in his hand, he looked like a little kid. I found myself thinking, "Awww, he's so cute," though luckily I didn't say it out loud despite the late hour and my general, ever-present exhaustion.

While I was adjusting the light and plugging it in, he said, "I was trying to figure out why I decided on this look." He batted at the banded tufts. "I realized that my cousin used to wear her hair like this, when we were kids."

Then, getting ready for the camera, he pulled on a furry, floor-length coat.

I wondered if his cousin used to wear one of those, too.

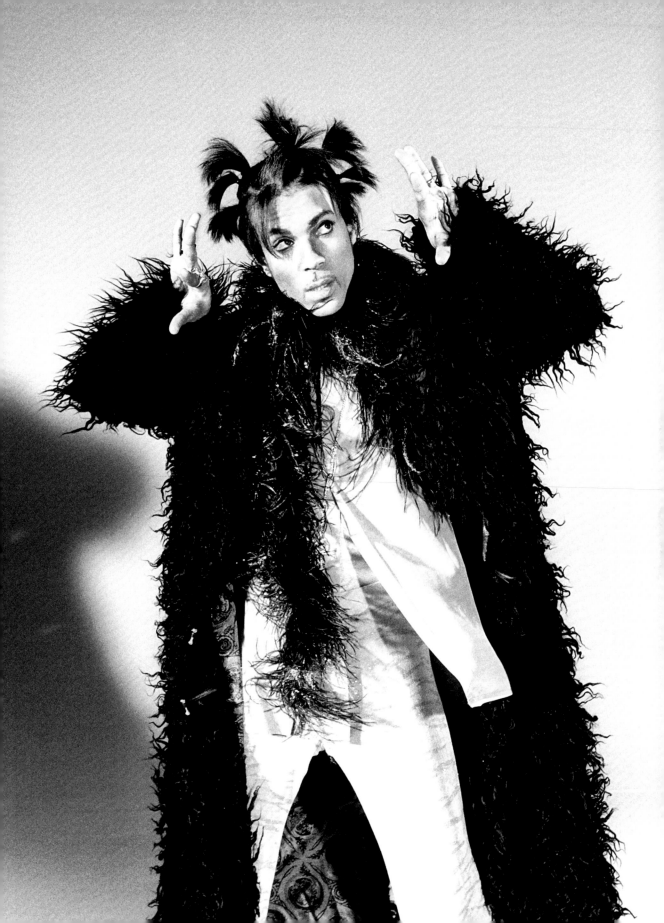

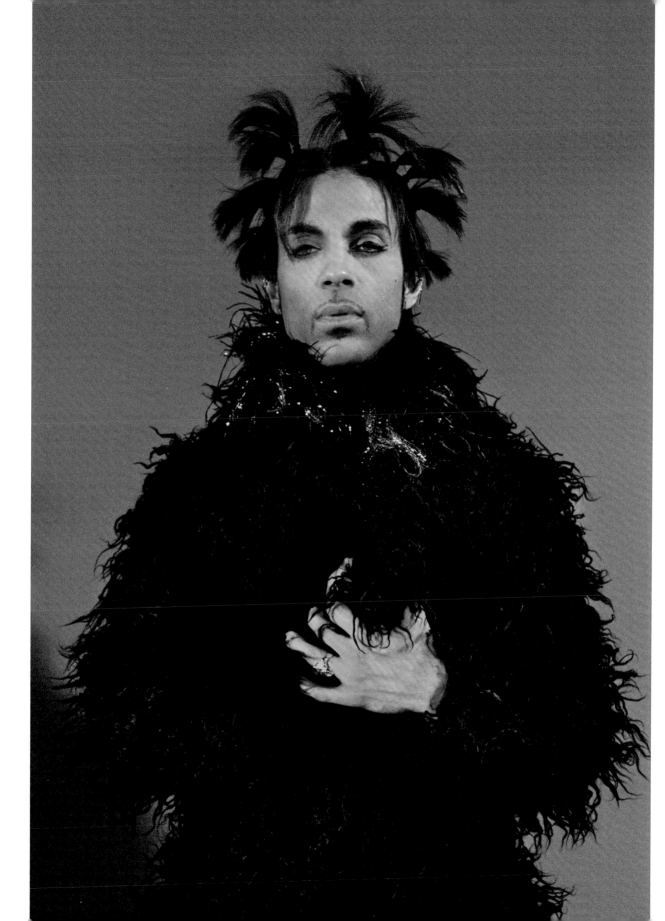

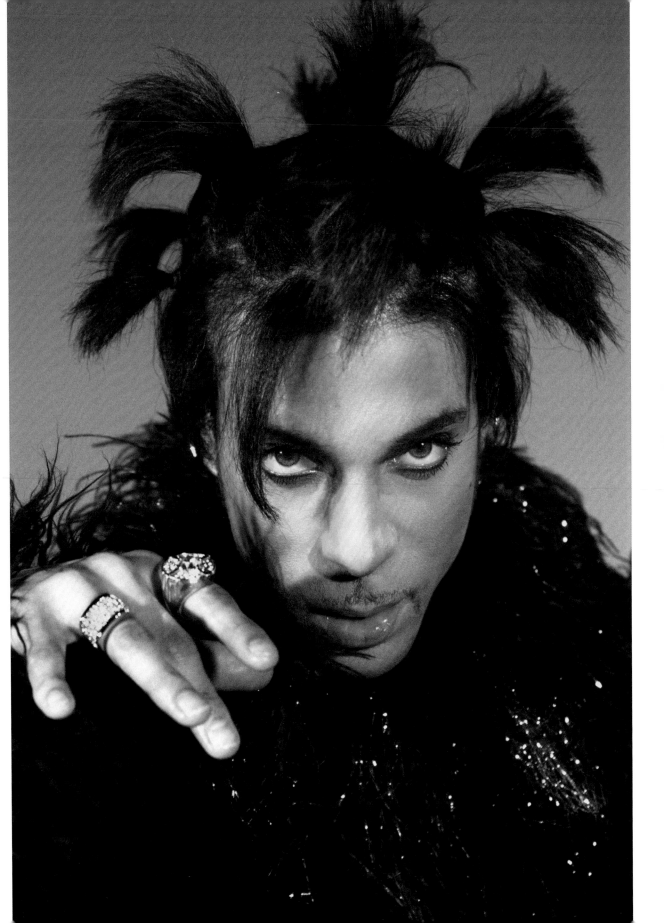

# INTERVIEW WITH THE VAMPIRE

A whole bunch of people swirling around the atrium on a Friday night usually meant a party, and this time it was people with a lot of equipment so that was something different. Sure enough, they were setting up for an impromptu jam with the entire band, *and* they were going to film it. So, I called some friends of mine who were coming to visit and let them know they might be in for a treat. I took a rare dinner break with my friends that actually involved leaving the building.

We returned around 9 p.m. and things were starting to buzz. It was not a crowd, more like a bunch of random people waiting for a bus, but busy. I told my friends to come hang with me in my office. Around 10 p.m. someone popped in and said come downstairs. We walked down just as the music was starting. A few more bodies had been added to the crew, so that there was now a crowd of 50 or so. We hung off to the left near a wall and disappeared into the awesome full-tilt show taking place in a space no larger than most double car garages. Partway through the set, Prince was playing Tommy Barbarella's gold version of the Purpleaxxe guitar (a keytar/keyboard guitar hybrid that Prince had told me he customized and patented) and sauntered over to my little group. He leaned into me and started talking, while continuing to play.

"I like what you did today," he said, referring to the project we'd been working on.

"Thanks!" I replied loudly.

Then he sort of looked right at me while doing an insane run of notes, turned to my friends and said, "Are you having a good time?" I think they nodded an *"Of course!"* He smiled and headed back to the band.

Above the music I could hear my friends asking "Is it like this *all* the time?"

"Not exactly," I said, "but kind of."

The show ended and I got word he was taking everyone out to a movie. So I found out what theater and we all met there. As usual, it was close to the magic 2 a.m. Paisley Park entertainment hour. An open concession stand reminded me how thirsty I was, and how much I needed some sugar—I reached for some Twizzlers. We waited a bit longer for Prince and the band to show up and then *Interview with the Vampire* started rolling at about 3 a.m. With the end credits starting, my friends and I walked out to see the sun glowing over the horizon. Just like in the climax of a Hammer vampire movie where the sun saves the day.

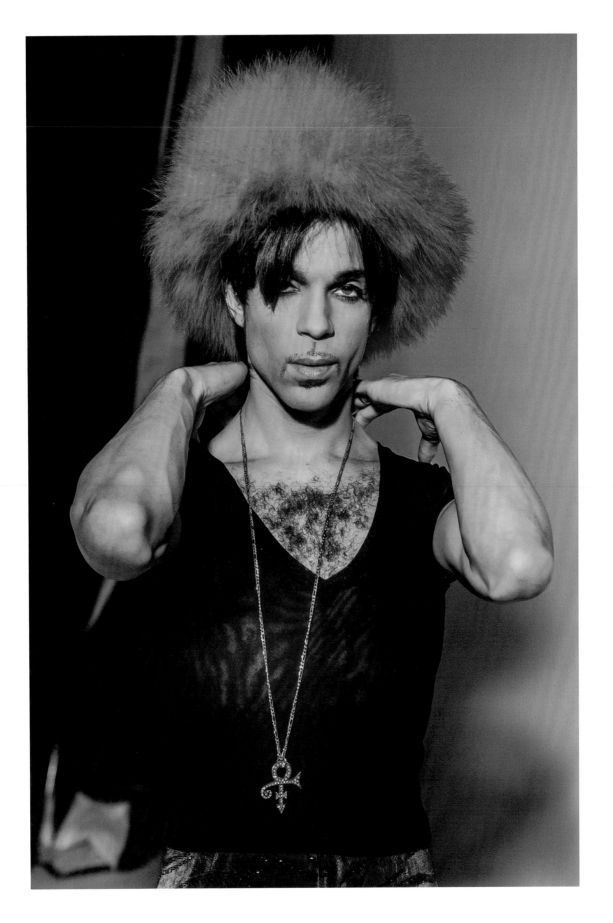

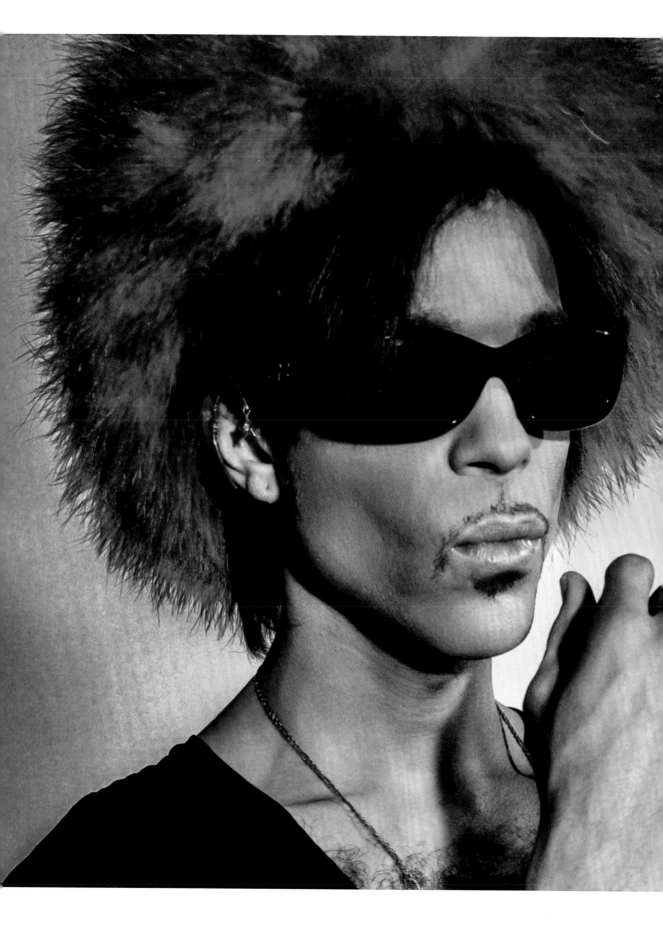

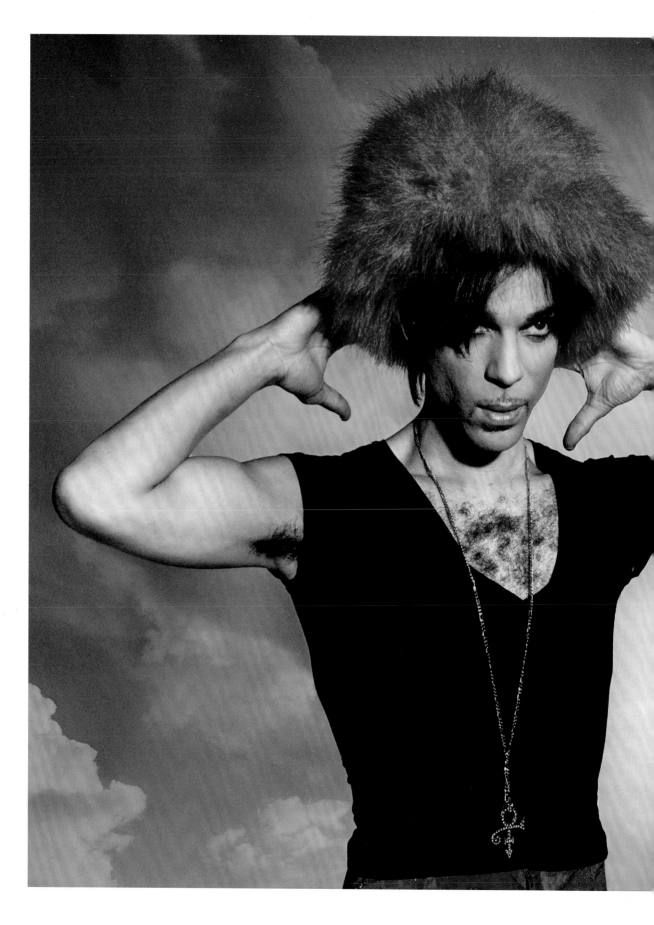

# IN THE REEDS

One day we were heading outside to shoot some photos off the cuff, across from the soundstage entrance into the grass I saw every day from my office window. I wondered if we'd encounter the two groundhogs I'd often see from my window, too. They didn't seem to do much other than wander around. (This was pre-social media, so those groundhogs could be pretty entertaining.)

A big wooden chair was planted in the middle of the grass, and Prince posed, working the chair for all it was worth. After the session, I suggested moving back into the reeds and flowers that would bloom around a small pond (though in Minnesota it might be considered a lake) every summer, to the northeast of the building. He agreed but wanted to change his clothes. I sat in the shadow of the building, enjoying the grass and being outside. He reappeared minus hat and robe, but still wearing sparkly gold boots with those heels. As we walked over, the ground started to get mushy but he kept going. He stopped and turned.

"Can you get more into the reeds?" I asked.

I knew I was pushing it but I thought the shot would be worth it.

He stepped back and back and back. I can only imagine he was starting to sink, but he didn't seem to mind. "That's great," I said finally.

As I looked through the lens I noticed his demeanor was a world apart from his usual one: he just seemed utterly relaxed and at peace.

Looking back, I wish I'd suggested the reeds more often.

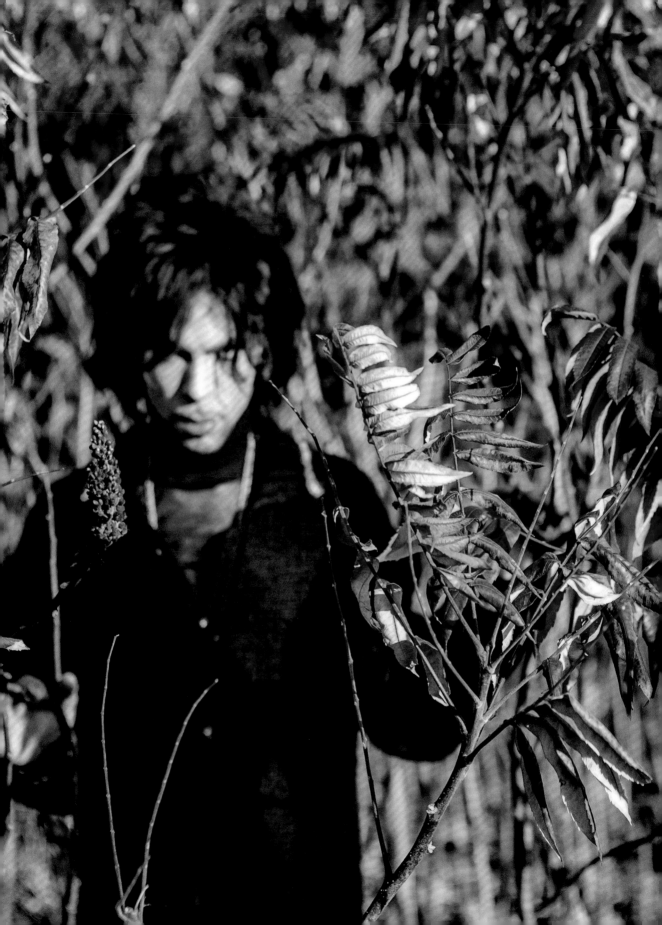

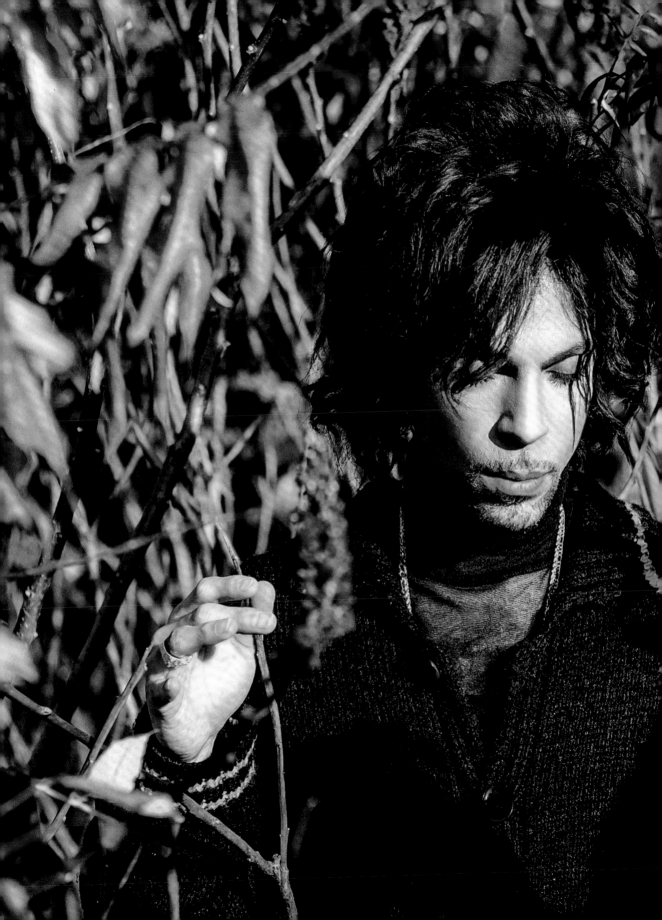

# HOMETOWN HERO

When Prince brought the New Power Soul tour—or "revue" as he liked to call it (with soul meisters Larry Graham and Chaka Khan)—to Baltimore in late September 1997, I went to see them. It was fun and a little disorienting to see Prince in my hometown (as much as it felt like I lived at Paisley Park sometimes).

We were hanging out backstage before the show when Prince called me over and asked me to follow him.

We walked into the empty arena, and when we were a ways back from the stage he turned and motioned to the huge set (which I'd sat and loosely designed with him in Photoshop in *one night*) and said, "See all this? You made this."

I blinked for a few minutes, taking it all in, and then sort of whispered, "Thank you."

All I could think was: "But you…*you* are going to fill it up."

At that moment, the doors to the arena opened and people started streaming in. Some of them started to notice who was on the floor and yells of "PRIIIIIIIIINCE!" filled the air. He waved, then turned and said, "Let's go."

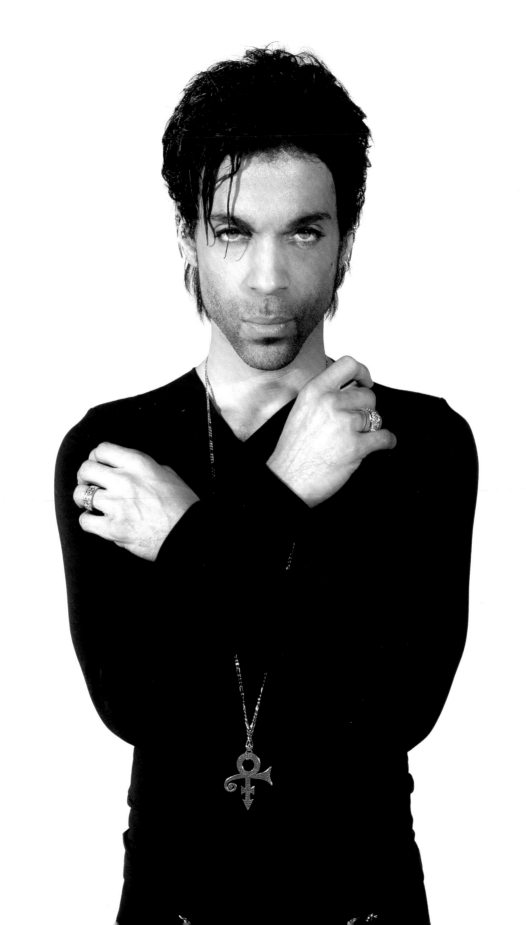

# PURE IMAGINATION

How do you make the Chocolate Factory more fun? Stay up with Wonka and scheme when no one is looking.

I got to be Charlie one night, after Prince decided that Paisley Park needed to be way more funky and less corporate. We stayed up late into the morning dreaming up things—a waterfall mural behind the water fountain; his eyes greeting you as you walked into the studios; his symbol acting as a third eye against a sky full of clouds; a gigantic symbol inlaid into the marble floor of the atrium; star fields, more clouds and birds near the skylights; piano keys on the ceilings; lyrics and symbols cut into the rugs; and color. So. Much. Color.

This refurb process was as slapdash as it could be. I took Polaroids, scanned them into the computer, and drew on top of them in Photoshop with Prince sitting next to me. I never knew where any of it would lead; sometimes, we'd toil away on projects that went nowhere. So, I watched in wonder, my jaw dropping and my heart pounding as, over the next days, a crew flew in and out and brought every one of those fantastical ideas to life. I half expected the water to start flowing purple from the fountains and tap.

That's how things were in Prince's world. Then the nail biting ensued, as I started to wonder about the judgment of two people lacking sleep and having a blast at the computer. But, fortunately, it all worked out.

These were the sorts of nights that pretty much proved anything is possible. And if it's impossible, at least you can try.

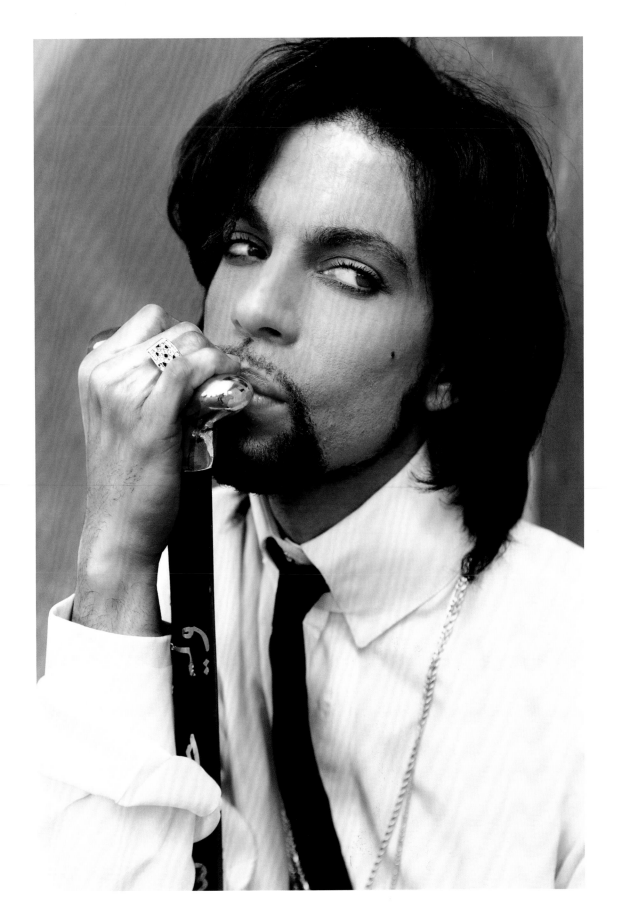

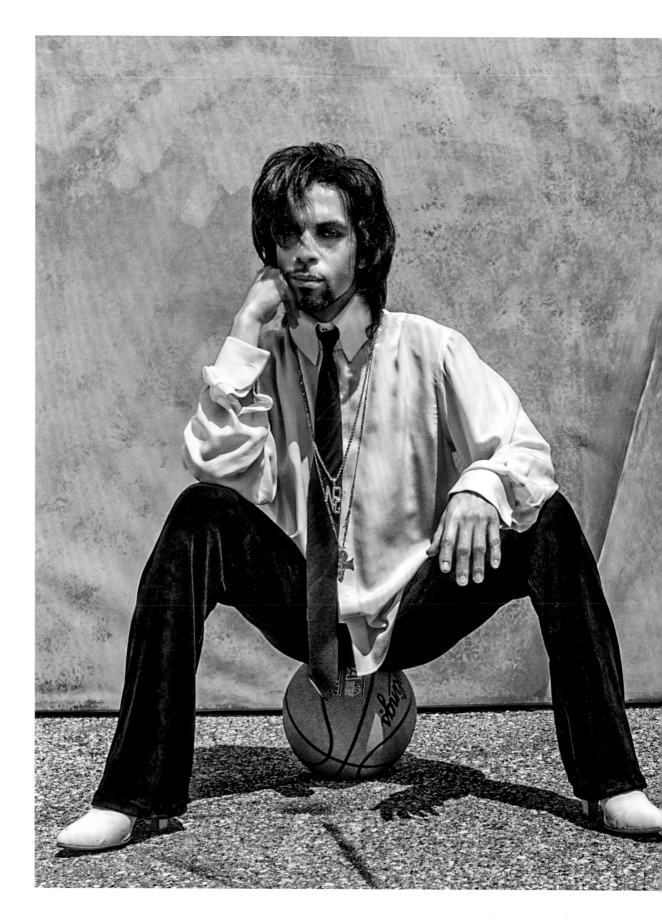

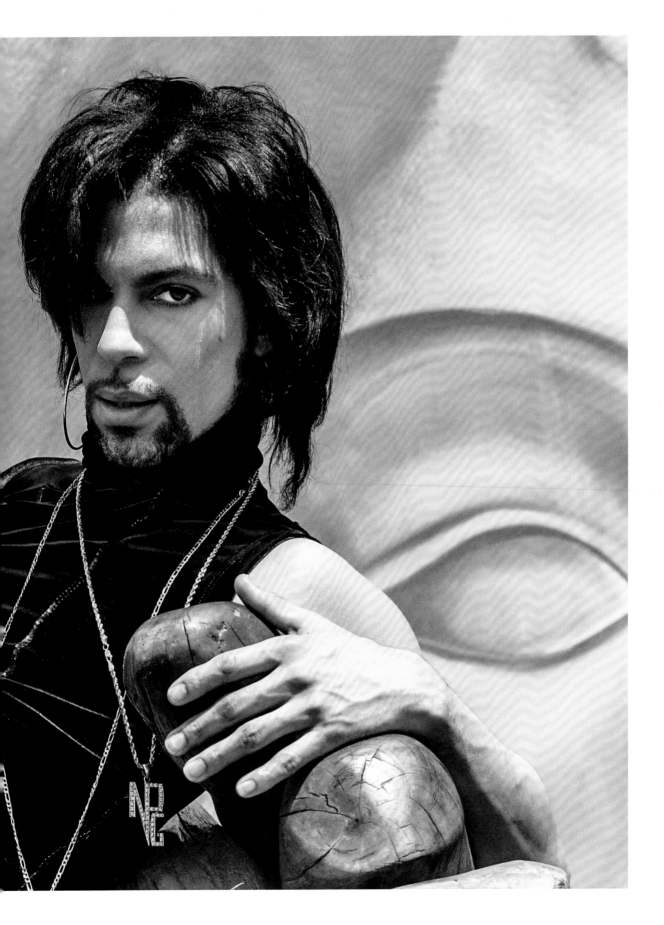

# FROM NAME TO SYMBOL

For the *Emancipation* album CD booklet, Prince put together the credits somewhat on the fly. I did my best to type the information as he spoke (not my strong suit). We got to a song called "Face Down," which included a car horn sample.

"Do you drive a BMW or a Jeep?" he asked.

"Neither," I said. Crappy old Nissan hadn't been an option.

"You drive a Jeep."

My fictitious Jeep was then credited. Looking back, I should have tried to roll that into an endorsement deal.

As we got to the end of the credits he asked, "Have you ever thought about changing your name to a symbol?"

"No."

"Why not?"

"My mom wouldn't like it."

"Good answer," he said, and let it drop.

Prince had a habit of creating new monikers for the people he worked with: Bobby Z., St. Paul, Sheila E., Carmen Electra, Tommy Barbarella, Dr. Fink, Brown Mark, Vanity, and Apollonia, for example. And he had a host of his own alter egos, too: Joey Coco, Jamie Starr, Alexander Nevermind, to name but a few.

I suppose I shouldn't have been surprised when he suggested I change my name to a symbol. Since I resisted that, we agreed on just "Parke". I suppose it was better than some of the alternatives.

I never pondered that one too hard, because sometimes just thinking it made it a reality when dealing with Prince.

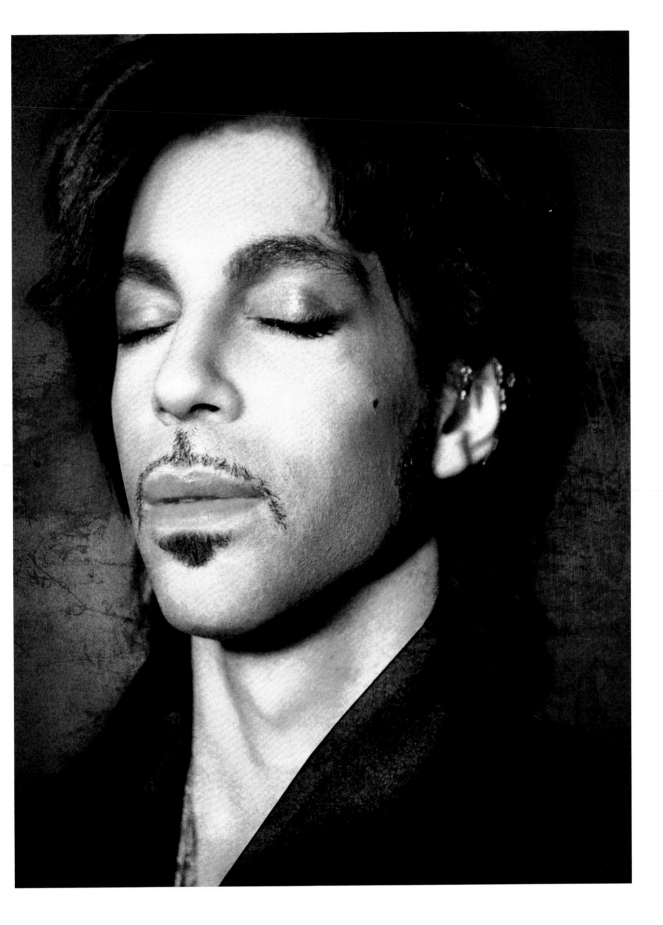

# IN THE MOMENT

One impromptu photoshoot took us to Chanhassen Arboretum. We hopped in Prince's Prowler, squealed onto the highway, and a few minutes later turned into this park I hadn't even realized was there. It was early on a weekday in the fall, so we had the place to ourselves, devoid of summer tourists and school bus field trips.

Prince drove down the road, turned right, and parked his car in the middle of the road. We got out. It was quite beautiful. Trees were heavy with their gold and copper leaves, Prince contrasting them in all black with heavy dark-rimmed glasses. Initially he sat on the hood of his car. We snapped a few shots and then heard a crunching sound to the right of the car. Prince startled and had the look of someone who'd been found out (I managed to catch his reaction in one shot, which he liked and found funny), but the sound was from an older gentleman who was busy leaning down to identify a particular plant. He walked by and gave the purple Prowler and Prince no notice.

Relief settled in and we walked to a set of brick stairs where Prince sat (click). He stood and messed with the turtleneck of his sweater (click), moved towards a bench and squinted towards the sun (click). All resulting in beautiful images. I'd been photographing Prince for a while at this point and it occurred to me that this was the most relaxed I'd felt on a shoot with him, probably because he was the most relaxed I'd seen him. I've always enjoyed the woods and apparently he did as well. We walked through tall grasses, he sat down inside a stone circle with his face towards the sun and closed his eyes (click). We walked and walked (click), then returned to his car and drove further down the path to flower-filled hedges (click). I took a picture of his reflection in the shiny hood of his car (click). I recall very few words exchanged that day, and honestly was a bit sad when we were finished because it'd been such an "in the moment" immersive experience—for once, no rushing and no deadlines.

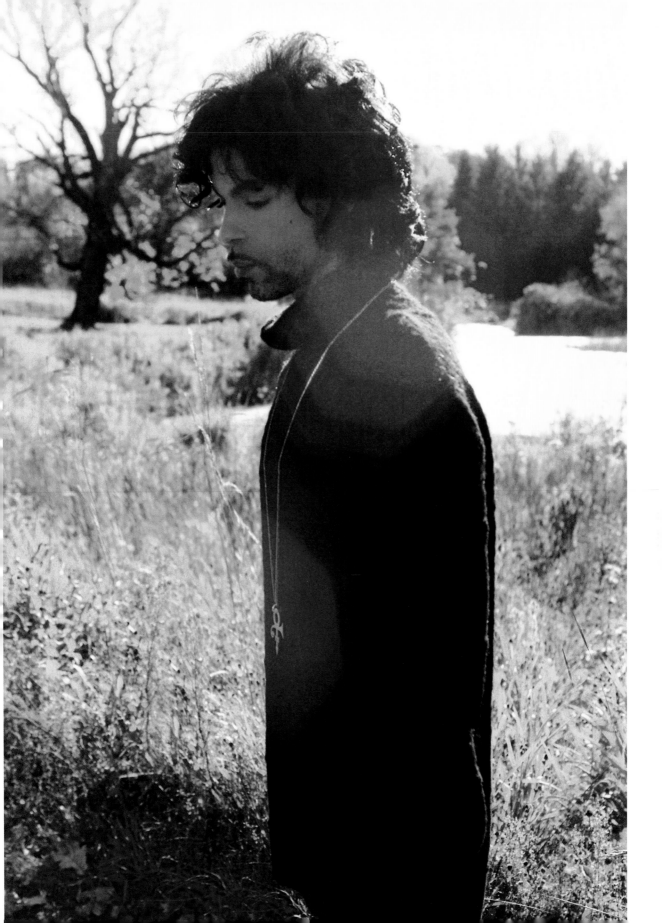

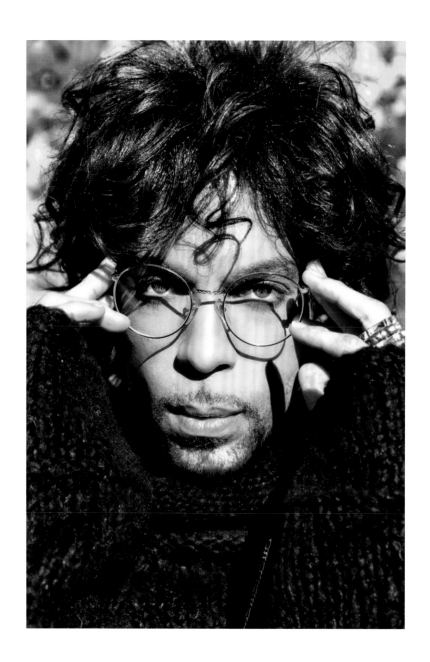

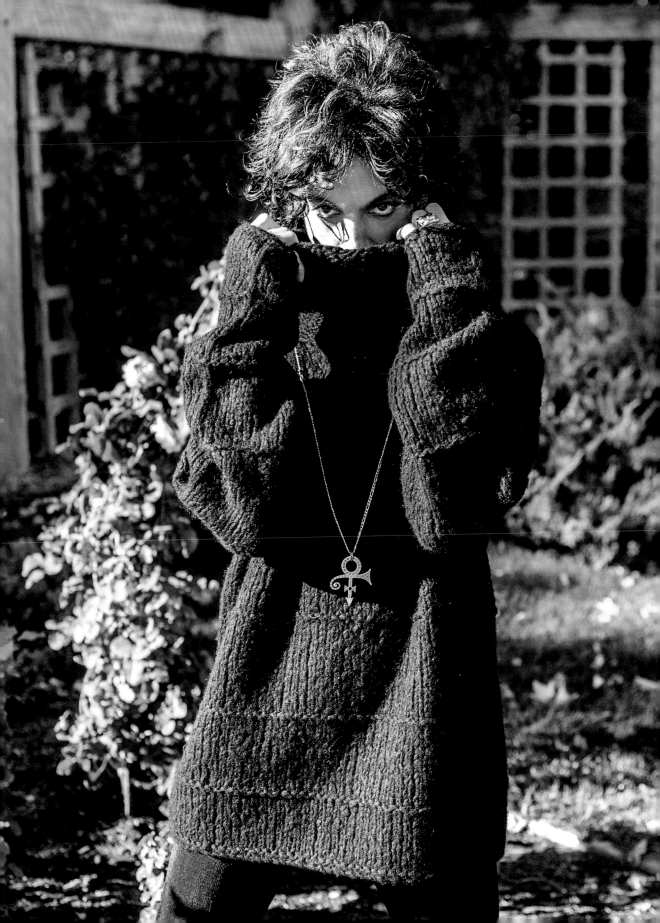

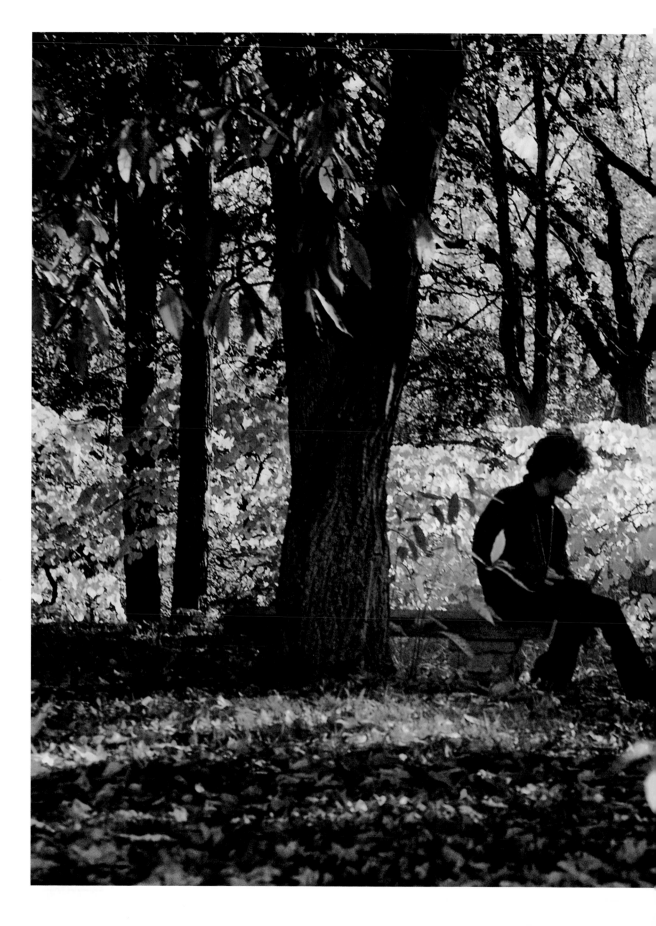

# FORCE OF NATURE

Seventeen years later, in August 2016, I returned to Chanhassen Arboretum. I hadn't been to Minnesota in well over a decade. I brought my son, then 15, to the places he'd seen in my photos for years.

You can never exactly go back again, of course—the park had grown into a much bigger place, there was more to see and there were far more people in attendance, and now Prince was gone. But I found many of the spots Prince and I had visited that long-ago day. The people who worked at the arboretum were helpful in looking at my original images and identifying the places in them.

Before we left, one of the kind and helpful women who worked there told me that Prince had visited a few weeks before he passed, but unfortunately the back paths, which he really enjoyed, had been closed for repair.

That moment packed a fairly heavy emotional punch, one I suspected was waiting and caught up with me. The finality sunk in and for a moment the loss seemed unbearable. There'd be no more of that crazy creative whirlwind, him wrecking the way things are supposed to work, endearing, educating, and irritating the status quo. He'd been a force of nature as expansive, beautiful and taken for granted as the woods I was walking through.

Walking the park that day was haunting in a beautiful way. I took the opportunity to have my son sit in those same spots—on the very steps where I had photographed Prince, in the street next to the cabin, on a park bench where Prince squinted in the sunlight—and took pictures with my phone.

It did my heart good to see my son fill those spaces, and to walk the woods where Prince had seemed most at peace in all the time I had known him. Finding that he still visited those woods from time to time made it feel better. I once thought if I could give him a gift, it would be to turn off all that noise and let him walk outside with nothing but the air around him.

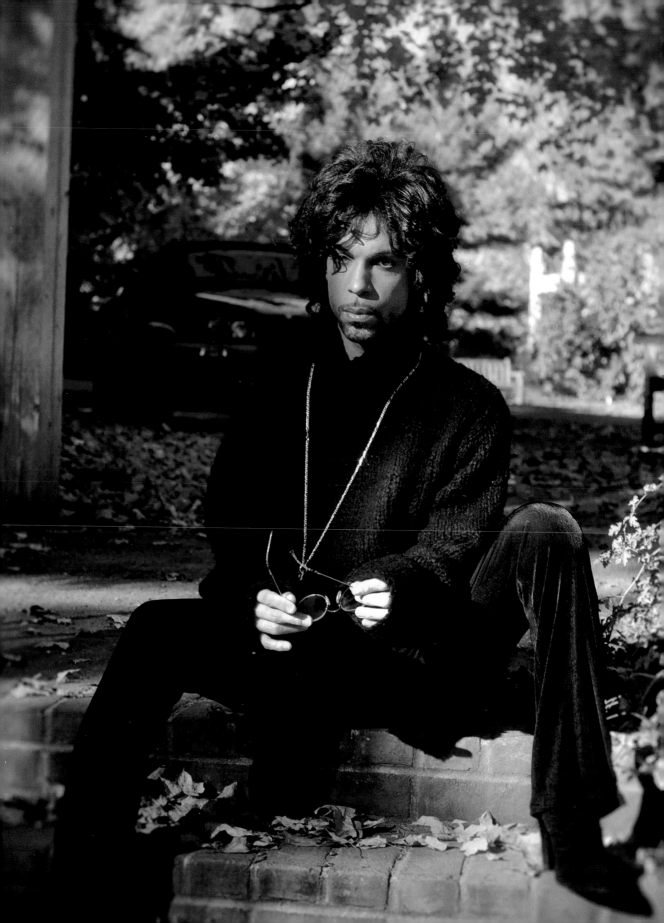

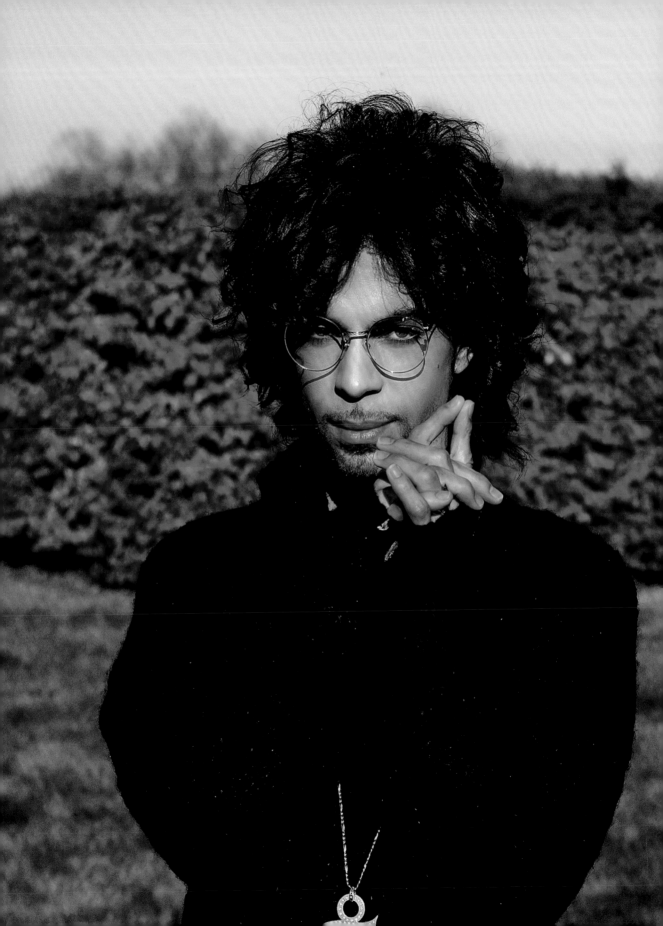

# WHEN YOU'RE DRESSED

Prince and his wife Mayte had a house near Marbella, Spain. I flew in for a one-day shoot at this white villa on the coast. I spent the morning of the second day looking for supplies in a town that went to sleep for a few hours every afternoon—siesta time—right when I finally got out to buy equipment at the local photo stores. Aaron (one of Prince's security guys) and I traveled the city with no luck, then decided that all we could do was be tourists until things opened back up.

Once we returned to the house I had the pleasure of shooting in the lovely grounds, in the pool, inside the house, and even in the salon area. We packed in a lot of different looks, some that appeared on singles for *Rave Un2 the Joy Fantastic* and several that appeared in *Vogue España*. That night we went out to a restaurant that Prince and Mayte frequented (it was obvious from the familiarity of the owners and staff) and ordered dinner. As we were eating Prince asked if I ever had a glass of wine "to give you a different perspective" while shooting? Being a lightweight who only enjoys a drink if there's a place to sleep nearby, I replied, "If you want the different perspective to be your boots from the sidewalk, then sure…I'll have a glass."

Prince smiled a bit. "It's like that?"

"Yes, it is."

He laughed.

After the meal Prince asked, "Why don't we have a picture together?"

My mind raced. Here it was, finally, an opportunity for a picture of me *with* Prince and Mayte. Of course, this was all before smartphone cameras and I thought: Who will be able to shoot in this dark place with no flash (we never shot at night on the fly because of the camera's limitations and harsh lighting of the onboard flash)? I scoured the staff.

"I don't know why," I finally responded.

Then he gave me an up and down look and, commenting on my usual jeans and, in this case, button-up work shirt, said, "Well. Maybe when you're dressed."

I was relieved and bummed at the same time. After, we went into the parking lot and I photographed them in the headlights of a car and then captured a rather bizarre image of Prince in the waiting paparazzi's flashes; as usual, flying by the seat of my pants. We went back inside and I shot in the dark club, figuring I wouldn't be able to capture much (for the photo geeks, the camera only had a top ISO of 200 and my lens was 3.5 at best) but I took my chances. The risk-taking paid off and I captured a very beautiful moment between my host couple, one that was both engaging and abstract.

We were up late enough that there was no time to sleep. I was driven back to the airport and crashed hard on the flight back, probably dreaming of the "selfie" that never happened.

The closest I ever got to a photo with Prince was in the occasional reflection…like my shoulder in the mirror or my tiny reflection in a cane top or pair of sunglasses. One day I'll have to document those, too.

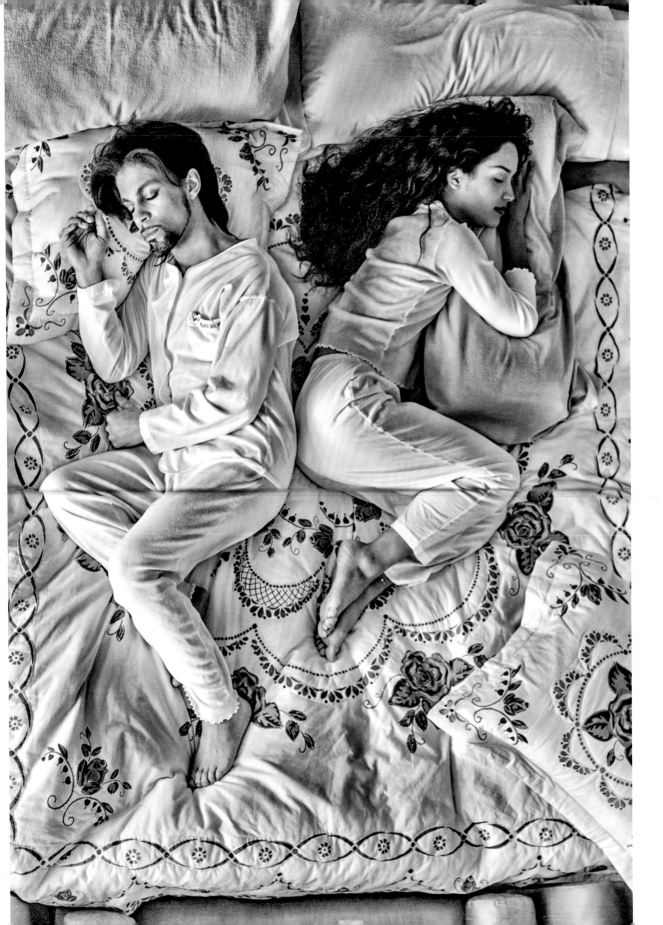

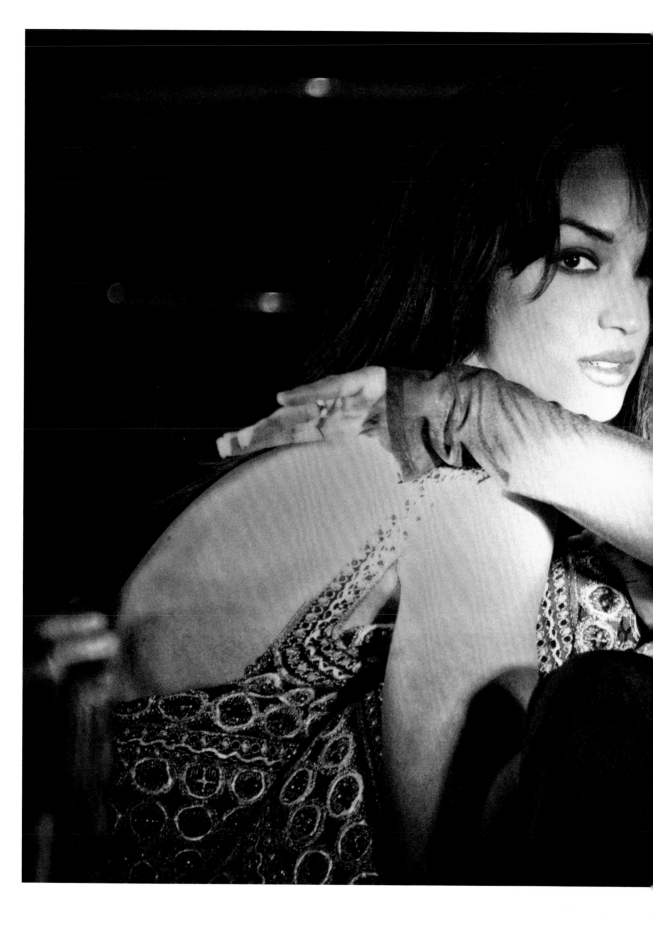

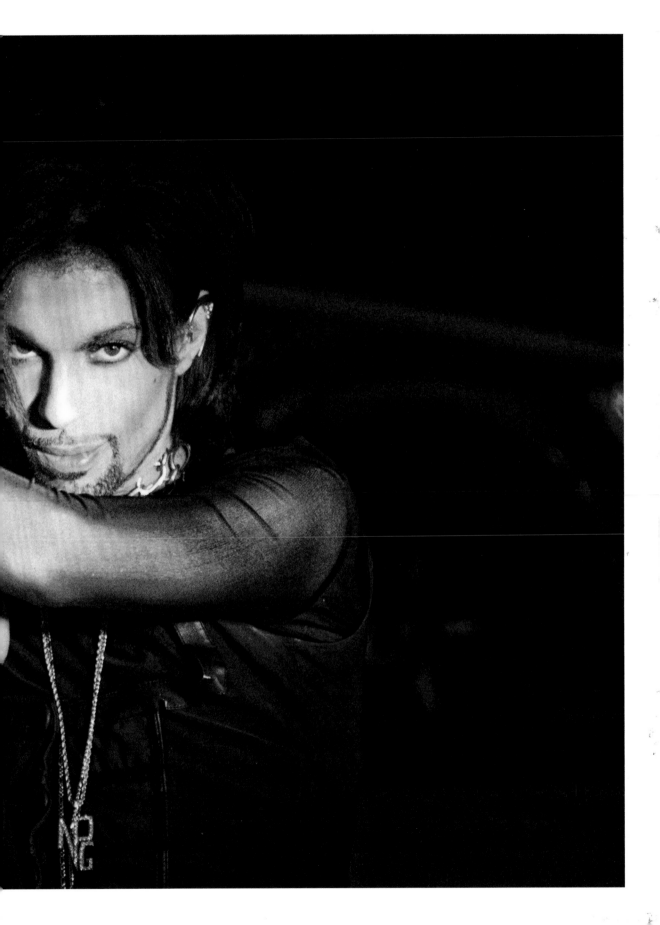

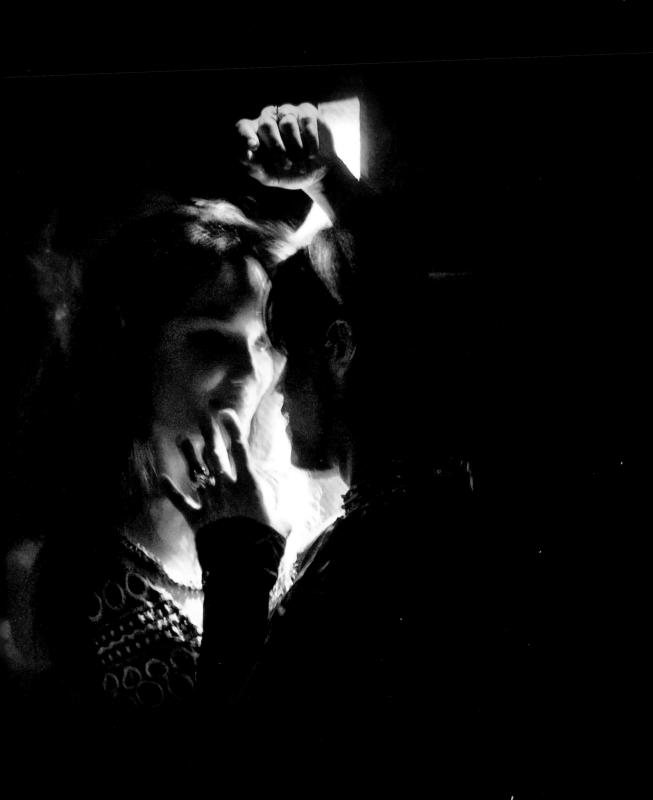

# NOSE OF OLD

In the middle of a shoot on the soundstage with Prince, his guitar, and a really sparkly outfit. Prince asked me why people always thought he'd had a nose job. Apparently, it's something he was asked about with some frequency.

"I have a pretty good idea," I said. "Do you want to know what I think?"

Always good to ask.

"Yes."

"Your early images were mostly of you looking level with the camera lens, which caught the ball of your nose and the shape of your nostrils. Most of your recent images are of you looking out from under your eyes, which emphasizes the straight line and sharper angle of your nose mostly seen from the side."

He took that in. "Can we take some pictures like that then, like the old ones?"

"Sure."

In fact, one of those images ended up being the photo for the Mill City music festival poster for 1999. Dead straight at the camera, Prince's nose looking just like his nose of old. Not sure anyone noticed, but it should have stopped those rumors.

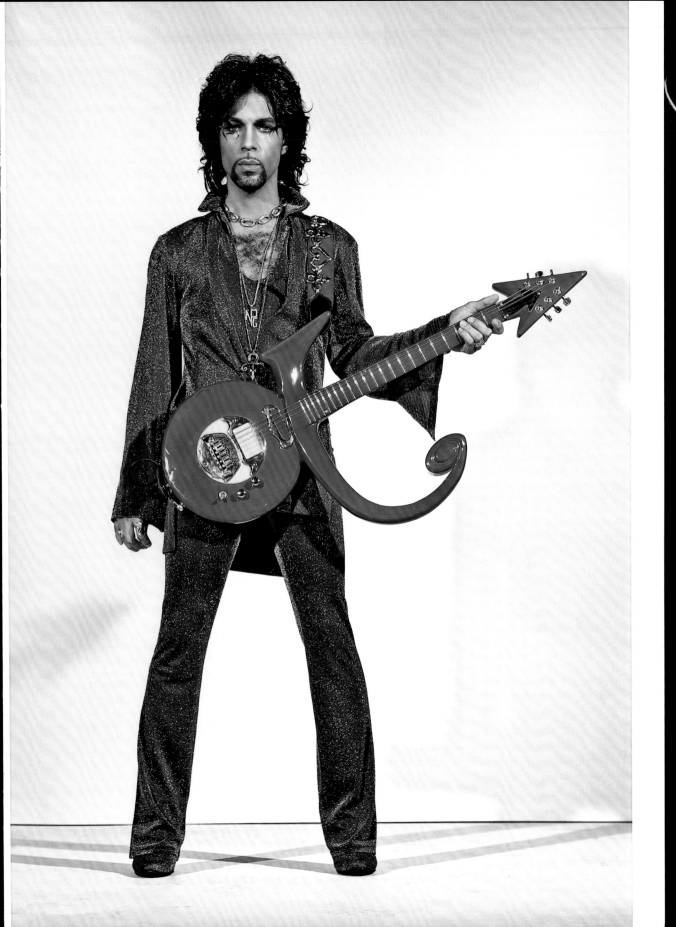

# LEGENDS OF THE FUNK

Minneapolis's Mill City hosts a music festival every year and in 1999 Prince agreed to play, just after his "other band" The Time. This was a pretty big deal, even in his hometown. I shuttled down with the band, and watched as the crowd packed the streets. I was just enjoying this show, not having to work and just standing to the side of the stage next to Prince and Mayte, who were both warming up—Prince throwing some high kicks, while Mayte was doing all sorts of beautiful dancer stretches. I was excited to see the show, which was amazing.

While I stood watching and grooving, Maceo Parker (James Brown's long-time sax player) walked over to wait for his cue. At one point he leaned toward me and said: "Your boss. I've worked with a lot of great performers, but that guy is *the* best."

I nodded in agreement, fully understanding that a living, breathing legend was paying one of the highest compliments possible to another of his kind. (I'd heard Prince bragging on Maceo before, too, talking about how he would come in and lay down the saxophone track three times; each take different and each take perfect.) A few minutes later, Maceo stepped out on stage and the two legends proved exactly why they deserved that moniker, leaving me alone, another fan in the wings.

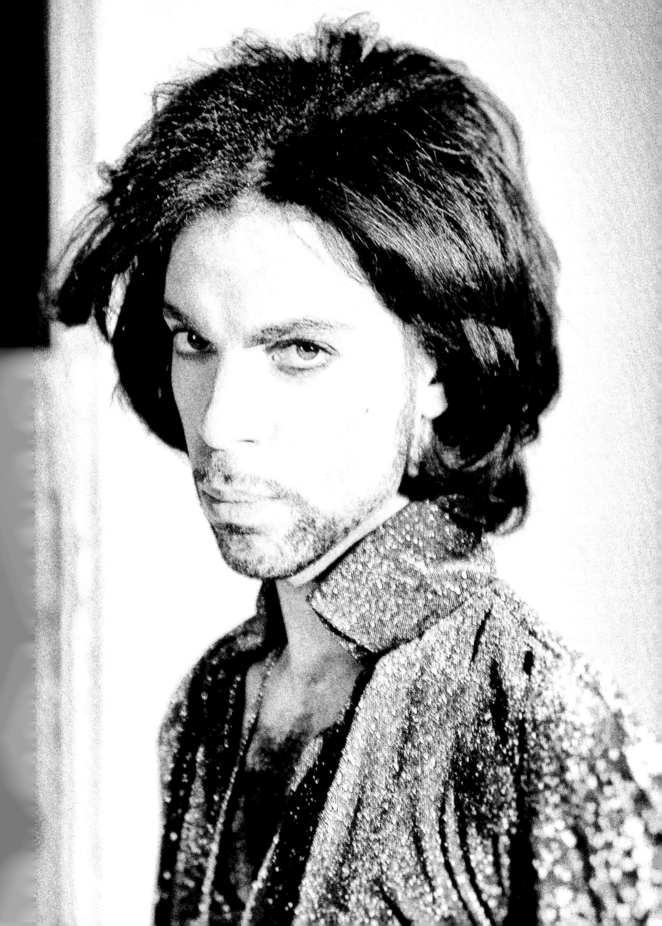

# MAGIC BOWLING BOOTS

Recreational activities with Prince always seemed to take place around 2 a.m. One night he dropped by my office and said, "We're going bowling. Want to come?"

Of course I did.

"OK, I'm going back to the house to change, I'll pick you up out front."

I waited in the lobby and to my surprise a big white limousine pulled up. I wandered out and sure enough it was Prince. Usually he drove himself. I got in and his wife Mayte was there, too. They both looked like they were going to a club, not bowling. But maybe that's because I was just wearing jeans and a T-shirt.

We pulled up in front of the building and sat for a while. "Magic Man" came drifting over the speakers, a fairly obscure hit by Robert Winters & Fall. I started to mutter "oh, cool" and Prince turned his head. We caught each other's look and did a little head nod to acknowledge we both dug the song. Having spent a lot of time listening and sharing music with each other, it was one of those "you know if you know" moments.

Another car pulled up and we got out. It was Larry and Tina Graham, and Larry was decked out in white (as was usual for the co-founder of Sly and the Family Stone). They both gave me a big hug and we walked in. Larry and I got bowling shoes at the counter, and I can't recall if Mayte and Tina had their own, but Prince sure did—in the form of white, knee-high, fake-yak-fur ski boots. Yes, they let him bowl in those things. It was super fun because really we weren't playing a game. Prince, no surprise, was knocking out strikes every time…in his big furry boots. We clapped and hooted for each strike, while he did little hand waves like…ah, it's nothing. Which appeared to be true as far as he was concerned.

I got a couple of strikes for which I was loudly applauded and cheered. But by the end of the night I knew that the real magic was in those boots.

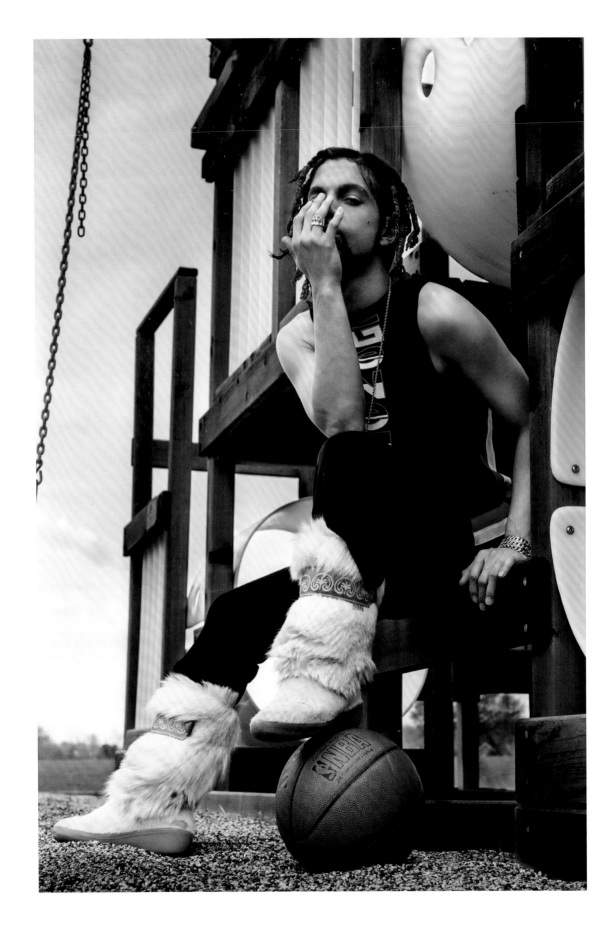

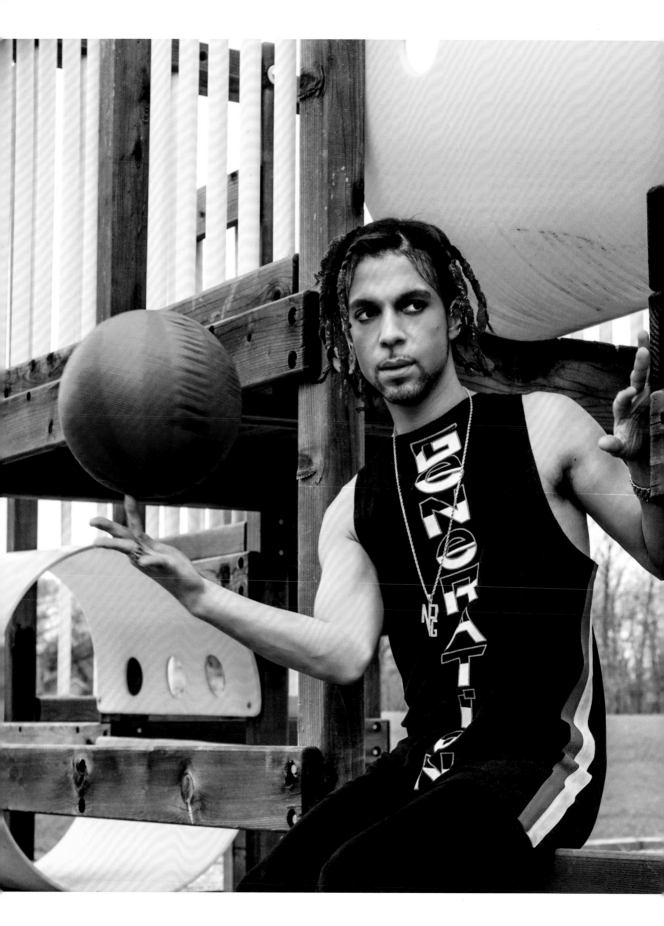

# SOMBER MOOD

In the mid-1990s, Prince had a playground built out in front of Paisley Park. I'm sure you know why, and how devastating it was after.

   As time went by, we occasionally did photo shoots in and around the wooden structures, the swings and the slide. One day while we were shooting, Prince was twirling a basketball and talking to me about it a bit. We were actually sort of playing like kids might: he'd climb the structures, pressing his hands against and looking through the bird-poop-covered plastic bubble ("Keep that in there," he said later as he pointed to it on the screen, "it's edgy.").

   At one point he nodded to the playground and told me how he'd built it thinking about his employees' and friends' children all coming there and playing together. It was sort of a sad moment, the two of us standing there alone.

   I could tell that he went somewhere else and then he pulled himself out by changing the subject. But, understandably, his mood was more somber as we finished the shoot.

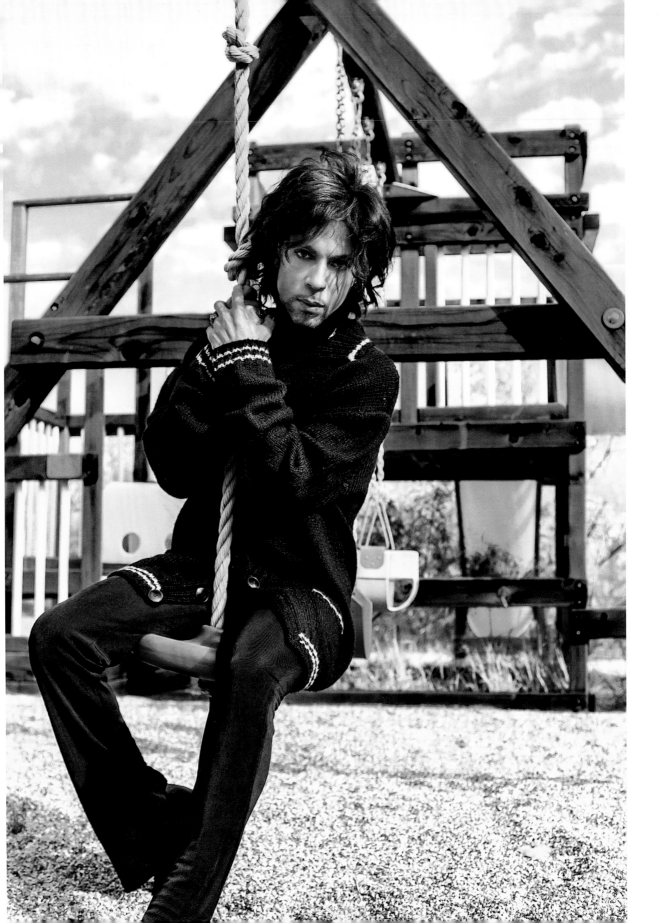

# "STEVE, THIS IS..."

I often say you never knew what would happen out at Paisley Park, and it never failed to be true.

The phone rang. "Steve, come down to Studio A."

I walked through the door to see Prince standing next to a tallish lady in cut-off jeans with her back to me. She was browsing through a small set of CDs that were sitting on a shelf.

"Steve," Prince said, as the woman turned, "this is Mariah. Mariah, this is Steve. He did all the art you see in the building." Sure enough, it was Mariah. Mariah Carey. She was super relaxed with a big, gleaming smile. She offered her hand and said, "Hi."

Taken aback a bit, I fumbled out a "Hi, nice to meet you." Prince asked me some questions he already knew the answers to, made some small talk with the two of us, and then said he'd see me later. It was clear he just wanted to give me that moment.

I had several of those moments.

In my office:

"Steve, this is Chilli. From [girl group] TLC." Uh, hi.

"Steve this is André [Cymone], we grew up together." I saw you at Wax Museum in Washington DC.

In the recording studio:

"Steve this is Rosario [Dawson]." I saw you in [the film] *He Got Game*.

"Steve, Chaka. Chaka, Steve." She told me mine was the fastest photo shoot she'd ever had; her hair took longer.

"Steve, this is Larry Graham." Yes I know, I ruined my speakers playing Graham Central Station's "Earthquake" track too loudly.

"Steve this is Doug E. Fresh." I *love* "The Show"! It was a staple of DC radio when I was growing up.

And elsewhere:

"Do you know when Prince is going to show up?" Asked guitar legend Steve Vai while I was getting coffee in the kitchen. He left the chocolate-covered potato chips for me. Thanks, Steve.

"How's it going?" asked M. C. Hammer, walking with his massive entourage in the hallway. Good, very good.

"Have you seen Prince?" Ann-Margret asked while filming *Grumpy Old Men* on the soundstage. "That dear boy." Uh…I love you.

"We're working on an album," said Lenny Kravitz as we got lost with his band mates coming back from downtown. No GPS.

"So, tell me about yourself," said Donny Osmond as we sat in the hall to Studio B. I did.

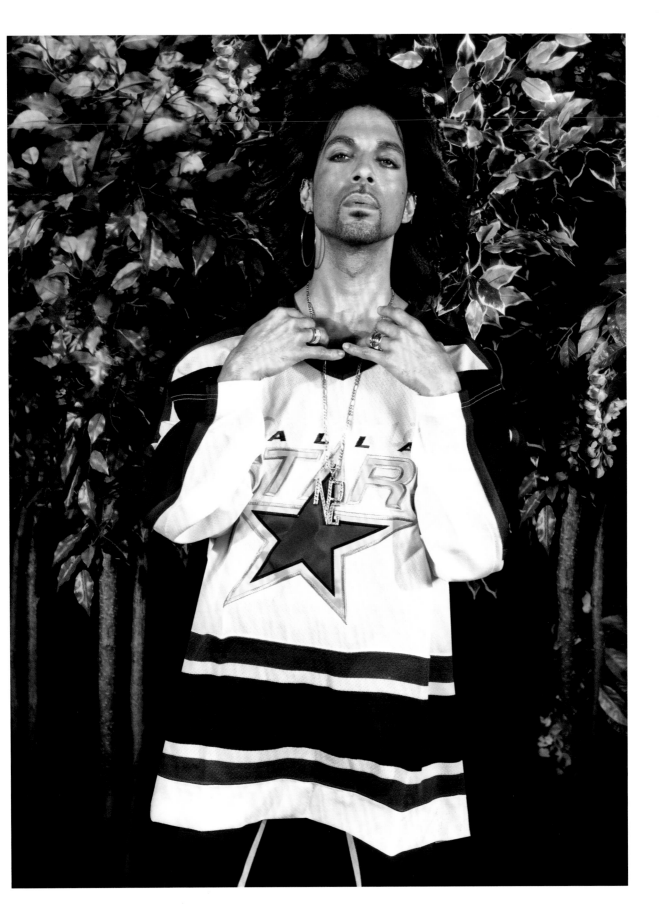

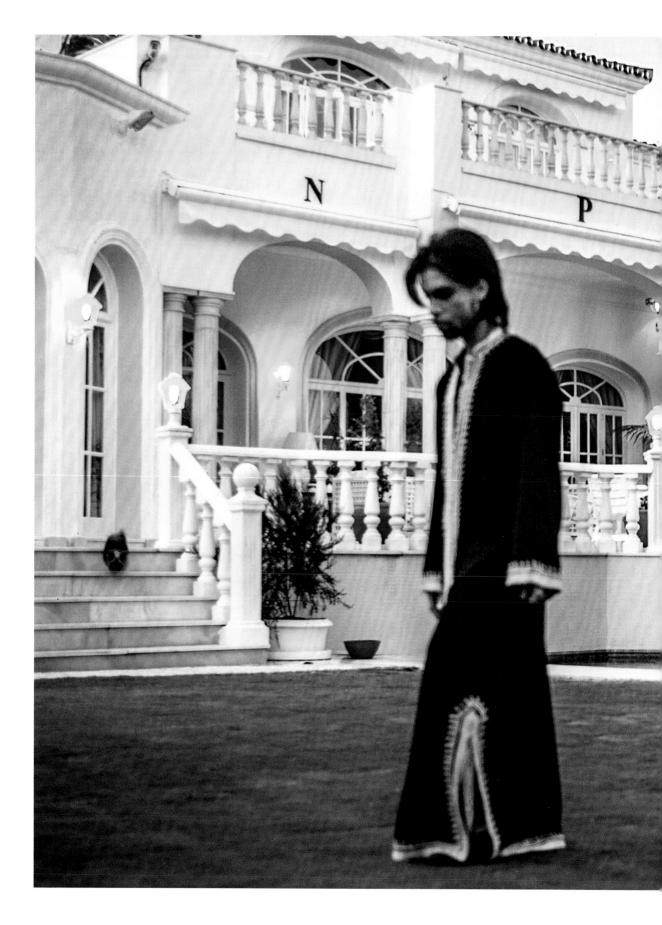

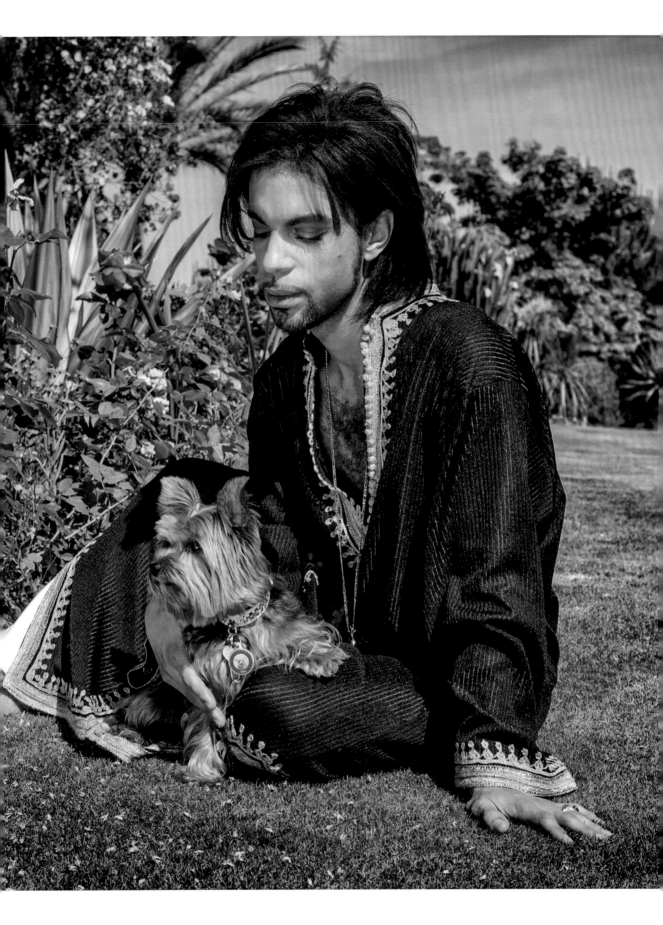

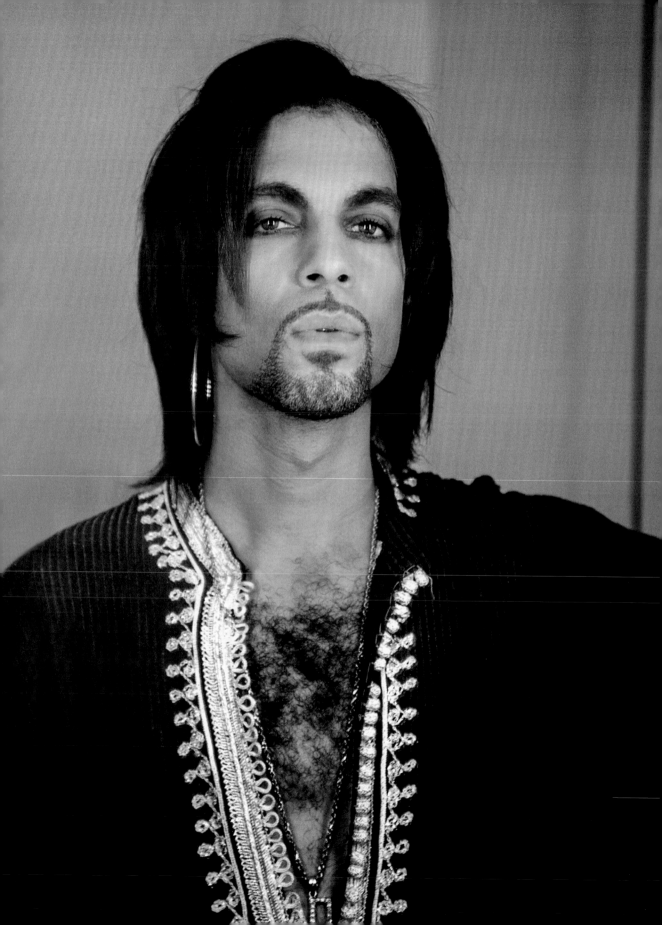

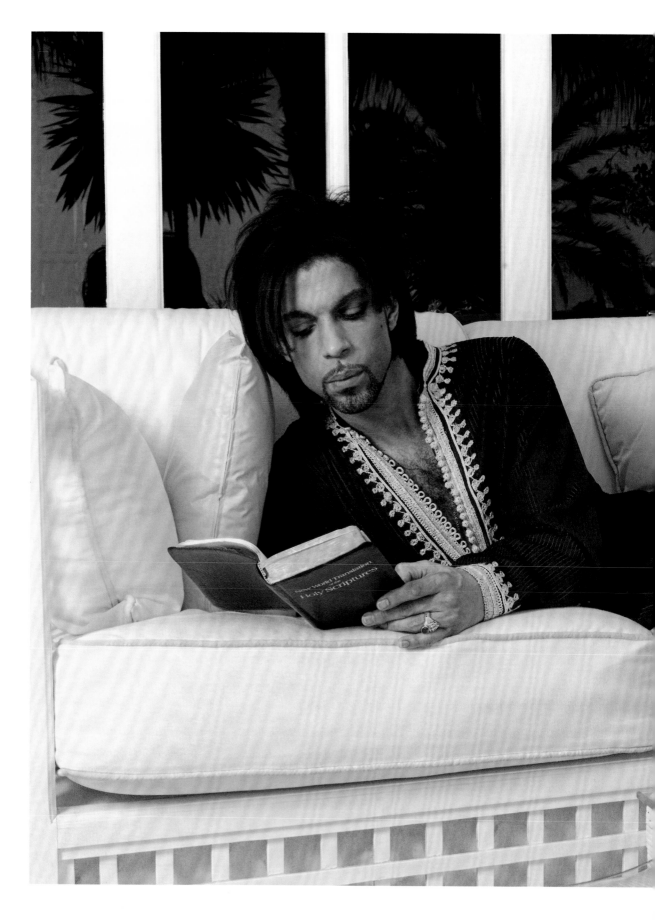

# THREE PRINCES

My partner in graphics crime at Paisley Park, Michael Van Huffel, called to tell me he'd heard an interview with film director and comedian Kevin Smith on NPR (National Public Radio), and, it turns out, Kevin was a huge Prince fan. Prince was doing a 1999 celebration and Michael said I should try to get him hooked up. I knew that *Dogma* was one of Prince's favorite movies, so I called his manager Jacqui and asked if I could offer up passes and I got a definitive "Yes."

I tracked down Kevin's company and called. A very nice lady named Grace (who turned out to be Kevin's mom) picked up the phone. I asked about the tickets and was told I'd get a call back. The phone rang soon after with another definitive yes. So, I hooked up Prince's management and Kevin's View Askew production company and all went off without a hitch. Then, more calls came. "Can you get Morris Day's number?" I got it. Next up, "How about a number for The Time?" Sure; they featured in Kevin's 2001 movie *Jay and Silent Bob Strike Back*. Grace and I continued to chat from time to time, and I started getting cool holiday cards from View Askew.

One day Grace called and told me that Kevin was spending the week out at Paisley Park working on a project that he was not quite sure how to deal with. I tried to tell her that things did not always work the same way out there as they did in many other parts of the universe, and that Kevin should listen to his instincts and only agree to what he was comfortable with.

It was a pleasant exchange, but I felt bad because I knew that situation and had simply learned to deal with each thing as it came. One day Prince was your best friend and a guy you could speak your mind to, another day he was your boss and all that comes with that, and yet another day he was simply the public persona of Prince with the trappings that came with the current incarnation, good or bad. Some days it was all three. Learning to roll with it was as important as your skill set.

Years later, during one of Kevin's talks—An Evening with Kevin Smith—at Kent State University in Ohio, I heard his not-so-positive take on the situation and I laughed. That said, I also felt sorry that he didn't get to experience much of the "best friend" side of Prince that I'd seen over the years.

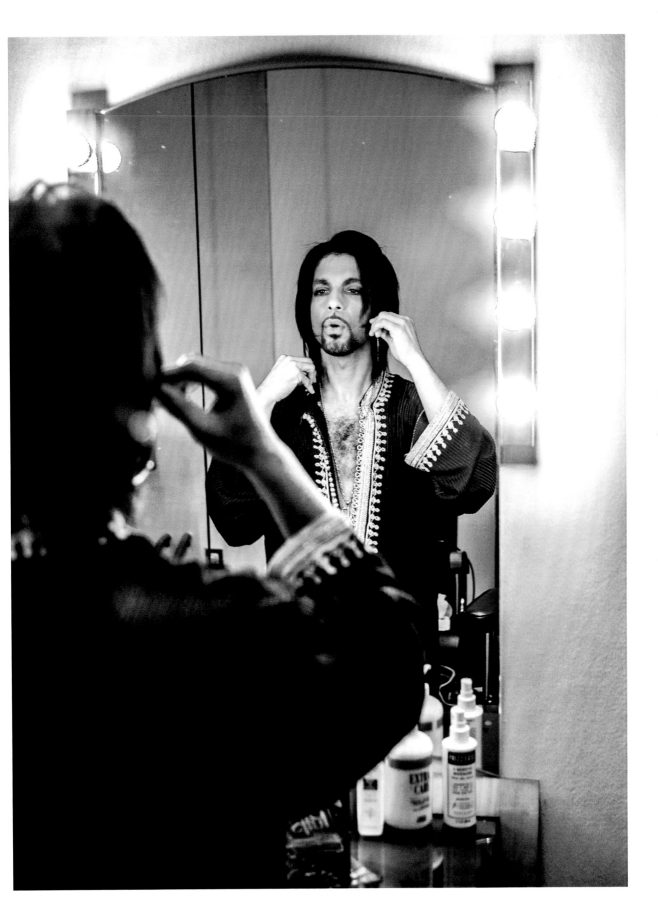

## HIGHER EXPECTATIONS

Larry Graham and Prince were sitting on the couch in the kitchen area watching *The Late Show with David Letterman*. I'd come down to make some tea, and Prince said to come join them. We chatted while the show hummed along. Larry advised me to take pictures of my soon-to-be-born child *every* day as he had with his daughter, because it "goes by so quickly." He also told me about his photos from Woodstock that no one had ever seen (now, let's talk about that, Larry!).

That night, the musical guest was about to come on and Prince always liked to see those. We'd recently watched Beck singing his clearly Prince-inspired "Debra" on a New Year's show, where Beck lay face down on the stage and pulled on his boot just like Prince had done in *Purple Rain*.

"I don't get it," Prince had said, to my surprise.

The current musical guest (after a commercial break) was a relatively new band called Destiny's Child. Larry and Prince chatted through the break. The show returned, the performance started, and Prince leaned forward and turned up the volume. We were all quiet until the performance ended.

"Not bad," Prince said, "but they need a little more work to live up to that name."

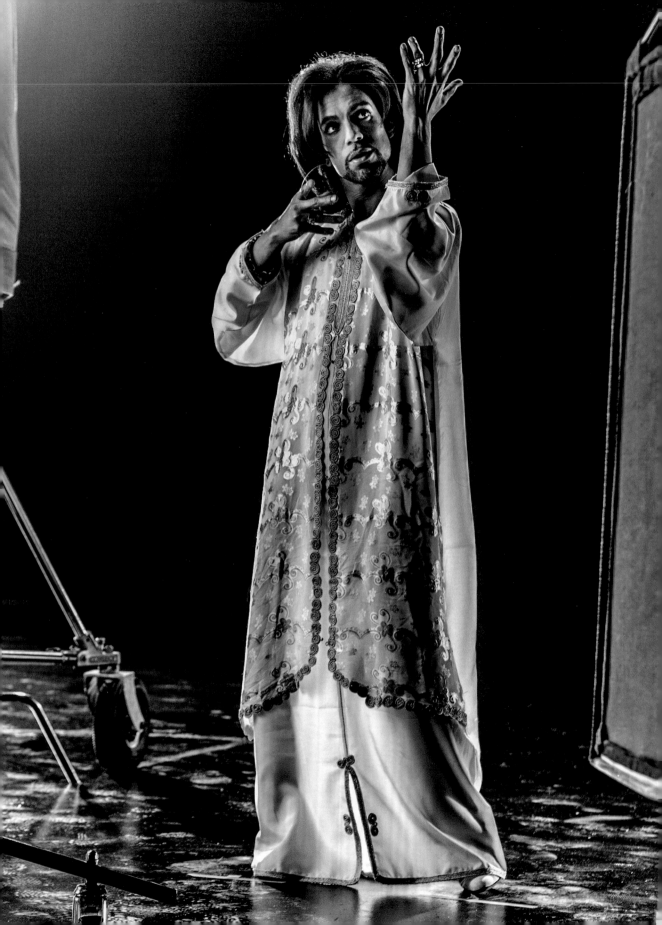

# STAR CHILD AND SPIRITUALITY

I noticed Prince had a big, thick book he was diligently reading while I toiled over some art or another. I didn't ask anything about it, but he started to read from it. The general gist was something about star children, a concept I mostly attributed to my days of listening to P-Funk records, including *Mothership Connection (Star Child)*.

As I listened, I understood this version of star children to be different from the P-Funk mythology. I turned slightly as Prince was reading and he paused, looking over the top of the book at me, and then went back to reading. It was all interesting stuff. This developed into a long night, talking religion and spirituality.

"What do you believe?" he asked, at one point.

It was early in the morning by this time, so I asked if he really wanted me to tell him. He did.

So, with a bit of nervousness and a sense of "unloading", I told myself "Here I go" and just let it flow. I told him that I was not into a specific religion as such, but into being a spiritual person. That each of us has energy in the universe and is responsible for how we direct it. He listened respectfully and genuinely seemed to absorb what I was saying. I suspected it was not his way of seeing things but he never tried to argue or interrupt. He asked a few questions along the way and after several intense hours we were done.

I rarely had this kind of conversation. Period. Much less with Prince. It was nerve wracking but somehow I was totally comfortable sharing my beliefs with a guy who had intermittently shared his beliefs with me: coming in various wrappers over the years; they were a mishmash of ideas and thoughts that ultimately impressed me as coming back around to loving each other as humans.

This belief seemed to be at his core, no matter what path he was on.

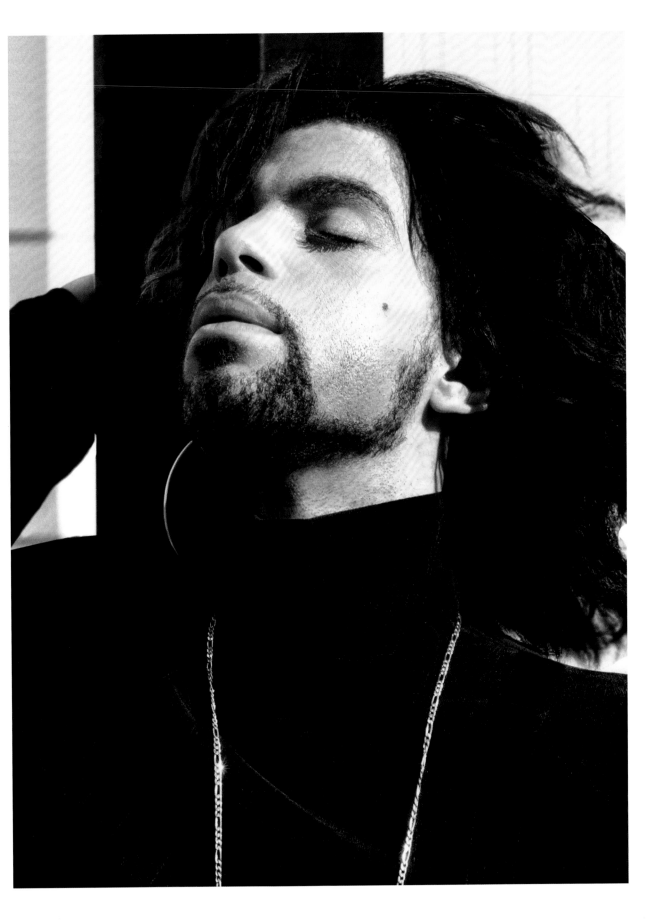

# A TALE OF TWO CITIES

Living in Baltimore in the early '90s was a very different experience from living in the Midwest. I noticed this first when I was shown around Minneapolis and people talked about "bad parts of town" that looked perfectly respectable to me. Baltimore was full of areas literally falling down from neglect, but still people lived there. This was a time when Midwestern cultures had not become so homogenized. MTV had just taken hold and the Internet didn't exist. MTV, based out of New York and exposing a lot of East and West Coast rappers, was beginning a cultural invasion into the middle of the country.

I would often tell people about my experiences living in an impoverished neighborhood in Baltimore. This city (and I still live there) has seemed to always have its own traditions and style. Prince would pump me for details about what it was like. So, one day, I told him about the adult men who rode little-kid bikes around the city, how they rolled one pant leg up to avoid the chain catching their pants. And how the one-pant-leg-rolled-up look became a general fashion trend. Prince found this hilarious and I recall him passing this story along to several band members.

I told him, too, about the older black women who wanted to touch my long red hair (I let them), and how if someone yelled from across the street that I had a weave I'd run my hands through my hair to prove them wrong. He laughed at that as well.

His reactions were interesting to me. I knew Prince had grown up in an iffy part of Minneapolis, even though I really never asked him about details, but I was bringing him a slice of culture from a totally different part of the nation and it seemed to fascinate him. I realized, soon after, that the studio, located near a whole lot of cornfields, was where he spent his time, unless he was off on the road and in hotel rooms. All in all, his world was a fairly limited one.

So, it made sense that he would absorb stories from those around him, those of us who didn't live the life of a top-selling musician raised in the Midwest.

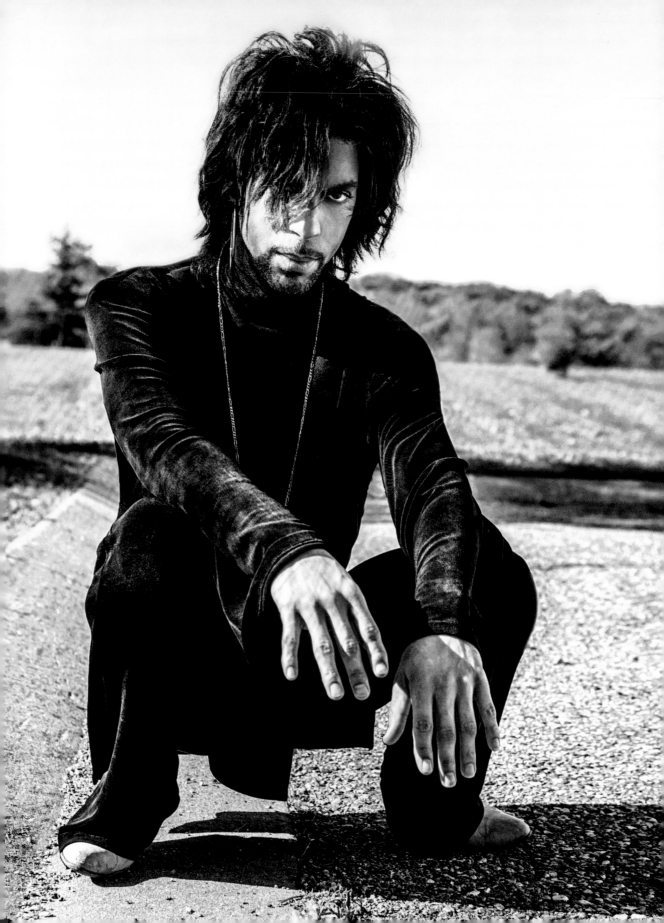

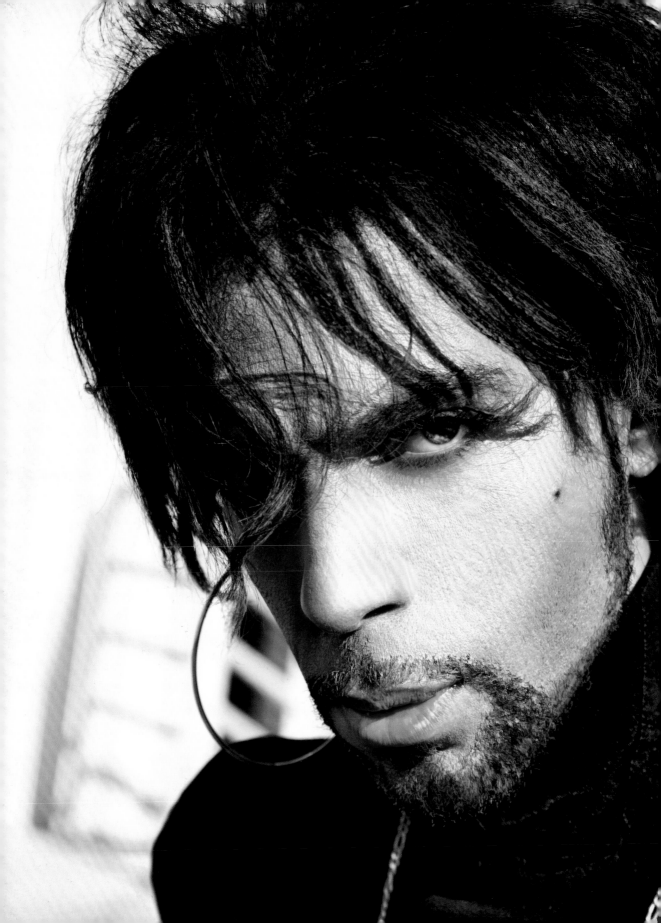

# MUSIC NERDS TOGETHER

Prince and I were music nerds. No two ways about it, though he was a music nerd who could also *play* everything. I just listened and knew a fair amount about it. He would come up to my office and ask what new music I'd brought in a given week, and we'd sit and listen to new albums, then kick back into old school and jazz. He confessed he didn't get avant-garde saxophonist Ornette Coleman at one point, so I brought in an earlier example of his playing from the album *Tomorrow is the Question*, to which he said, "Ahhhh. I see." We sat and made our way through some jazz fusion via Weather Report's and Return to Forever's back catalogs, just months before he recorded *N•E•W•S*.

One night he called me in Baltimore and we talked music on the phone, and during that conversation I realized that if he'd never made it big he would have held down whatever day job he had to just to play at night. I always observed that he was happiest when he was playing, especially the jams out at Paisley Park.

He'd bring me tapes of what he had been working on and wait for my reaction. The good part is I never had to lie because he had always played awesome music (some of which I never heard released). Often he'd call me to the studio to listen as he recorded. I never took it for granted; Prince laying down a chunky rhythm guitar track while carrying on a conversation with me, or him playing back a track while we bobbed our heads, him twirling knobs and giving me the "funk face." I always assumed this was par for the course, but learned from several sources later that even his band was not in the studio as much as I had been.

My teenage Prince fan self wouldn't have believed it if I'd been able to go back and reveal the future. Good thing I couldn't.

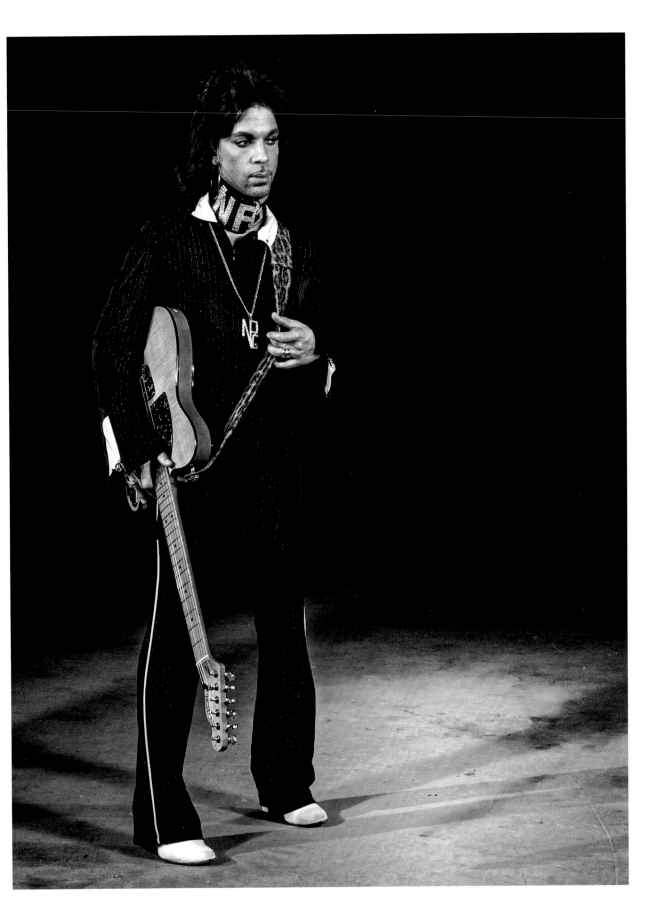

# THE SINCEREST FORM OF FLATTERY

Sometimes we'd be listening to something and I'd hear a sample of one of Prince's songs in whatever was playing. Usually Prince couldn't hear it, which was surprising. One song sampled "D. M. S. R." and he cocked his head sideways and listened hard after I pointed it out. He hit the back button and listened again. Then he immediately picked up the red lawyer phone (ok it was tan, and it was just a regular phone, but you get the idea).

Another was a sample of "Nasty Girl," which he caught as soon as I said something. Lawyer phone in action, again.

One of my favorite mash-ups of sounds was a 2000 release by Brit record producer Luke Vibert and B. J. Cole—a steel pedal guitar and electronica album called *Stop the Panic*. I thought it was super cool, even the fact that they used the same sample Prince had used, right before the song "Head" launches on the *Dirty Mind* album. To my dismay (and eventually Prince would change his mind), Prince said, "That's not a sample, I created that sound!" as he picked up the red phone once more…

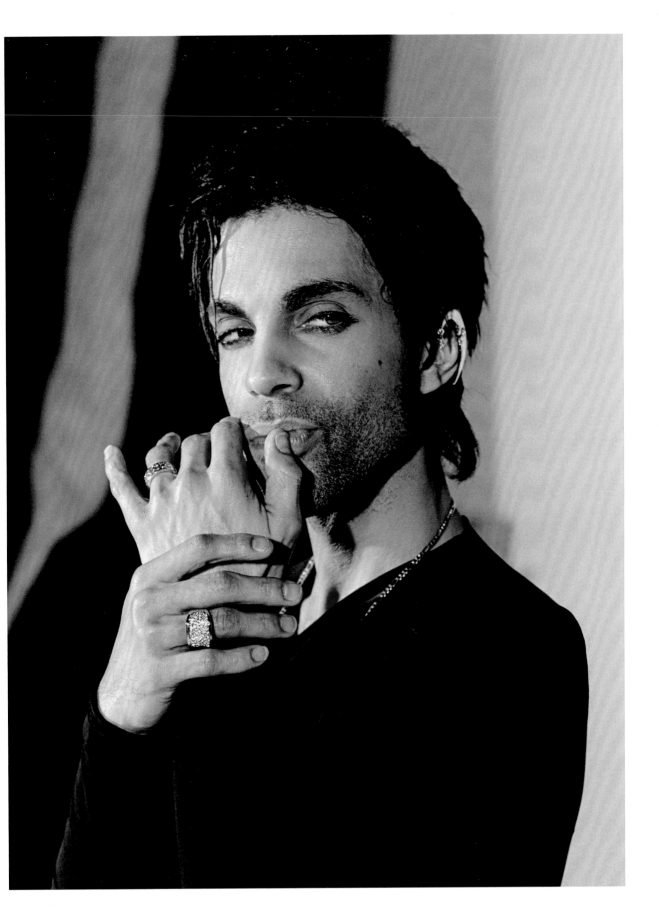

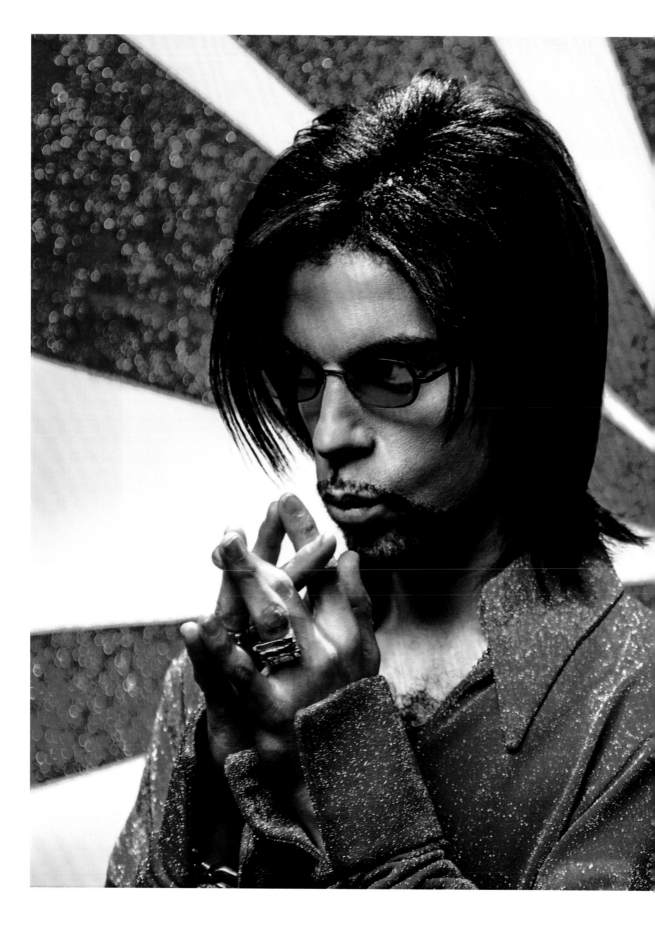

## SICK DAY

I was pretty healthy during my run at Paisley Park, despite the long working hours. I almost took a sick day once, after flying in from Baltimore with the flu. Prince was only in for that one day since he was on the road, so I thought I needed to be there—flu or no flu. He didn't insist but definitely let me know that he'd flown back home just for me. I had a quick acupuncture treatment to stay on this side of passing out and went to work.

Once he saw me I think he regretted being insistent—and kept his distance.

Another time I hurt my neck and couldn't really move it, but that didn't inhibit my work. At one point Prince called me down to the studio. A few other people were in there. They'd just completed a super funky track, the kind your head naturally bobs to. Mine started but it hurt.

Prince noticed and cracked up. "Steve can't move his neck, but it's trying to move on its own!" And it was.

Fortunately, my neck was in perfect funktional shape on my next trip out.

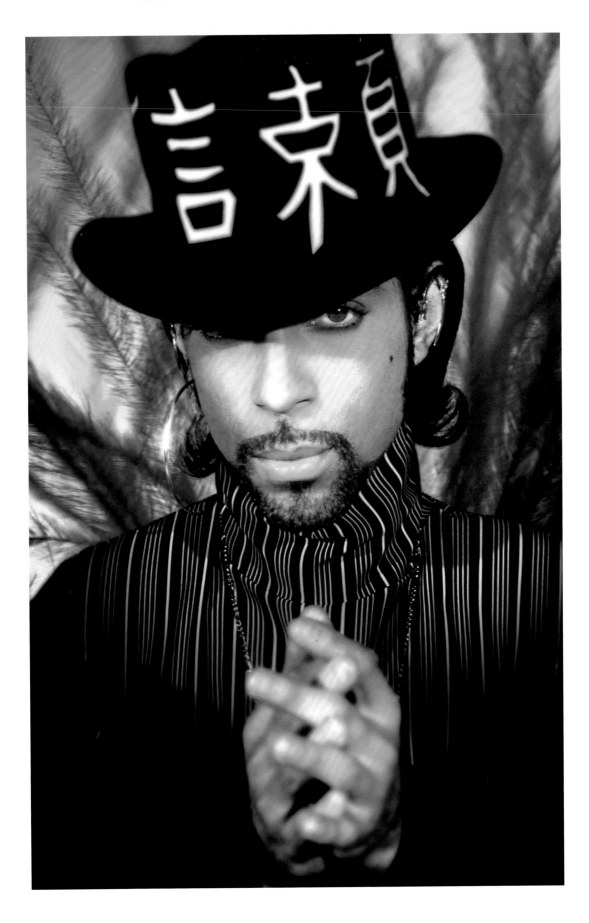

# WHEN I'M OLD

*The Truth* album is one of my favorites by Prince, a real sidestep towards acoustic that ditches a lot of his standard, go-to sounds. While we were shooting the photos for the album (Prince dressed in a pin-stripe suit and working it à la Robert Johnson) I was treated to 15 minutes of awesome acoustic blues as he stood and played, then sat on a stool and played—all with finesse and the right amount of grit.

I had to say something. I couldn't imagine why this music was not being recorded. "When are you going to put out an album that sounds like that?" I asked.

"I'm saving it for when I'm old," he said.

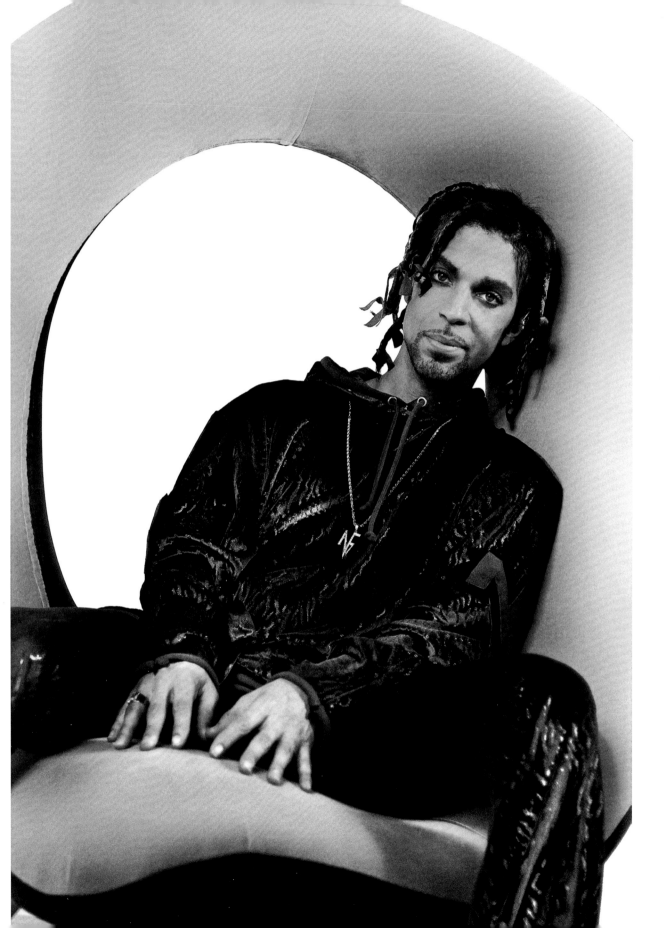

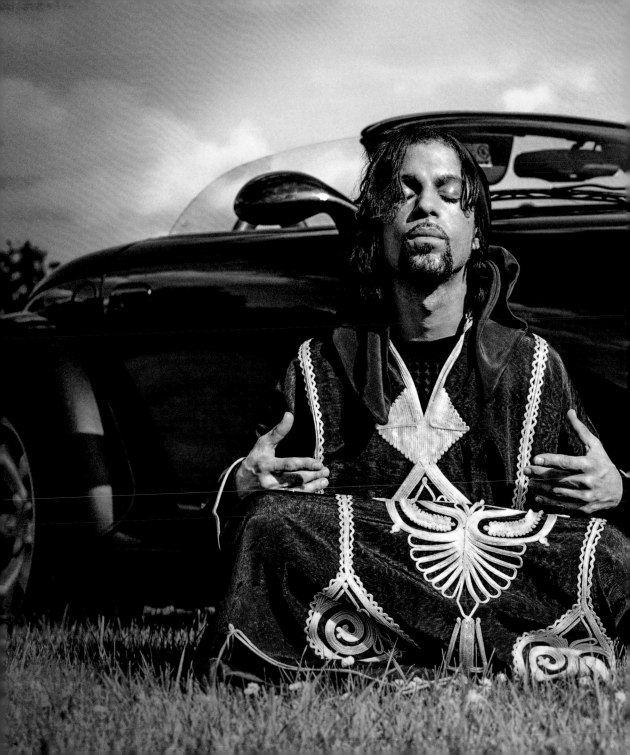

# WHAT'S THAT SOUND?

A long-time fan of the Béla Fleck & the Flecktones and a recent devotee of the albums of bass player extraordinaire and producer Victor Wooten, I brought my stockpile of Vic's solo records (*A Show of Hands*, *What Did He Say?*, and *Yin-Yang*) and had them on heavy rotation one week in the studio. Prince walked in and stopped. And listened. I could see the gears turning in his head. "Does all of his playing sound like that?"

"No, he has different styles."

"But it's funky, right?"

"I think so."

We sat and listened. He occasionally popped up and forwarded the track to hear more. After several CDs Prince asked, "Is he in a band?"

I said yes.

"Do you have any of that with you?"

"No, but I can bring some next time."

"Do that."

Next time, I reminded Prince that I had the CDs. He told me he'd be up. I settled the disk in the tray and pushed play.

For those of you unfamiliar, Béla Fleck is a banjo player, playing in a way you wouldn't hear much of anywhere else, but still…a banjo player. So, the track starts, with… a banjo. A few seconds of that, and Prince jumped up to change the track. The next track started, adding Victor on bass, Futureman (a.k.a. Roy Wooten) on drums and Jeff Coffin on saxophone. Each in their own time signature, on the same song.

Prince looked at me. "Do they *want* to play like that?"

Then, he asked if I had Victor's albums with me.

I did.

Which meant we were yinning and yanging for the rest of the day.

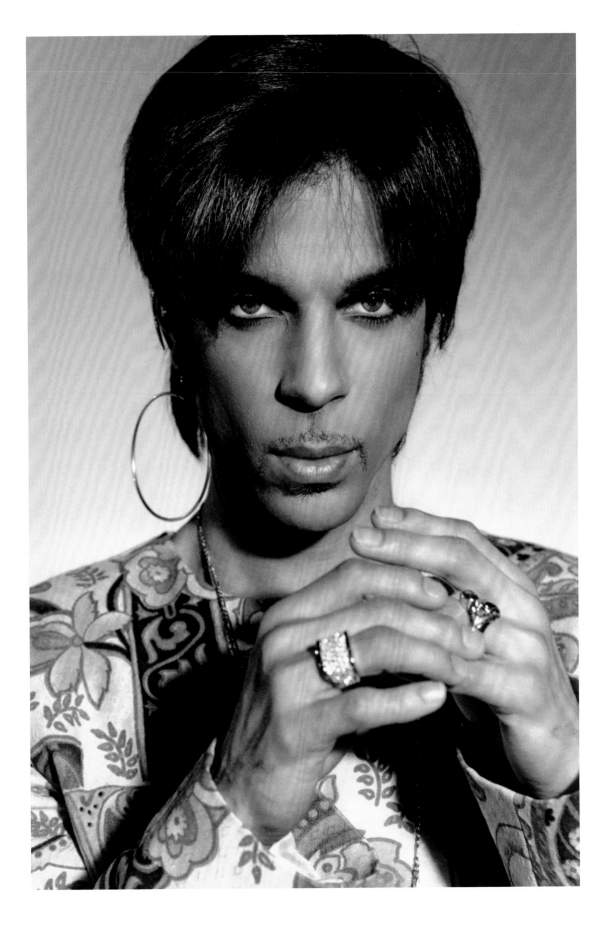

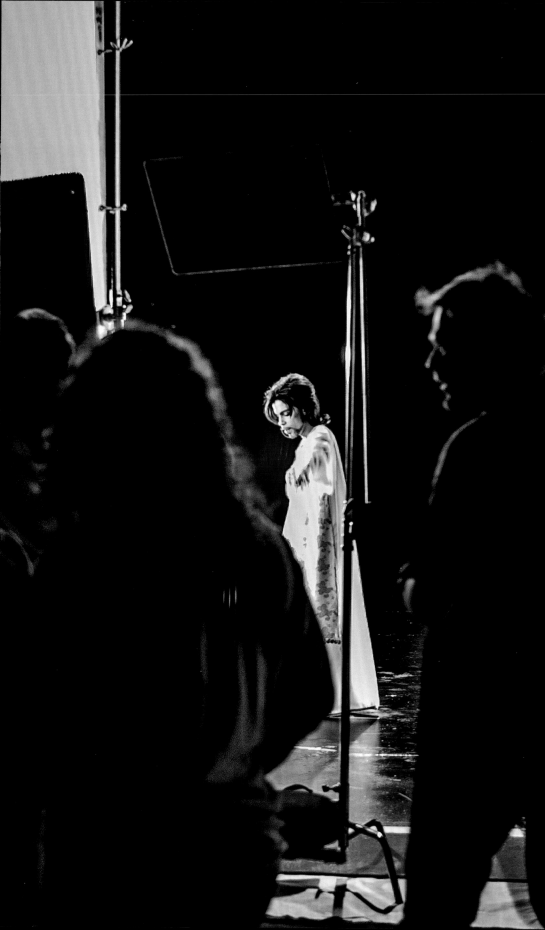

## SEEING MUSIC

When I was a kid, one of my favorite things was listening to music and drawing my musical heroes. I made mixtapes and copied album and artist logos in miniature before I gave them away. I pored over album art and learned the names of the artists.

So, working for Prince was like doing what I did anyway, but I was able to expand my creativity and make a living all at once. I think that's part of why I was fairly attuned to what was going on at the studios. I was in the rare position of being let in on a world only musicians ever know, without the pressure of working for a guy who could do your parts at least as well as you. (A thankless position the band members were in. Thank goodness Prince didn't like to draw or use Photoshop!)

My love of the music pushed me to be better and grind myself into the job, sometimes to my extreme sleep detriment.

One day I took some photos of the "The Holy River" video shoot that were going to be used in a tour book, and one of the shots sort of stood out. Prince's arms were out, his palms were up, and he was looking down. I really liked the colors in the background and thought it would make a nice painting. Of course I didn't have the supplies or time to paint so I futzed around with some paint-like filters in Photoshop, which I tended to not use because I thought they were pretty cheesy.

I worked hard to make them better; the end result was not bad. Toward the end of the "day" Prince walked in and saw what I'd done. He asked me to make a printout from my noisy desktop printer.

The next morning he showed up in my office, print in one hand and cassette in the other. "You see this picture?" he asked as he walked over and inserted the tape. "That's why I wrote this song." He pushed play.

An acoustic guitar started up and he sang a pared-back song with redemptive lyrics:

When the light of God is the only thing in life that will redeem / Welcome, welcome 2 the dawn…

The unbelievable happened on a regular basis working for this man, but I have to admit this one pretty well left me speechless.

Which, if you know me, is quite a feat.

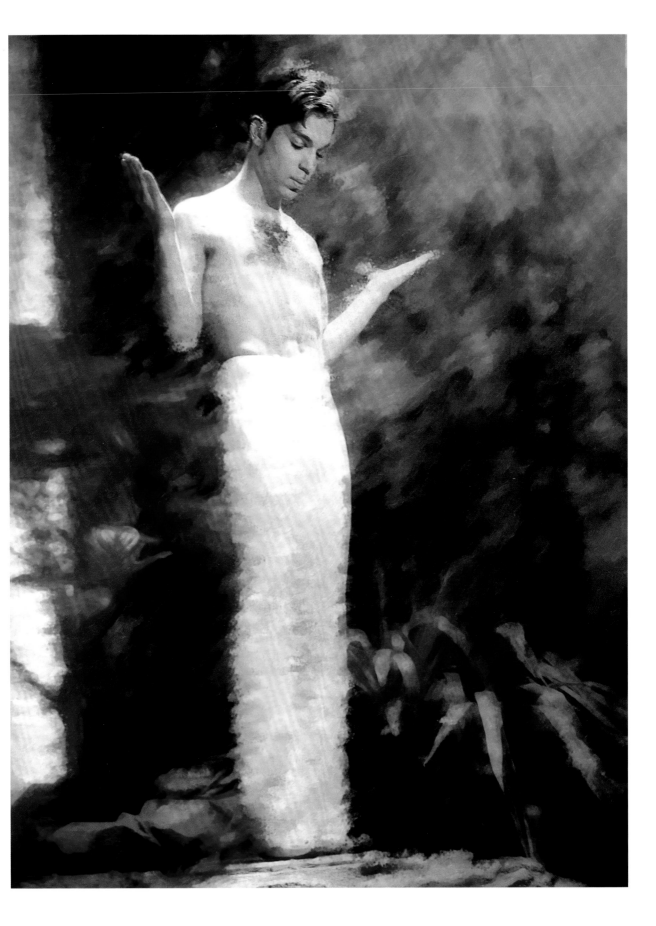

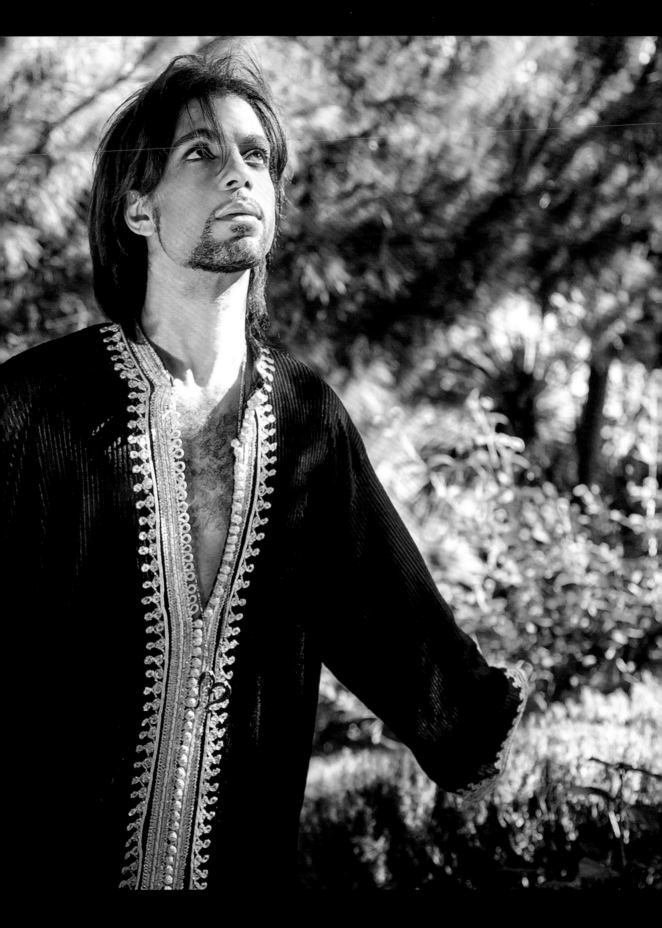

# NOTHING FOR GRANTED

I was working away in my studio in Baltimore when the phone rang. I picked up and said "Hello?"

"Steve, can you turn on MTV?" There was no pause. "Your work is on right now, it's all over New York in Times Square."

"Oh! Okay. Hang on," I said, as if I had a TV or cable in my studio.

Prince went on. "It looks really good. I'm proud of you."

"Thank you," I said.

"That's all. I have to go."

I knew Prince was in New York promoting *Rave Un2 the Joy Fantastic* and had non-stop events all day—interviews, meetings, an appearance on MTV's TRL with Carson Daly. The fact that he took a moment out to call me like that…Well, I never took this sort of thing for granted, not for one moment.

It took me a few minutes to collect myself and get back to work.

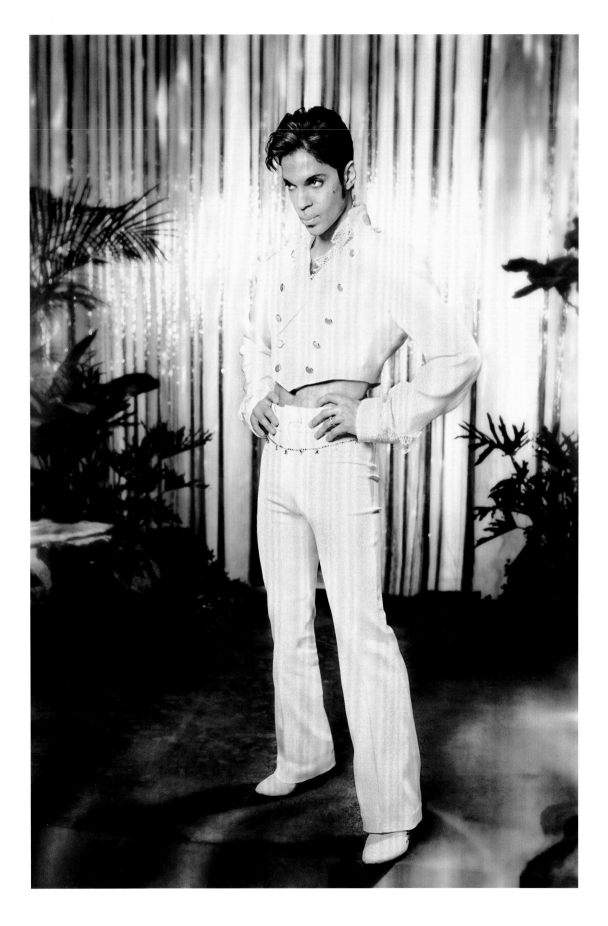

# WHILE PRINCE IS AWAY...

One day Zeke Clark (Prince's guitar tech) asked if I could paint Prince's eye (he had to mumble the name, since Prince was now a symbol) on his bass guitar.

"Of course," I replied.

I was told they'd been trying to do it for months. They had a reference photo I saw briefly (as it turns out the photo was not of Prince's eye…whoops!), but he would never give up the bass and it had had to be re-primed several times already (oils from the skin interfere with any further paint sticking).

I took the bass to the front lobby, as far away from the soundstage as possible. First, I had to draw out the eye lightly in pencil. Once I was satisfied with the sketch, I quickly lay down lots of newspaper and did a basic Krylon clear seal to fix the pencil, fired up my airbrush, and started painting. I was partway through when Zeke came back and said "Dude wants his bass." My jaw must have dropped. "Buuuut I'm not done."

"I know but he wants it."

So, I quickly used a hairdryer to set the paint as best I could and off it went, no sealer, no nothing. I left my set-up in the lobby (very professional, I know) and waited for my next opportunity.

It came quickly. Apparently they were taking a break. I looked at all the missing paint. *Sigh* I used rubbing alcohol to clean those areas in case any oil from his fingers remained on the bass and went to town. This time I finished! The plan was to get the bass off to a guitar maker to have it sealed with a hard urethane coat.

But…Prince came back and asked for his bass. So, he got it. And when he put it back in its holder he apparently put a note on it that said "DO NOT REMOVE." So that was that for a few days. I could only imagine the paint just wearing off over the days as he rehearsed, but I ended up tearing down my makeshift workshop, not knowing when or if there'd be follow up.

Another opportunity cropped up not long after. Prince left town, so now was the time.

I got the bass back, not as bad as I imagined, but still needing some painterly love. I was still under time constraints as we all knew Prince could practically appear in a puff of smoke, even when he was supposed to be gone. So, I wrapped the job up, off the bass went, and lacquered it was. Every time I saw Prince playing that bass it was another "pinch myself" moment.

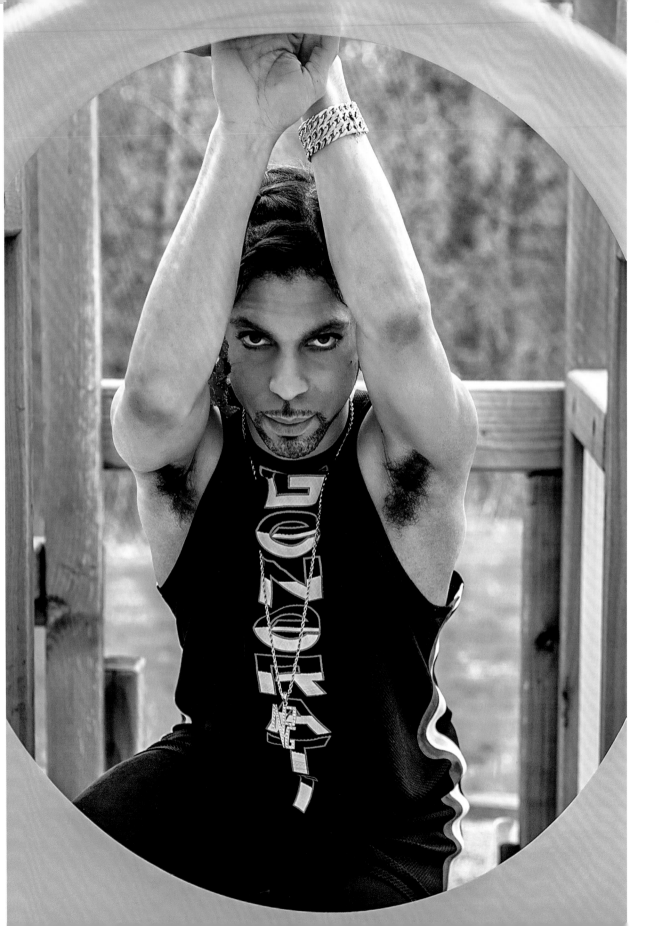

# STAYCATION TOUR

The summer of 1995 Prince and the New Power Generation played the greatest staycation tour ever from the soundstage at Paisley Park. Every weekend the doors opened and a crowd of 100 or so wandered into the cavernous soundstage to watch this band tear it up. It was all presented on a stage: a very cool set-up that, unfortunately I found out later, was never really built with the intention of disassembling and reassembling on tour in mind—in fact, it was very, very heavy. I hear tell that parts kept getting left behind on the European leg of the tour because it was so expensive to haul them. Check out the photo of the stage, it's featured in *The Gold Experience* CD package (under the CD itself).

Nonetheless, it was a great set, and the band ripped through songs Prince rarely played. I would stay the weekend just to attend (and all too easily got caught up in work, even though I technically could leave on Friday).

One night I was doing my usual hang at the back of the crowd and Prince apparently spotted me. From the stage he boomed over the sound system: "Steve Parke. I'm gonna come up in a bit. You got something for me right?" The crowd sort of looked around wondering who he was talking to.

I gave him a thumbs up. Because I did have something. I knew better than to not have something if I was going to stop and enjoy his performance. That said, he actually didn't come up because he played for a few more hours.

When I read about other artists' "longest concerts ever," I realize that these soundstage shows weren't ever in the public eye. Otherwise I think Prince would hold the record easily.

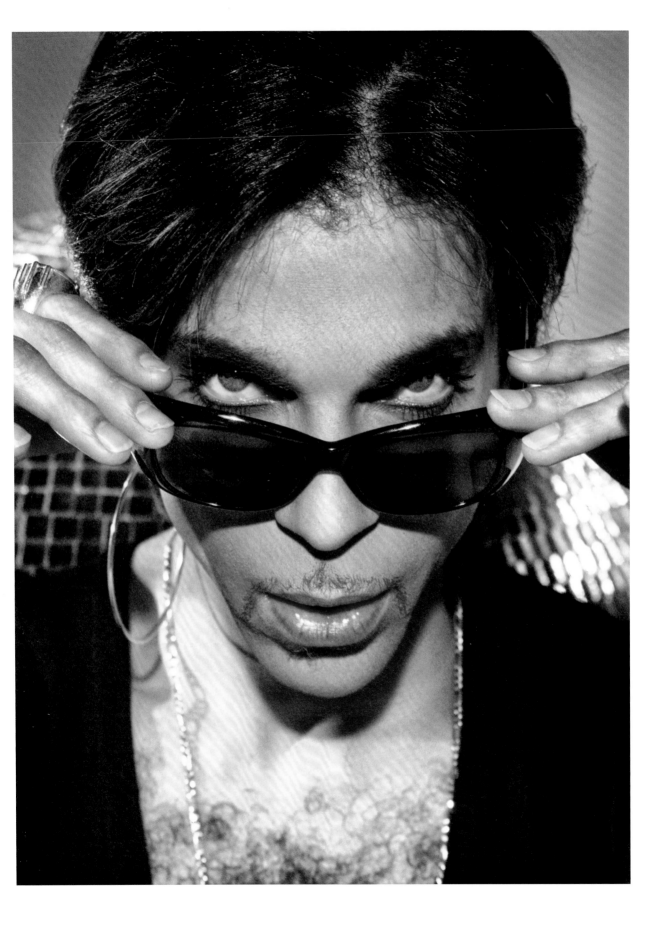

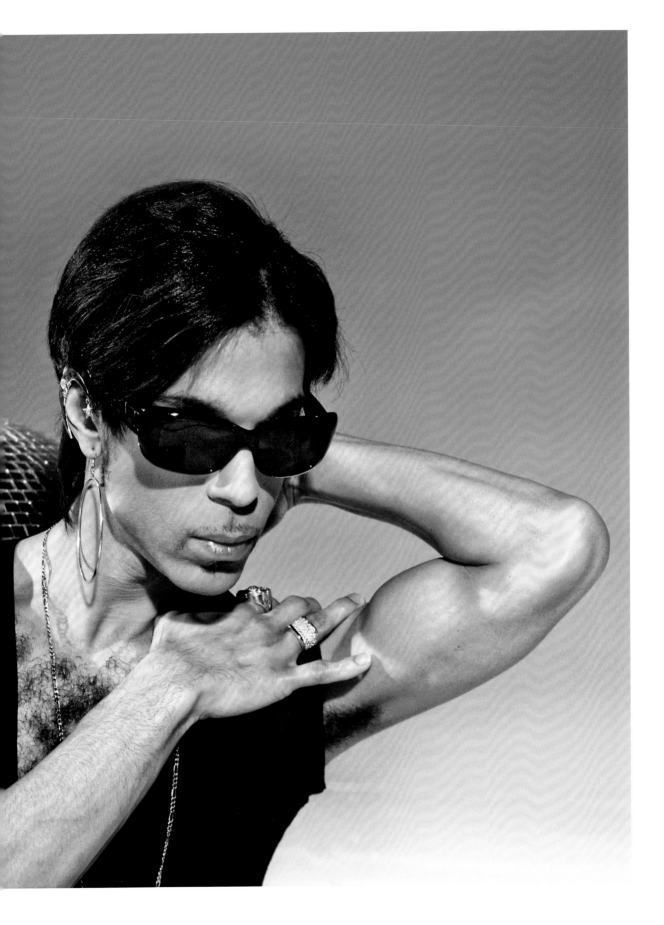

## LEMONADE STAND

It was fun to see Prince get excited. From what he was working on musically, to what his plans were for touring, to discussing world events. One time he walked into my office at Paisley Park after opening an in-house club at the studios in 1996. He was excited by how much he'd just raised for his new "Love 4 One Another" charity.

$5,000.

Relatively speaking it was not a massive sum because they didn't charge much at the door (and I can imagine the studio and crew overhead ate up a lot of the profit), but that is what I thought was so cool. He was excited because he'd done it himself on his terms. It was as if he'd opened a large-scale lemonade stand.

He was thrilled enough to keep doing in-house events and raised money that way for years to come. He extended the charity into tours and other fundraisers. And he raised and gave away more money than anyone could ever guess, since he only made donations anonymously or under the condition that his name not be revealed.

As he stood in my office, looking like a kid who'd just opened a present, I imagined— and hoped—he felt that way every time.

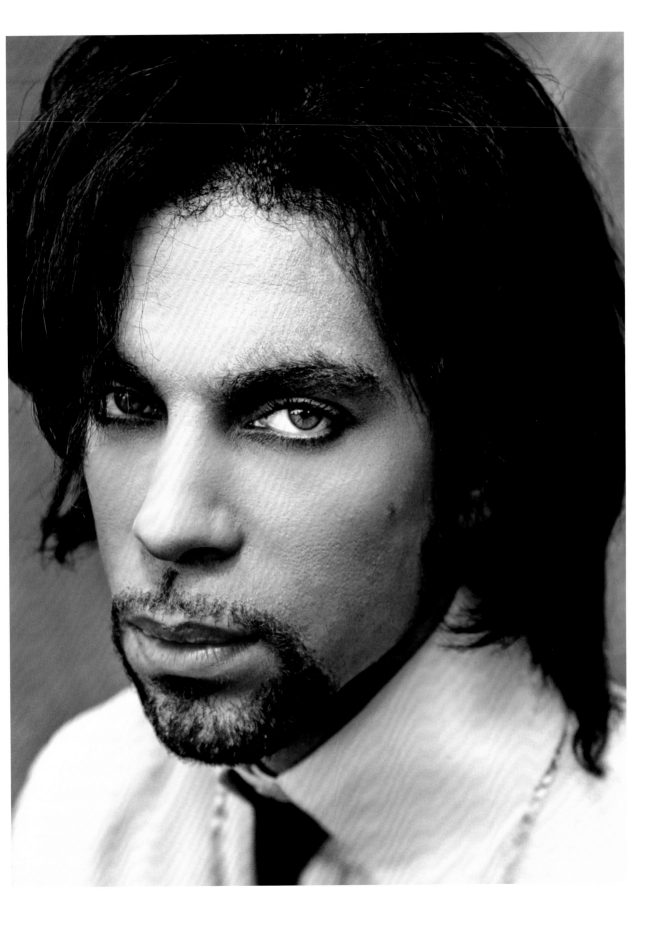

# INTO THE WORLD!

During the *Emancipation* promotion I went to New York to see Prince appear on *The Rosie O'Donnell Show*. I'd try to catch any gig near my home on the East Coast, PRN Productions were very cool about putting me and my wife up in hotels with the band when I did. It was interesting to see him being "Prince" in that situation. The guy I knew seemed a natural introvert when he wasn't playing music, but for public appearances he'd need to pull it out and turn it up to eleven, as they say. And he'd become this extroverted, social, super-charming version of himself.

Whenever Prince got ready to do those sorts of things, he tended to change up the people he talked to in the studios. He was generally very pleasant to people who worked in the building, no matter the capacity, but he didn't really talk a lot to everyone, mostly just the people he was working with directly. When he was getting ready to tour, suddenly I heard from some of the guys who did building maintenance or cleaning— the nuts and bolts of running the studios.

"Man, he talked to me for like 10 minutes," I'd hear.

Suddenly it occurred to me that Paisley Park, his studios, and the small town of Chanhassen were fairly insulated—especially when I first arrived at the big white building that seemed to grow out of cornfields. Prince spent countless hours in that white building, surrounded by a relatively small group of people.

Heading out into a world of people you don't know but have to deal with for months on end must have been not only daunting but also a bit overwhelming. I saw the difference between the guy I chatted with and who would ask about my kid and the guy who took over and commanded any stage he stepped on anywhere in the world.

It was a dramatic shift. Gearing up to deal with that must have been oh so tiring.

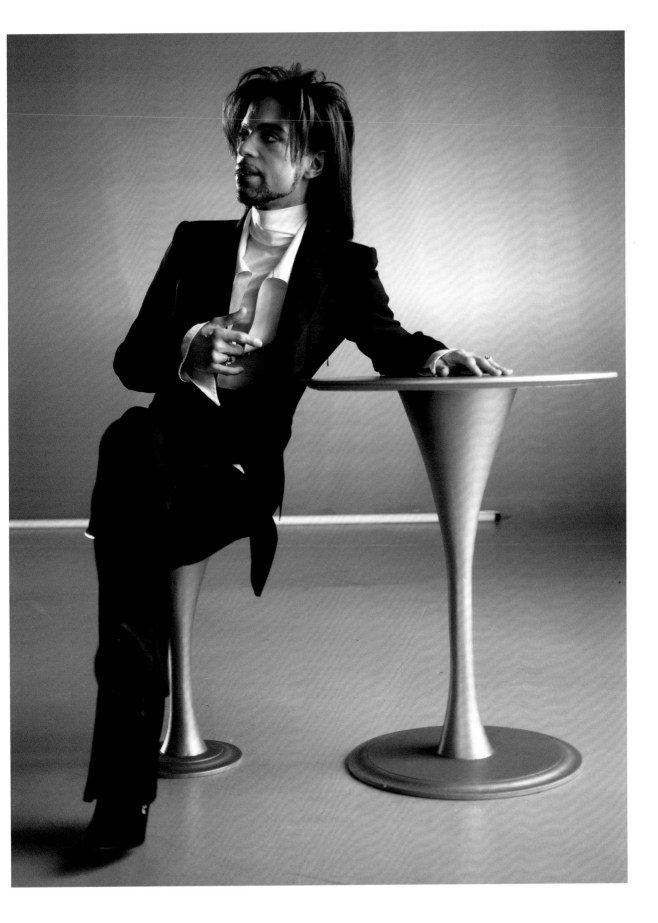

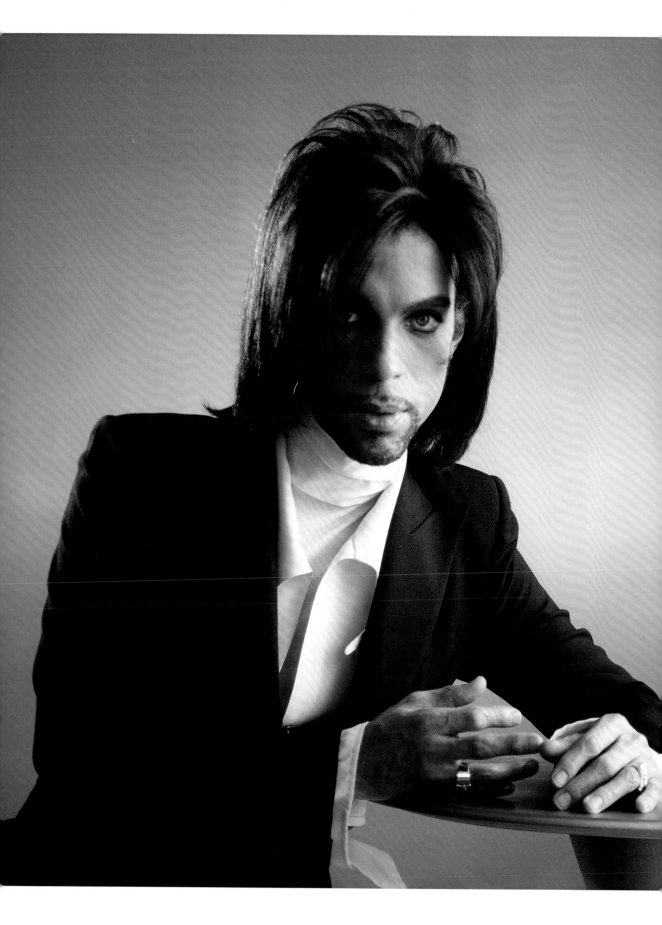

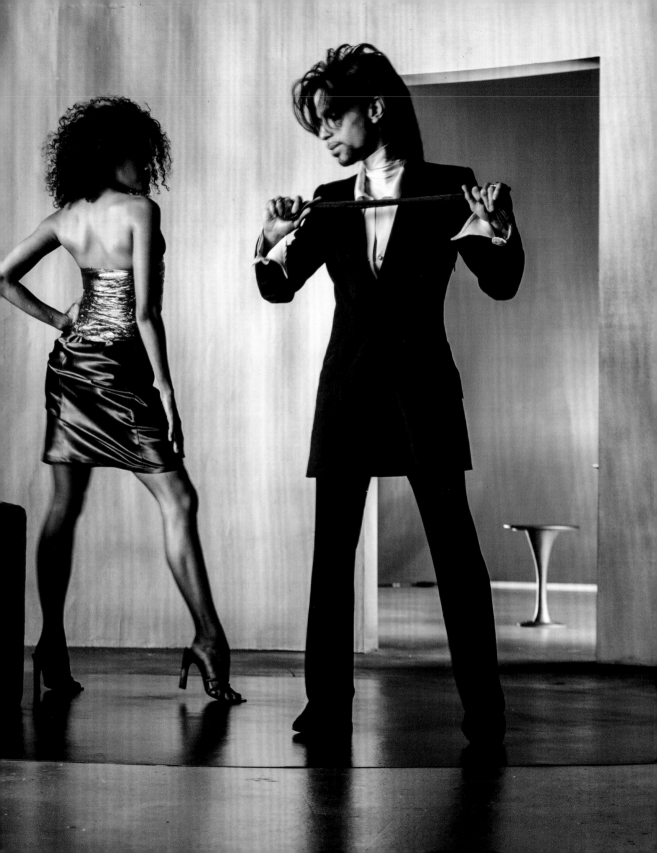

# CAR WASH

Prince decided to do an alternate version of *Rave Un2 the Joy Fantastic*, replacing "Un2" with "In2" and including a booklet that the Arista release did not have. It also contained remixes and extra tracks. One of the interior shots was of him sitting on a bench at Chanhassen Arboretum: a figure, really small, surrounded by woods. Peering over my shoulder and looking at it on my uncalibrated, tiny computer monitor, Prince asked, "Will that be too dark?"

"No."

"Are you sure?"

"Yes," I said, probably sounding a bit irritated.

"What happens if you're wrong?"

"What do you mean?"

"How about this," he said. "If it's too dark, you wash my car for a year."

I kind of laughed. "And what if it isn't?"

"You keep your job."

I looked at him for a trace of a smile. Thankfully, there was one. He walked out of the office.

I brightened the image a bit, just in case…

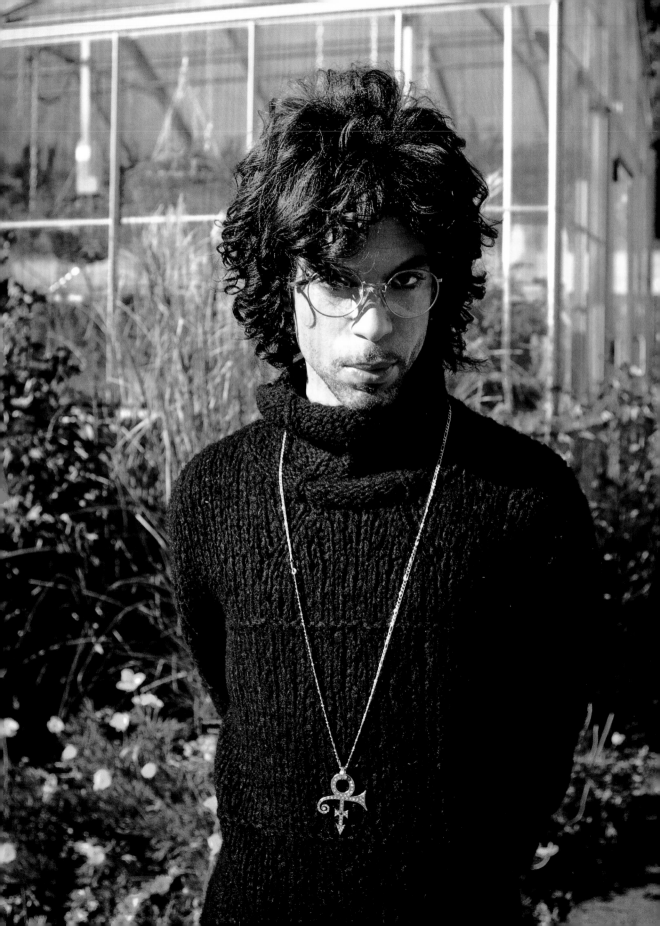

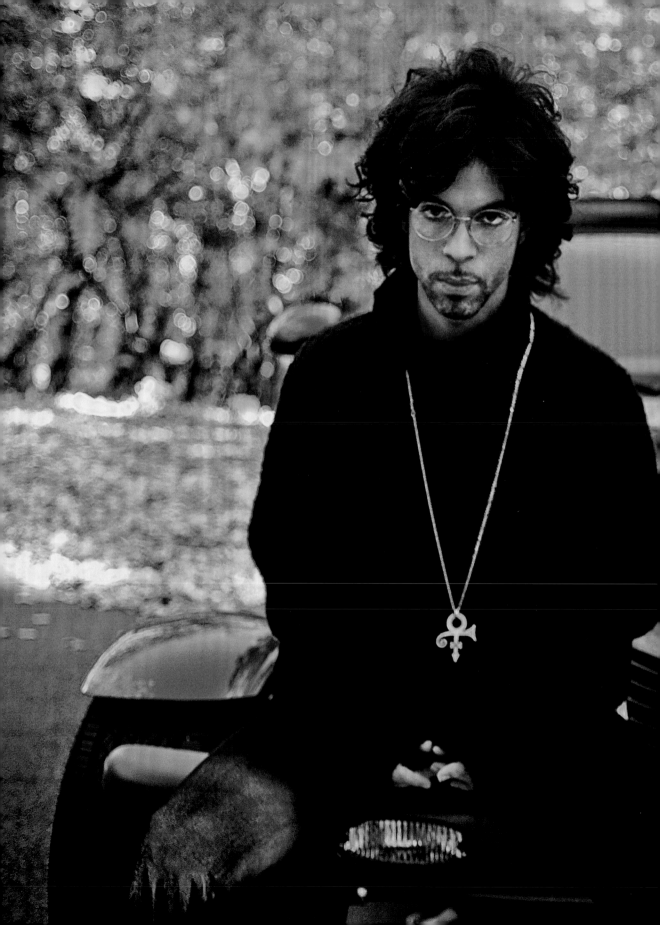

# STYLE ICON

I was wearing an ear cuff I'd purchased at the Maryland Renaissance Festival, an event I'd worked at for many years (yes, it's true). Prince admired my fashion sense for once and asked if I could scan the cuff and Photoshop it into a picture of him. I said sure. While I was adjusting the image, I added some razor cuts to his sideburns, too. As I worked, he asked me about the festival:

"What do they wear?"

"Tights and stuff like that."

"Is it like the Minnesota one?"

"Yeah. The people who started that one own the one I worked at."

"You worked there?"

"Yes."

"What did you do?"

Here's where I wasn't sure what to say. But I continued.

"You know how at baseball games they sell pretzels?"

He nodded.

"I sold those. And…pickles."

No particular reaction came.

"Does that company have any other ear cuffs?" he asked as he watched me add shadows to his ear.

"Yeah, they have a lot."

"Can you get a catalog?"

"Sure."

He paused and then asked, "What kind of hat did you wear?"

It took me a minute to realize he was asking about the festival. "One that was kind of floppy on top." I gestured around my head to describe it.

The next time I came in he was wearing that same kind of hat, and soon I was shooting pictures of him with moon wrap earrings from Marty Magic, the company I'd bought my ear cuff from. As it turns out, Prince had ordered custom wraps made of gold and diamonds and then had them produced to sell through 1-800-NEW-FUNK, his catalog and eventual online store.

No, I didn't get a cut.

I never saw myself as a style icon, mostly because it's not what you wear but how you wear it. Oh well.

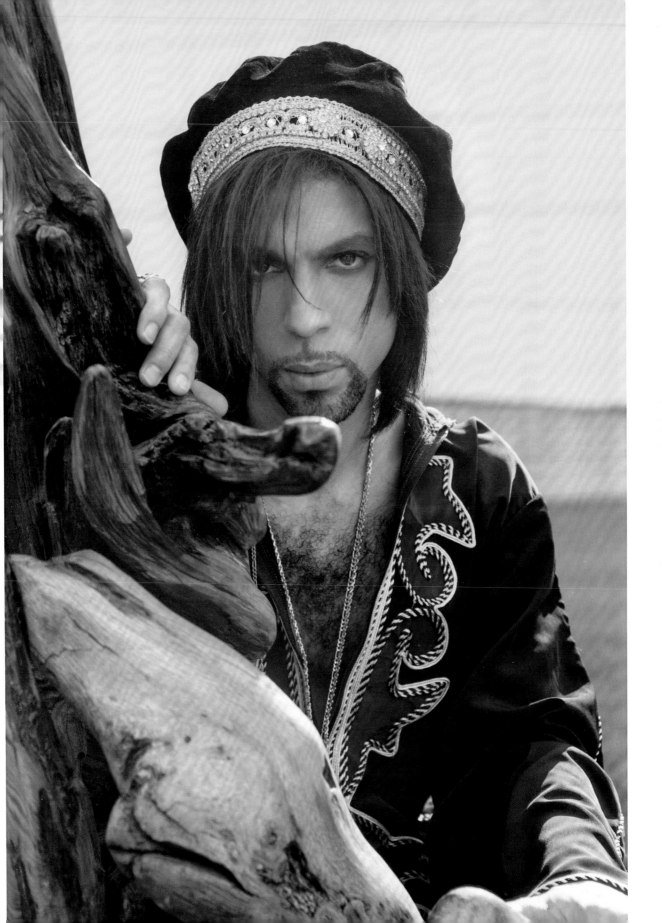

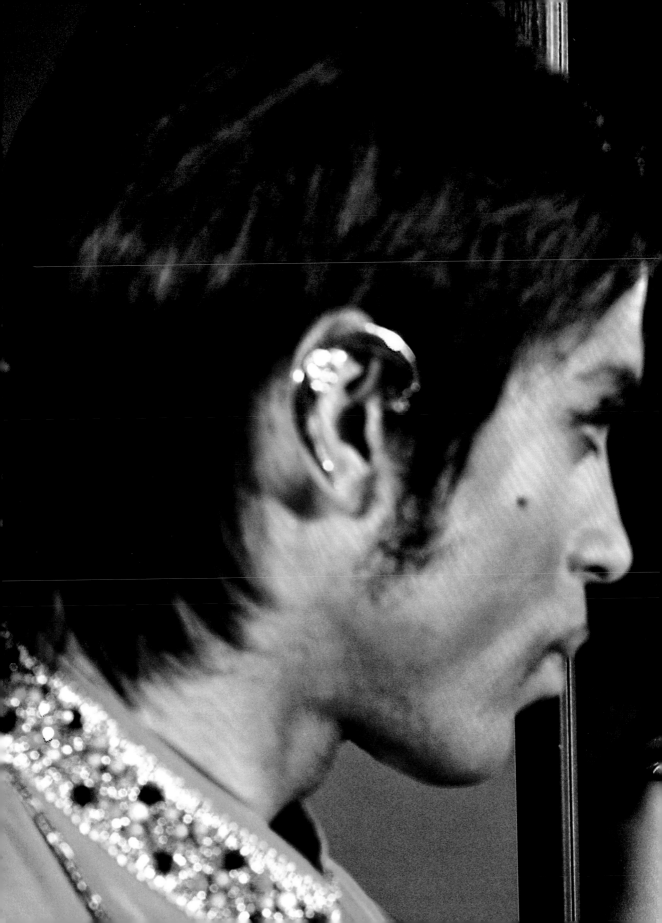

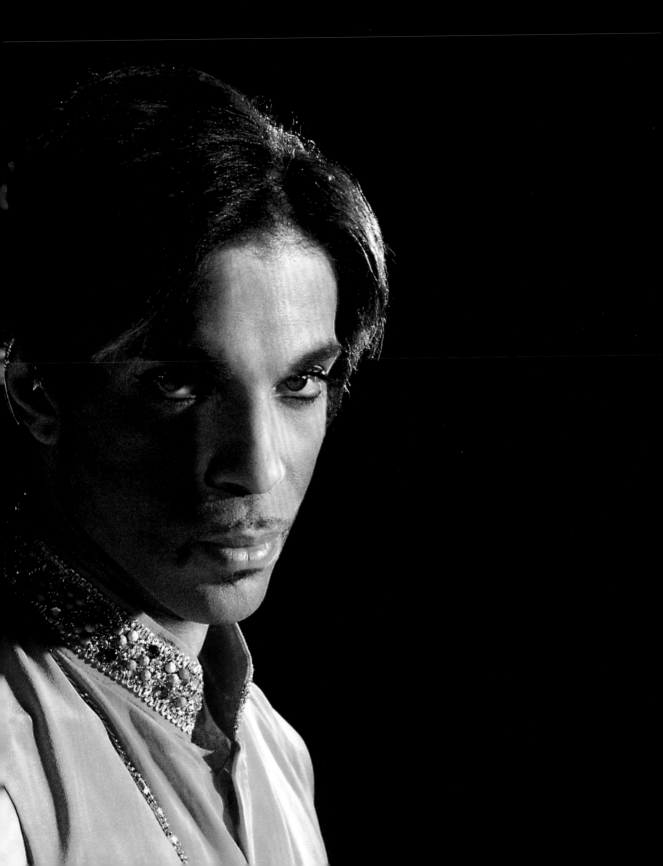

# LIVING DANGEROUSLY

When I first started working with Prince I could hardly believe it. I felt like I was walking on a cloud all day. On occasion, when there were a lot of tech people hanging lights and building things around the rehearsal set for the *Lovesexy* tour (the same set I was painting featured in the "Glam Slam" video), the band would move to the loading dock area to rehearse.

From time to time I would hang out in the little entryway between the small parking lot and the side entrance to the loading dock. The sound was really good right there. I remember thinking my friend Ricky back in Northern Virginia would be blown away by what I was hearing right now. So, without thinking, I grabbed the wall phone and called him.

"You'll never guess what I'm doing," I said, tilting the phone away from my mouth a little.

He was quiet and then I could hear his disbelief. "Really? Is that…?"

"Yep."

The cord on the phone was long. I walked a bit towards the hallway, trying to look casual but no doubt looking suspicious instead. I peered down the hall, letting the phone nonchalantly fall by my side, then looked out of the glass doors to the parking lot. When I was sure there was no one in sight, I pushed the phone out from my body and aimed it right at the open door—like a kid using a stick as a ray gun—for what felt like a potentially jailable amount of time. In reality, it was most likely a minute but felt like longer.

I let him hear what was mostly a super distorted version of the *Lovesexy* band kicking ass. I casually pulled the phone back to my ear. "I hope you could hear that."

He laughed. He could.

"I gotta go," I said, suddenly imagining I was on videotape and my career was over. Fortunately no one saw, or if they did they never said a word.

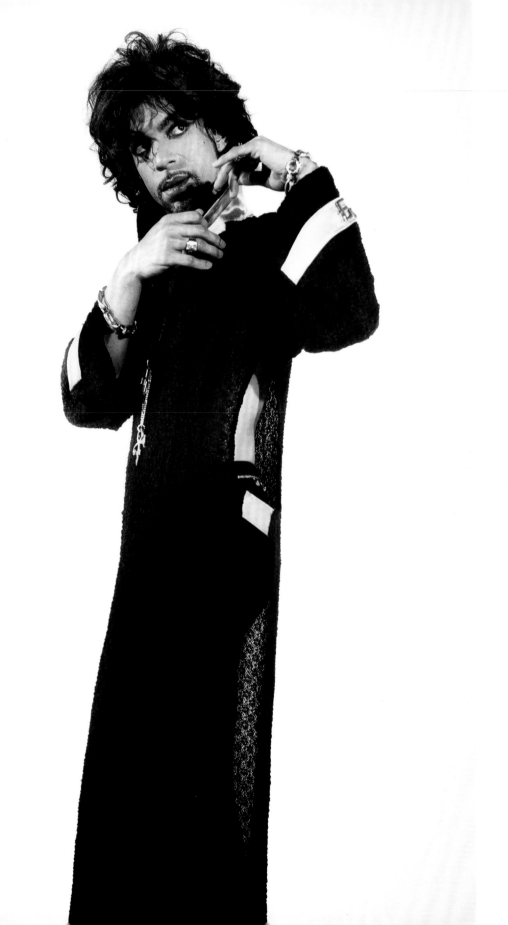

# LIFE MODEL

Because I couldn't let an opportunity go by I talked to Terry Salazar, who was working on merchandise for the *Lovesexy* tour, and told her I was available to do anything else if they needed it—even though I was working all night and watching rehearsals all day. (I was 25 and super hyped on caffeine.)

The set for "Glam Slam" had been finished, but I was there to do any other bits and pieces needed and to touch up the set if anything got wrecked during the video filming, which was a few days away. Terry said I should work up a sketch for a T-shirt and see what Prince thought.

I went to Uptown, an artsy neighborhood in Minneapolis, and bought a few sheets of illustration board, grabbed promo photos from Paisley Park, and started drawing up the idea at my hotel later that night. The idea was simple: four different portraits of Prince in four different styles collaged together as if one portrait had been ripped and patched back together. The effect was disconcerting and, I thought, pretty cool.

Terry liked what I'd done and we tracked Prince down in the wardrobe department the next day. I handed him the board to see what he thought.

He scanned it. "That chin's a little Lionel Richie, don't you think?"

I grabbed the board and looked from him to the drawing. He was right. "Hold on," I said. In my over-caffeinated exuberance, I reached into my pocket and produced a pencil and eraser. I rubbed out the chin.

"Stand still," I said.

He seemed a bit taken aback, but he did as asked.

I wasn't even thinking, just intent on fixing the drawing. I blame the caffeine. Holding the board with one hand, I looked up at him and then back to the paper and sketched. At first he looked right at me, then his eyes darted to the left and right, slightly uncomfortable.

"Just a few more minutes." I think I motioned for him to lift his head a bit and he let out an audible breath.

"How's this?" I asked a few minutes later, spinning the drawing around to him.

He eyeballed it and seemed mildly surprised. "That'll work."

I practically ran out of the room to rent an air compressor and buy an airbrush so I could work later that night, painting it so he could see and approve the next day. I didn't want him to change his mind!

The day I saw the T-shirt I'd designed hanging at a merch table at an actual show, after the band returned to the U.S. (the *Lovesexy* tour started overseas), I just stared and stared. The vendor asked if I needed something. I said no. And kept staring, unable to believe what I was seeing.

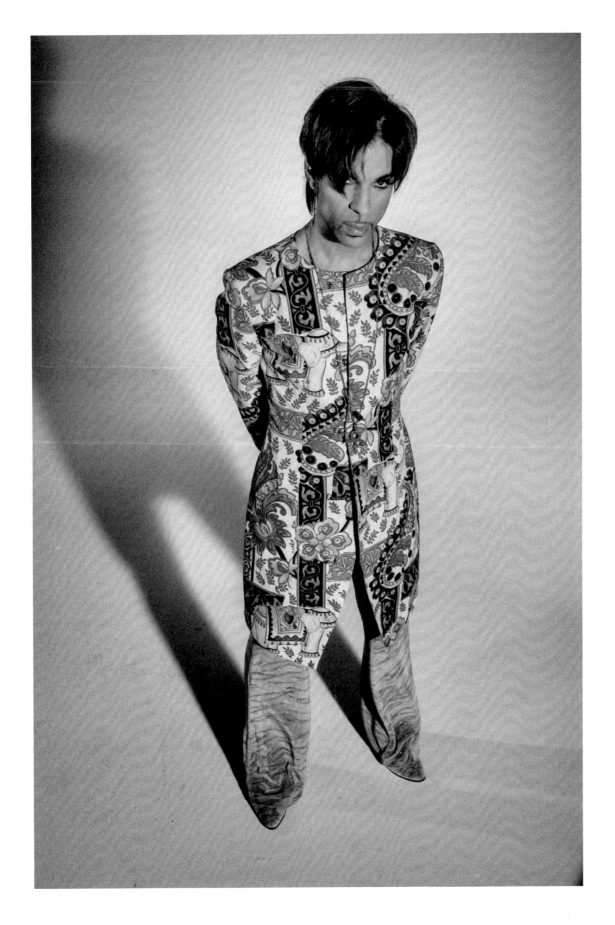

# JUST A LITTLE LONGER

Prince and I were working all night one night (as usual) around the time he was putting together the *Rave Un2 the Joy Fantastic* album. He would usually play a cassette tape of whatever he was working on for me, in my office—which he'd made sure had a great stereo system (by taking one from someone else's office and putting it in mine!). I think he knew it inspired me, hearing the music. And I was usually working on the art that would somehow go with it. That night I was working on the album's packaging for Arista.

On that album Prince wanted to use both his symbol as artist, and "Prince" as producer. Pretty clever, I thought. We'd already produced a cover that reminded me of Elvis Presley's stage set up, even toying with the idea of putting the name PRINCE in large letters on the cover and no symbol at all. Eventually we settled on Prince playing guitar in a full body silhouette, with his back to the viewer and a big symbol behind him. We sent the art to Arista Records and they immediately shot back that he needed to be face front. Prince picked the shot we finally used and just let me build a design around it, which was sadly, I thought, far less interesting.

My two office windows faced east, the blinds were all open, and the sky started to shift as the sun came up. This usually signaled that it was time to go home, but that morning Prince just slipped over to the window and slowly closed the blinds. It was funny—as if he didn't want me to realize it was daylight, and as if I wouldn't notice him closing the blinds.

I noticed!

The sky was pale pink when I finished the art, and Prince hung around to give me a ride back to my hotel. He did this from time to time, when there was no rental car available. I packed my bags and shut down, then walked a bit dazed down the stairs, molecules buzzing. The long hours had sunk in. We went down to the garage and got into his Prowler.

My hotel was only five minutes away, but instead he pulled out of the parking lot, turned in the opposite direction, and gunned it, driving fast down Highway 5, which stretched past Paisley Park. He stuck a cassette tape in the dash, cranked up the sound, and played me, for the first time, his cover of Sheryl Crow's "Every Day is a Winding Road." It's a great cover, very different from the original, with layered vocals, a club beat, and some heavy ringing bells. Suddenly I was wide awake and everything coalesced into a perfect moment. I loved it—listening to this great song, the pale pinky blue of the crisp fall morning, and Prince, driving about 80 miles per hour beside me on a rural highway that cut through farmland. We looked at each other and made that listening-to-music face, bobbing our heads, blissed out, green and gold zipping by on either side of us.

Everything at Paisley Park was so intense and frantic. But once in a while it was just amazing, like a fantastical dream you wake up from shaking your head, wishing you could hold onto it just a little longer.

When the song ended, he turned and drove me back to my hotel. We pulled up as some businessmen were leaving, looking a bit perplexed by this purple Batman car with music blaring and me with a backpack, jeans and T-shirt emerging.

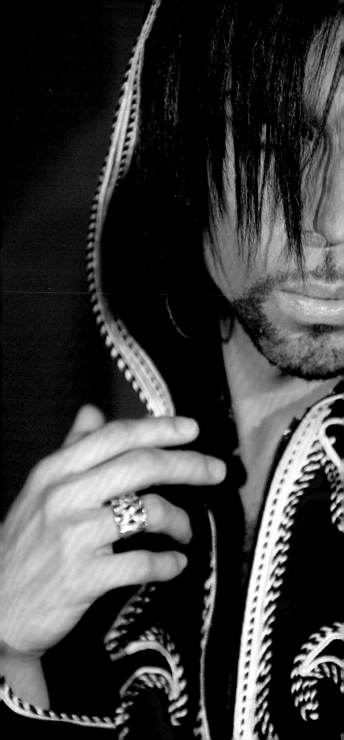

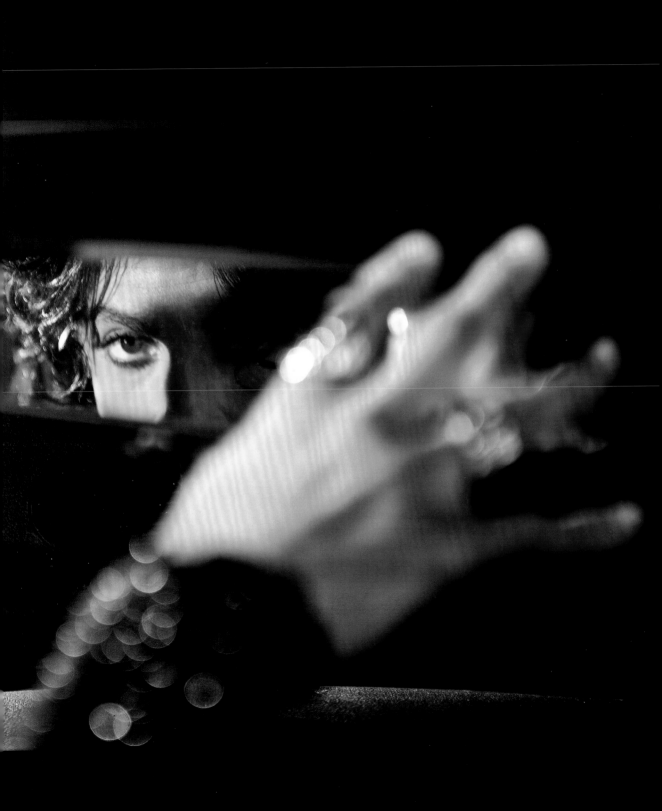

# AFTERWORD

When my son was born, things changed for me. I didn't have the same kind of energy I'd had before that let me work constantly on nearly no sleep, until the early mornings. I didn't love flying out to Minneapolis for that one week every month, and all the stress leading up to it and all the time it took me to decompress after when I'd return to Baltimore, drained and exhausted. I didn't want to bring that crazy, frenetic energy home to my family, my son. And I guess, after 13 years with Prince, I'd had enough.

I quit in 2001. I always thought I'd go back at some point, and that I'd see Prince again. He reached out a few times in the years after, through assistants, never directly, but I was always involved in other projects when he did, and I knew what "just a few days" meant in Prince time. I couldn't afford to screw up whatever work I'd managed to find. It wasn't easy in the few years after I left. It took a while to establish myself in the world outside, when everyone knew me as the guy who worked for Prince (and was therefore out of their price range). Newly unemployed, newly a parent, I threw myself into every opportunity.

And so it never quite worked out, my return to Paisley Park. And as close as Prince and I sometimes were over those long nights in my office, when we spent hour upon hour talking about everything in the world—but music mostly, that's the thing that connected us—it's not like he was ever really my pal in the traditional sense. Though I was, in many ways, as close to him as I've ever been to anyone.

In the meantime, my son grew up. He asked questions. He'd heard the stories from my one-time co-worker Michael Van Huffel, still a close friend, but I didn't tend to share them myself, not until recently. Duncan, too, is a music geek, it turns out, and when he was old enough he dug through Prince's catalog the way I'd done once, blown away at almost every turn, and it was through him that I came back to the music, and to Prince.

I'm sorry that Duncan was never able to see Prince in concert (though he does still have a backstage pass with his baby photo on it, from the 2000 Hit N Run tour). But just a few months after Prince's passing, he and I visited Minneapolis together for the first time. We stayed at The Chanhassen Inn, where the same people who owned it 16 years ago still did, and remembered me. He was able to meet some of my old colleagues — Jacqui Thompson, Hans-Martin Buff, Danny Soltys—and hear their stories. We met some local Prince fans at the Perkins restaurant & bakery where Hans, Michael, and I would sometimes go for an early morning or late night breakfast. He saw First Avenue. We hung out at Larry and Tina Graham's house. He saw that bright-green farmland along Highway 5, among all the new houses and construction.

And I took him to Paisley Park. It's not how I ever imagined my return. The building itself was closed but the fence surrounding it was covered in thousands of notes and tributes from around the world. And it seemed like another lifetime, as I remembered those days and nights spent there; how strange and beautiful it all was, all those moments when I thought I might have been in a dream. All I could feel, through the loss, was the most tremendous gratitude.

When I started writing these stories down, resurrecting these moments and memories I'd nearly forgotten, I realized how fortunate I was to have the relationship with Prince that I did, for the time that I did. I was able to ignore convention and talk to Prince in ways that might have been disastrous in any ordinary working relationship. But Prince was no ordinary boss, no ordinary anything. In the end I'm glad I let myself talk to him the way I did, and that I told him how much I appreciated him. He believed in me, after all, right from the beginning.

And the music. I always told him how much I loved the music.

I'm still listening.

# DISCOGRAPHY

**For You**
*7 April 1978*
Warner Bros.

**Prince**
*19 October 1979*
Warner Bros.

**Dirty Mind**
*8 October 1980*
Warner Bros.

**Controversy**
*14 October 1981*
Warner Bros.

**1999**
*27 October 1982*
Warner Bros.

**Purple Rain**
*25 June 1984*
Warner Bros.

**Around the World in a Day**
*22 April 1985*
Warner Bros.

**Parade**
*31 March 1986*
Warner Bros.

**Sign 'o' the Times**
*31 March 1987*
Warner Bros.

**Lovesexy**
*10 May 1988*
Warner Bros.

**Batman**
*20 June 1989*
Warner Bros.

**Graffiti Bridge**
*21 August 1990*
Warner Bros.

**Diamonds and Pearls**
*1 October 1991*
Warner Bros.

**⚥ [Love Symbol]**
*13 October 1992*
Warner Bros.

**The Hits 1**
*14 September 1993*
Warner Bros.

**The Hits 2**
*14 September 1993*
Warner Bros.

**The Hits/The B-Sides**
*14 September 1993*
Warner Bros.

**Come**
*16 August 1994*
Warner Bros.

**The Black Album**
*22 November 1994*
Warner Bros.

**The Gold Experience**
*26 September 1995*
NPG Records/Warner Bros.

**Girl 6**
*19 March 1996*
Warner Bros.

**Chaos and Disorder**
*9 July 1996*
Warner Bros.

**Emancipation**
*19 November 1996*
NPG Records/EMI Records

**Crystal Ball/The Truth**
*21 March 1998*
NPG Records

**The Vault... Old Friends 4 Sale**
*24 August 1999*
Warner Bros.

**Rave un2 the Joy Fantastic**
*9 November 1999*
NPG Records/Arista Records

**Rave in2 the Joy Fantastic**
*30 April 2001*
NPG Records

**The Very Best of Prince**
*31 July 2001*
Warner Bros.

**The Rainbow Children**
*20 November 2001*
NPG Records/Redline Entertainment

**One Nite Alone...
Solo Piano and Voice by Prince**
*14 May 2002*
NPG Records

**One Nite Alone... Live!/One Nite Alone...
The Aftershow: It Ain't Over**
*17 December 2002*
NPG Records

**Xpectation**
*1 January 2003*
NPG Records

**N.E.W.S**
*29 July 2003*
NPG Records

**The Chocolate Invasion**
*29 March 2004*
NPG Records

**The Slaughterhouse**
*29 March 2004*
NPG Records

**C-Note**
*29 March 2004*
NPG Records

**Musicology**
*20 April 2004*
NPG Records/Columbia Records

**3121**
*21 March 2006*
NPG Records/Universal Records

**Ultimate**
*22 August 2006*
Warner Bros.

**Planet Earth**
*15 July 2007*
NPG Records

**Indigo Nights**
*30 September 2008*
NPG Records

**Lotusflow3r/MPLSound**
*29 March 2009*
NPG Records

**20Ten**
*10 July 2010*
NPG Records

**Plectrumelectrum**
*30 September 2014*
NPG Records/Warner Bros.

**Art Official Age**
*30 September 2014*
NPG Records/Warner Bros.

**HITnRUN Phase One**
*7 September 2015*
Warner Bros.

**HITnRUN Phase Two**
*12 December 2015*
NPG Records

**Prince 4ever**
*22 November 2016*
NPG Records/Warner Bros.

***Albums credited to
The New Power Generation***

**Gold Nigga**
*31 August 1993*
NPG Records

**Exodus**
*27 March 1995*
NPG Records

**Newpower Soul**
*30 June 1998*
NPG Records

***Albums credited to
Madhouse***

**8**
*21 January 1987*
Paisley Park Records

**16**
*18 November 1987*
Paisley Park Records

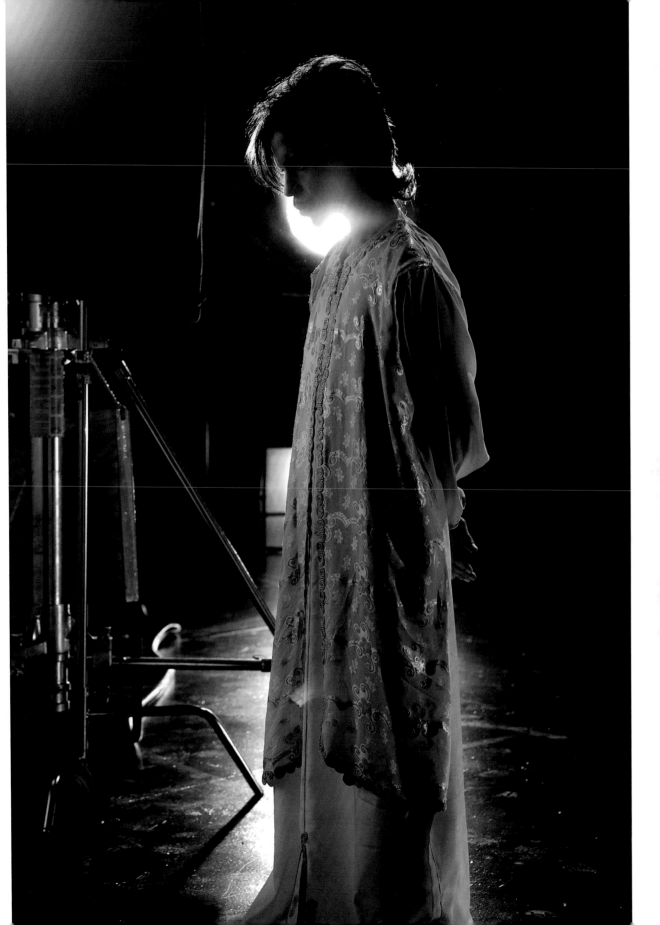

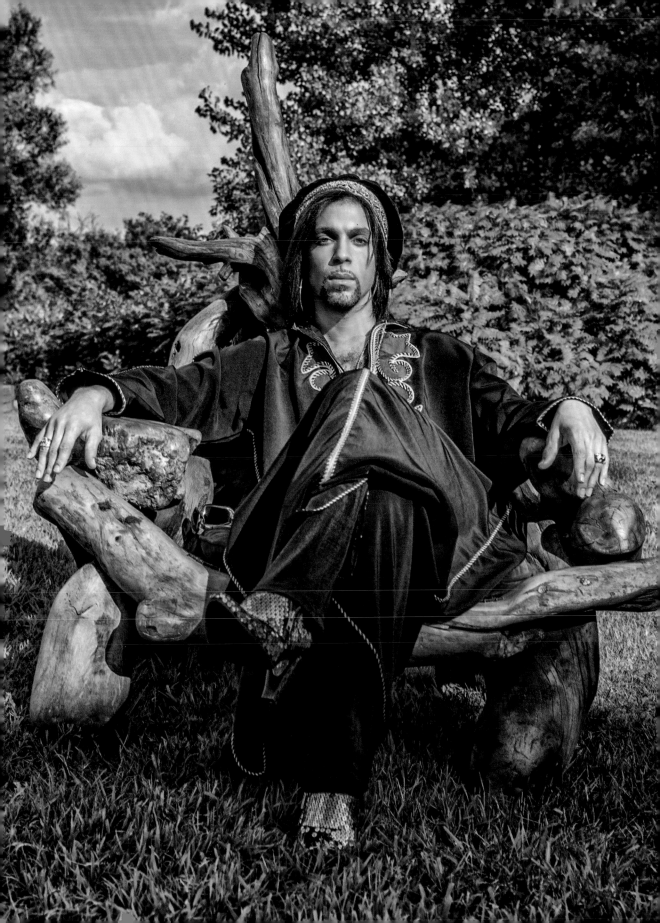

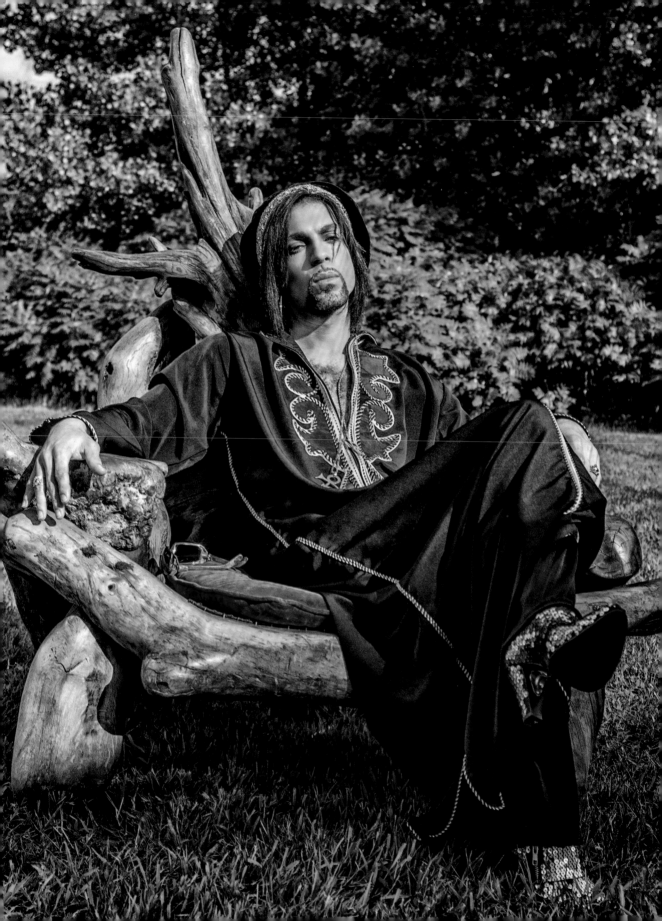

# INDEX Page numbers in **bold** indicate photographic vignettes.

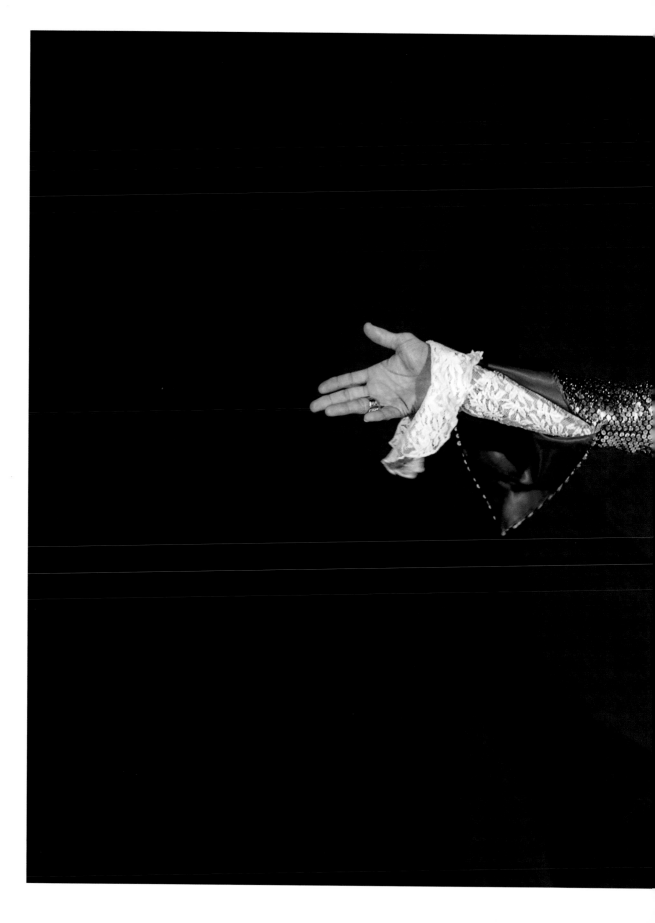

# ACKNOWLEDGMENTS

**This book is dedicated**

To my parents, Bob and Joyce, who always believed in me.

To Prince, who always believed in me.

And my son Duncan, who I'll always believe in.

I'd like to thank the wonderful people who I had the opportunity to know and work with because of Prince (in alphabetical order): Aaron, Kathy Adams, Hucky Austin, Tommy Barbarella, Roy Bennett, Jerome Benton, Kim Berry, Michael Bland, Matt Blistan, Boni Boyer, Hans-Martin Buff, Ingrid Chavez, Lisa Coleman, Gilbert Davison, Dez Dickerson, Damon Dickson, Leanne Doescher, Latonya Dupas, Steve Durkee, Kat Dyson, Sheila E., Matt Fink, Bonnie Flesland, Rosie Gaines, Mayte Garcia, Tom Garneau, Cat Glover, Larry and Tina Graham, Morris Hayes, Chuck Hermes, Helen Hiatt, Tim Hoogenakker, Sam Jennings, Jellybean Johnson, Kirk Johnson, Shane T. Keller, Chaka Khan, Andy Kistner, Juli Knapp, Karen Krattinger, Stacia Lang, Matt Larson, Kimberly Lawler, Alan Leeds, Eric Leeds, Brad Marsh, Micah McFarlane, James E. McGregor Jr., Debbie McGuan, Susannah Melvoin, Wendy Melvoin, Tony Mosley, Jeff Munson, John L. Nelson, Mike Oakvik, Maceo Parker, Robbie Paster, Ricky Peterson, Paul Peterson, Fafu Pfafflin, Mike Pittman, Craig Rice, Bevla Reeves, Neil Richards, Michelle Schwartzbauer, Levi Seacer, Jr., Joe Simon, Rhonda Smith, Danny Soltys, George Stephenson, Therese Stoulil, Manuela Testolini, Jacqui Thompson, Sonny Thompson, Tom Tucker, Duane Tudahl, Miko Weaver, Red White, Jill Willis, Victor Wooten and Bobby Z.

For helping eyes and brains: Val Margolin, Dave Pugh, Robin Stevens and Catherine Turgeon.

Thanks to Carrie Kania for finding me a great publishing team, Hannah Knowles, Joe Cottington, Leanne Bryan, Jonathan Christie, Karen Baker, Matthew Grindon, and Caroline Brown for being that great team. Your support and enthusiasm to make something really great is inspiring.

Thank you to all of those who respected and supported Prince as an artist. I made this for you.

**Special thanks to**

Carolyn Turgeon – you helped me to get this book started and found it a home when I was too devastated to even think about it. You helped to pull the genuine love I had for collaborating with Prince to the surface for all to read about.

Kathryn Parke – for putting up with it all for those 13 years.

Michael Van Huffel – my lifeline at Paisley Park for several years, I'm just trying to return the favor.

gofundme.com/myfriendmichael

An Hachette UK Company
www.hachette.co.uk

First published in Great Britain in 2017 by Cassell, a division of Octopus Publishing Group Ltd, Carmelite House, 50 Victoria Embankment, London EC4Y 0DZ
www.octopusbooks.co.uk

Text copyright © Steve Parke 2017
Special photography copyright © Steve Parke 2017
Design and layout copyright © Octopus Publishing Group Ltd 2017

All rights reserved. No part of this work may be reproduced or utilized in any form or by any means, electronic or mechanical, including photocopying, recording or by any information storage and retrieval system, without the prior written permission of the publisher.

Steve Parke asserts the moral right to be identified as the author of this work.

ISBN 978-1-84403-959-3

A CIP catalogue record for this book is available from the British Library.

Printed and bound in Italy.

10 9 8 7 6 5 4 3 2 1

Commissioning Editor: Hannah Knowles
Creative Director: Jonathan Christie
Senior Editor: Leanne Bryan
Copy Editor: Nikki Sims
Photographer: Steve Parke
Discography: Antony Hitchin
Production Controller: Meskerem Berhane

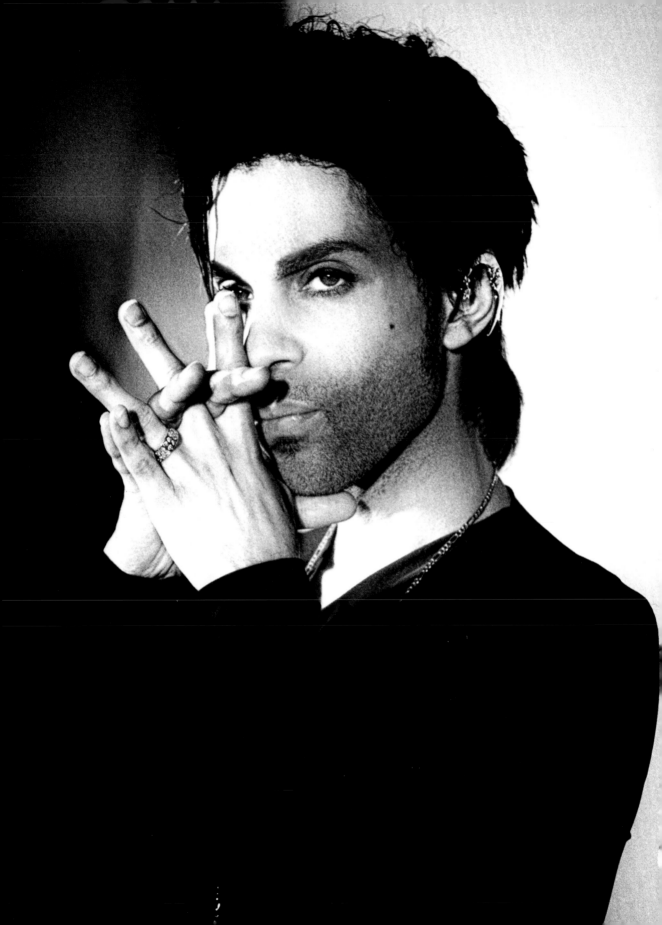